Painting What You *want to* See

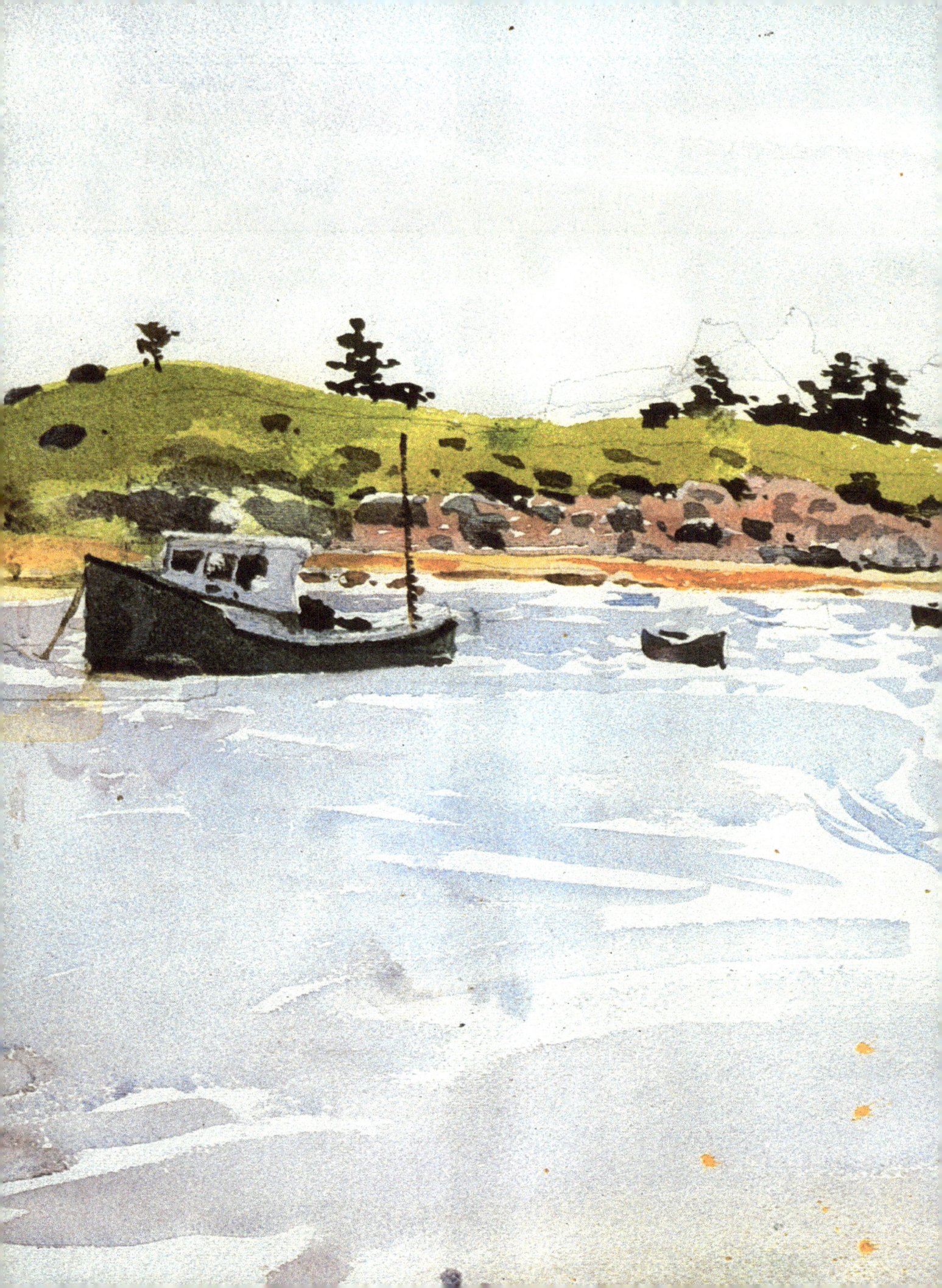

Painting What You ^want to See

BY CHARLES REID

EPBM

ECHO POINT BOOKS & MEDIA, LLC

To Judith, my love and best friend.

Published by Echo Point Books & Media
Brattleboro, Vermont
www.EchoPointBooks.com

Painting What You Want to See
ISBN: 978-1-62654-378-2 (paperback)
978-1-62654-379-9 (casebound)

Interior design by Bob Fillie

Cover design by Rachel Bootby Gualco
Editorial and proofreading assistance by Ian Straus,
Echo Point Books & Media

Printed and bound in the United States of America

ACKNOWLEDGMENTS

My thanks to Chip Chadbourne and Joe Lasker who helped me to be a painter; to David Lewis, Bonnie Silverstein, and Bob Fillie who helped to make this book; and to Vin Greco for the excellent photography.

CONTENTS

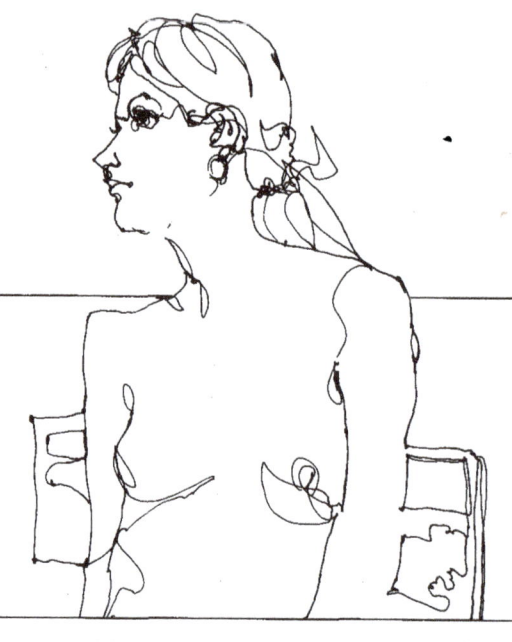

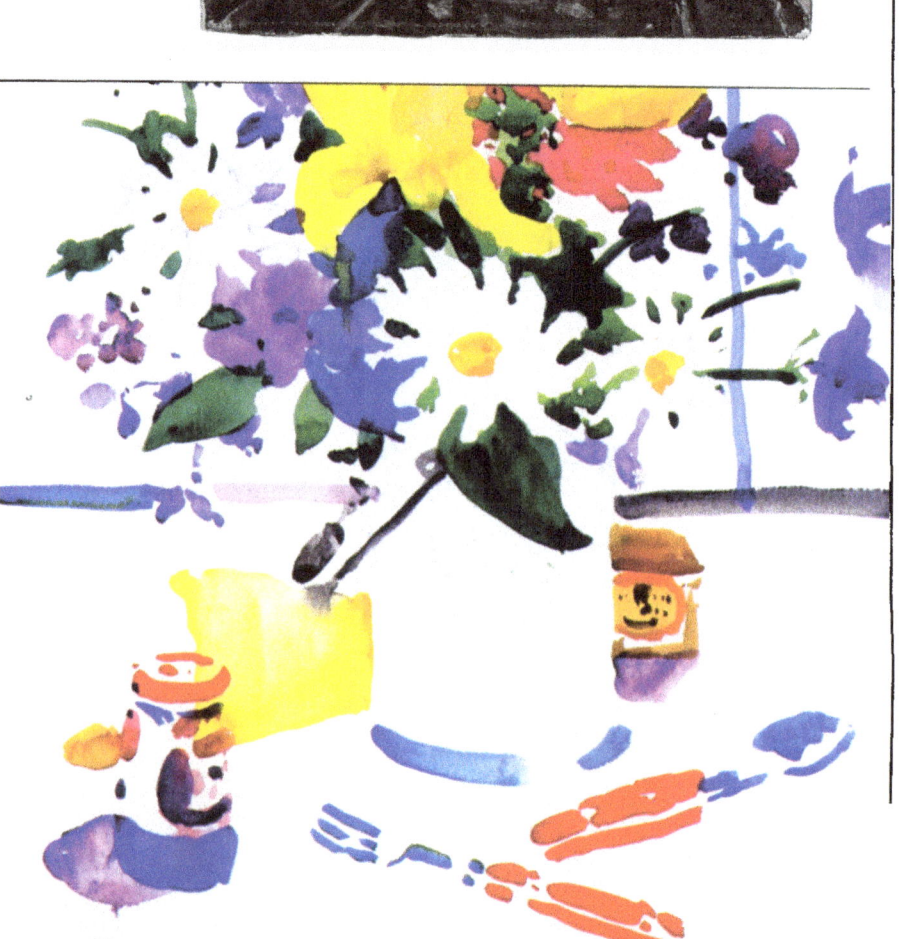

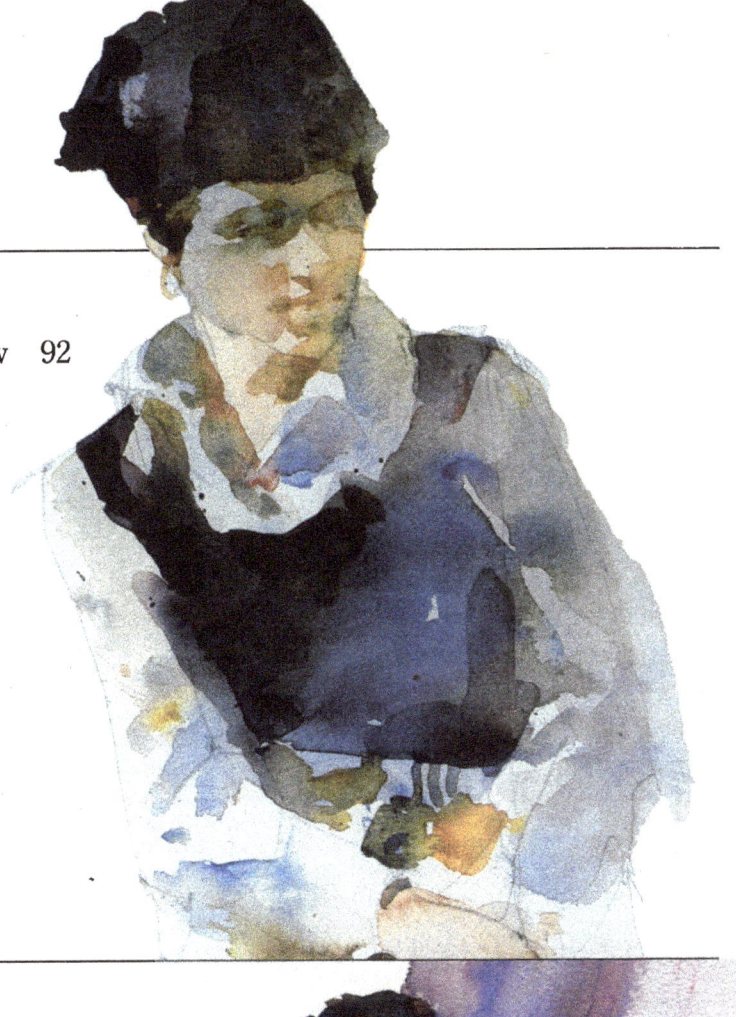

PART 4. DIRECTING THE EYE

PART 5. CRITIQUES AND SOLUTIONS

PART 6. LEARNING FROM THE MASTERS

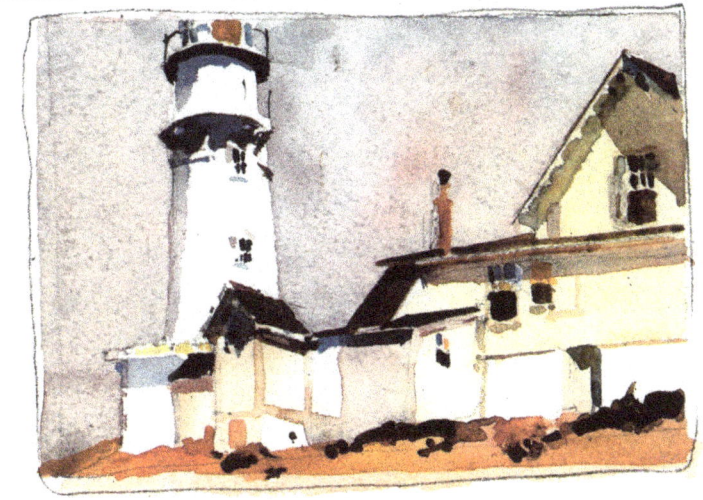

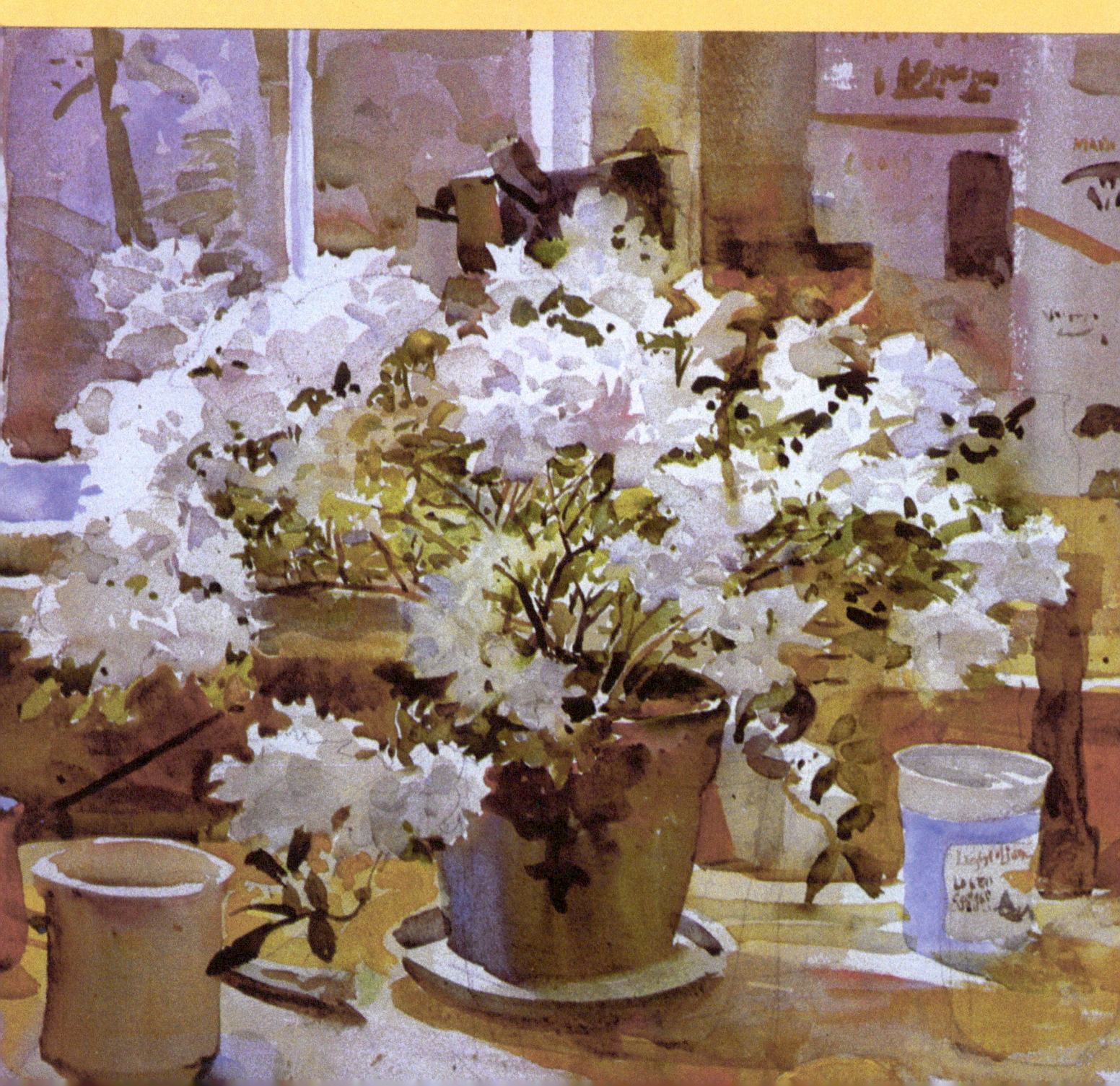

part one
REVIEWING THE BASICS

INTRODUCTION

This is not a "how to do it" book, but rather a "way to see" book. When I began work on this book, I started out with the idea of writing down various projects I've used in my classes. I had thought then that the projects were all quite different, but when I showed them to my editor Bonnie Silverstein, she pointed out that they were all really about the same thing. They were about editing and altering what we see in order to make a painting.

At the core of this book is the idea that we're not painting "things" in terms of objects, rather we're painting things as patches of color and value. I love things and that's what I paint. Yet I don't copy them—a photograph could do that better. Instead, I react to them. That is, I try to change what I see and make the pieces fit like parts of a jigsaw puzzle. The point is that no one piece is important except as it fits the rest of the puzzle.

The idea of reacting to color and value rather than to objects is difficult to describe, but it is the basis of abstract art. Perhaps that's the problem. Many of us have been told we had to make a choice between realism and abstraction as artists. But this is not true. I don't paint abstractly, but I still react like a non-objective painter when I determine the colors and values I'll use in a painting. I also spend more time than an abstract artist getting a shape that resembles the object I'm painting.

STRUCTURE OF THE BOOK

Painting What You Want to See covers topics and ideas I teach in my classes, and includes many of the same projects too. I work with a range of subjects—still lifes, figures, portraits, landscapes—using two mediums, oil and watercolor, plus contour drawing. But the idea is not to teach a particular medium or style or subject matter because, if you can paint, you can paint anything! The aim of this book is to teach you to paint better.

Painting What You Want to See is divided into six parts. The first part is a review of the basic aspects of picture-making—for example, how to make a contour drawing and value scale, how to layer washes until you arrive at the right value, and how to see shapes and measure proportions. The second section deals with values—such as understanding local value and light and shade, simplifying values, and learning how to plan a basic value scheme. Part three is on color. There is advice on mixing "different" colors such as greens, grays, fleshtones, lights, and darks; painting with analogous and complementary color schemes; working with pure color; and painting light, shadows, and local color. The fourth part deals with composition—how to direct the eye through edges, vignetting, darks, and color; how to handle patterns and negative shapes; ways of integrating subject and background and of subduing or emphasizing contours; and hints on loosening up your own style. In part five these lessons are applied to student paintings, and to my own work, as we learn how to correct and improve our paintings, and solve problems. Finally, in part six, the paintings of four famous masters—Hopper, Matisse, Stubbs, and Homer—are examined and we discover how their "lessons" can transform our own work.

MAKING A CONTOUR DRAWING

Contour drawing is a valuable tool for several reasons. First of all, it helps us later when we paint because it forces us to think in terms of shapes. Thus, even though we are using line when we draw, in the end we are more aware of the shape of our subject as a whole—its contour—than we are of the actual line we used.

Contour drawing also forces us to see connections between the subject and its surroundings because we are constantly working from the subject to the background and back to the subject, without lifting the pencil from the paper.

Finally, contour drawing helps us discover new ways of seeing. As a result, a student with no previous figure drawing experience may be able to create an exciting image through contour drawing. And even if the drawing is "incorrect" in its proportions, it will probably say a lot more about the model than another student's labored effort to get the drawing just right. In fact, that's why I like my students to forget about getting proportions accurate—even though I do permit them to measure the overall proportions in a general way. (I will show you how to do this shortly.) It's impossible to get absolutely perfect proportions, and overemphasizing them, I think, defeats the purpose of doing a contour drawing.

So just relax as you draw and don't try to be exact. You're not a camera. You're an artist trying to express what you see. And self-expression and correctness don't necessarily go hand in hand. Here's a general idea of how to proceed.

STEP 1

You can start the drawing anywhere you wish. In this case, I started with the eye and completed it before I went on, but sometimes people start with a hand or foot. Experiment with different starting places. The results may be strange, but the experience may force you to break old habits!

Now, working with a fine pen (a no. 2 office pencil, Pentel-type pen, or ballpoint pen will work well, too), I draw the shape of the model very slowly. Wherever there is a change in direction, I stop—without lifting my pen from the paper—and decide

where I'm going next, and then change direction.

Drawing a contour does not only mean recording "outside " shapes. You can also record the outlines of form within the model, too. In fact, notice that I drew "into" the boundaries of the figure whenever I could—the mouth, collarbone, shadow or cast shadow, and toes. I also avoided staying within the outline of the figure by bringing my line "out" into the background wherever the figure touched a picture or chair or any background object for that matter. So when I got to the chair, without lifting the pencil, I drew its shape, then I returned to the model's form and continued to draw, working down to the feet.

Notice also that I made a mistake. I made a new line, without changing the first one. And when I reached a dead end, I repeated the form, backtracking, still keeping my pen on the paper. (You can see this happening on the inside of the model's right leg.)

STEP 2

As I continued to draw the figure, I tried to let my line "escape" from the figure wherever possible, tying the model together with the surroundings. For example, I drew the model's left leg into the chair and joined her left elbow with the background picture behind the model. (Most students keep their line too contained within preconceived boundaries. This is probably the hardest habit of all to break.)

STEP 3

Just as I tied the figure into the background in some places, I was also careful to separate it from the background in others. I did this by deliberately omitting the boundaries in various places. (Can you see where?) I also combined negative and positive drawing for additional information and variety. (Again, see if you can find where I've done this.) Then, beginning with the cup on the right-hand table and gradually working from inside the drawing to the outer boundaries, I created a border. Finally, I connected the figure to both sides of the drawing and the top, and I was done.

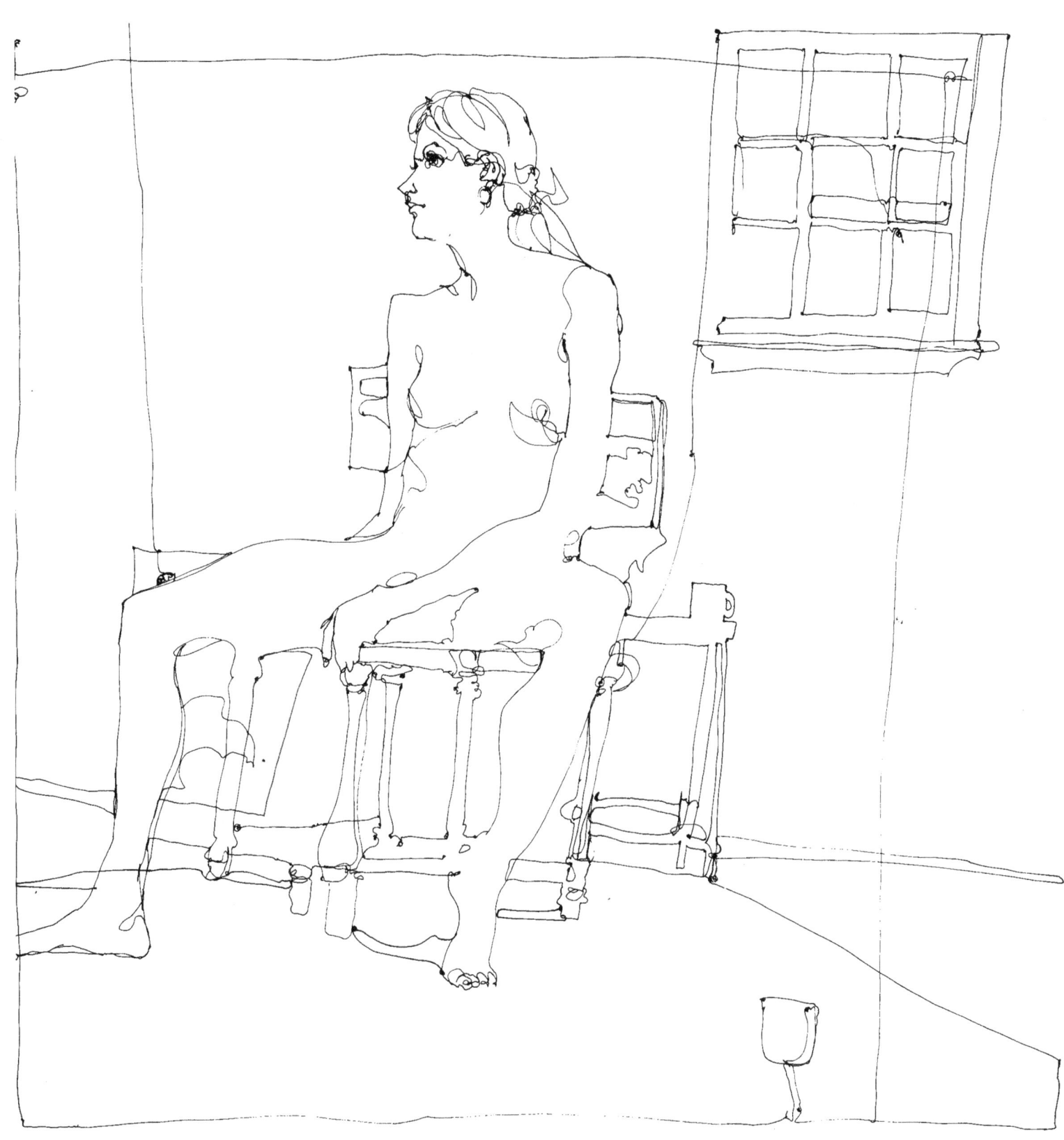

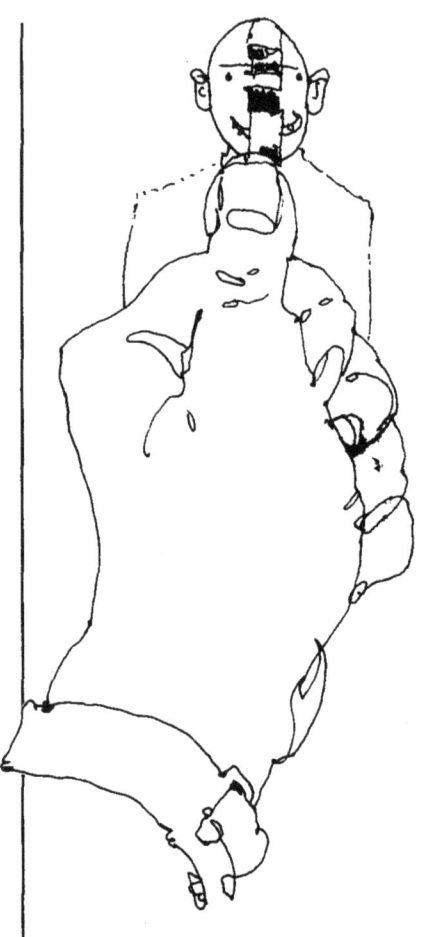

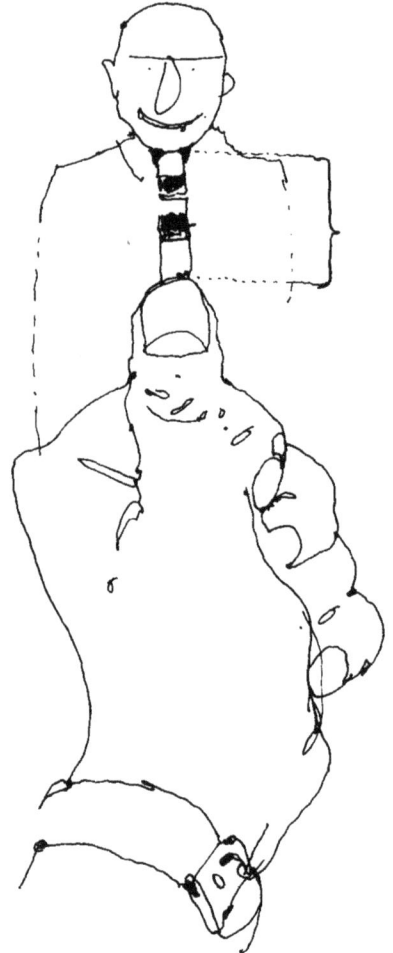

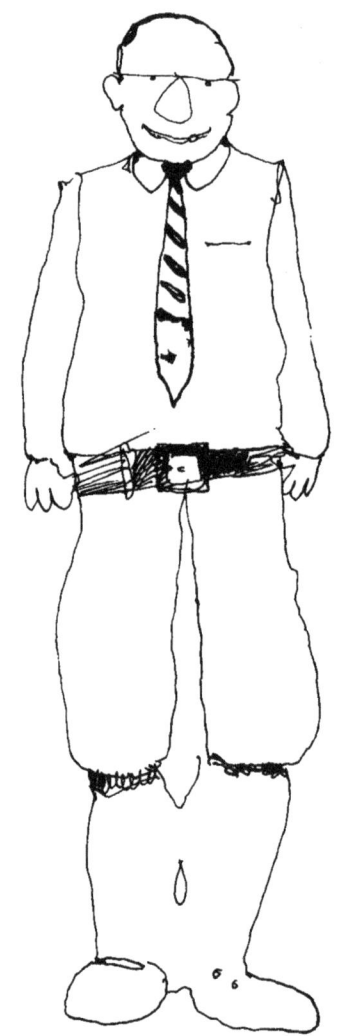

MEASURING PROPORTIONS

As I said before, getting the exact proportions isn't terribly important. But if you want to establish the general proportions of your model, this is how you would proceed.

1. Draw a light oval on your paper. This will represent the model's head. Now look at the model.

2. Holding your pencil in your fist, with your thumb upright and keeping your arm stretched out, stiff, and at eye level, let your eraser tip "touch" the top of the model's head and the end of your fingernail on the pencil "touch" the subject's chin. This is one head length.

3. Still keeping your arm straight, lower the pencil so that the eraser top is at the chin and your fingernail is somewhere below the chest. This is a second head length.

4. Now continue to lower your stiff arm until you come to the belt. Then compare the length of the torso to the first measurement (the head). How many head lengths is the torso?

5. Continue in this manner, working down to the feet. Then jot down the total number of head lengths of the figure. Don't worry if it's a bit off. It doesn't matter. This should just be a rough guide to the proportions of your model.

6. Now you will express proportions in your drawing. Returning to the oval you originally drew for the head, place your pencil eraser over it, from top to bottom, keeping the eraser top even with the top of the oval and grasp the pencil so your thumbnail hits the "chin" of the oval (step 1). This is one head length.

7. Move the pencil down the paper another head length and make a dot (step 2). Continue moving down the figure like this until you've marked 2½ head lengths or the amount of head lengths necessary to reach the hip or belt. Mark that spot with a dot.

8. Continue marking these dots at every head length until you reach the feet (step 3). You can use this same measurement—the head length—to help you fix the proportions of other parts of the body, such as the length of the arms and shoulder width.

ASSIGNMENT

Make a contour drawing of any convenient subject. Use either a pen or pencil. Just make sure it's finely pointed. If you plan to paint in watercolor over your drawing later, I suggest using a no. 2 office pencil so the lines won't show too much and you can erase them later if you want.

Before you begin, let's review a few important "rules" about contour drawing:

1. As you draw, rest your pencil or pen on the paper at all times. Don't pick it up when you check the proportions of the model. This is the most important "rule."

2. Draw very slowly and stop every time you change direction.

3. Pretend your pen is actually resting on the model, not on the paper, so it must follow the exact contour you're drawing.

4. Don't draw only the outline of the figure. Draw into it wherever you can, and draw out into the background wherever the figure meets other objects.

MAKING A VALUE SCALE

Making value scales is good practice in helping you to see a range of values from light to dark. Many students see only the lightest or darkest tones and have trouble seeing and painting the values in-between. Even though it's possible to perceive as many as ten distinct values from white to black, I think that this many differences are too subtle for students to see at first. Therefore I want you to work with a six-value range (five values plus white). Later, when you can express all six values in your paintings, you can try to extend your values to ten.

In making the scale, I suggest that you keep the individual boxes fairly large, about 1½″ × 1½″ (38 × 38 mm). This will help you "hold a single value over a fairly large area. You might even try using larger squares, say 3″ × 3″ (75 × 75 mm). Holding a value with only minor variations in a large area is difficult, especially in watercolor. But it is good practice.

Although I will be working mostly in watercolor, remember that this information also applies to other mediums. In fact, later you will see how I adapt it to oil. So don't feel that you have to use watercolor for this exercise. If you prefer to do these projects in another medium, by all means use it.

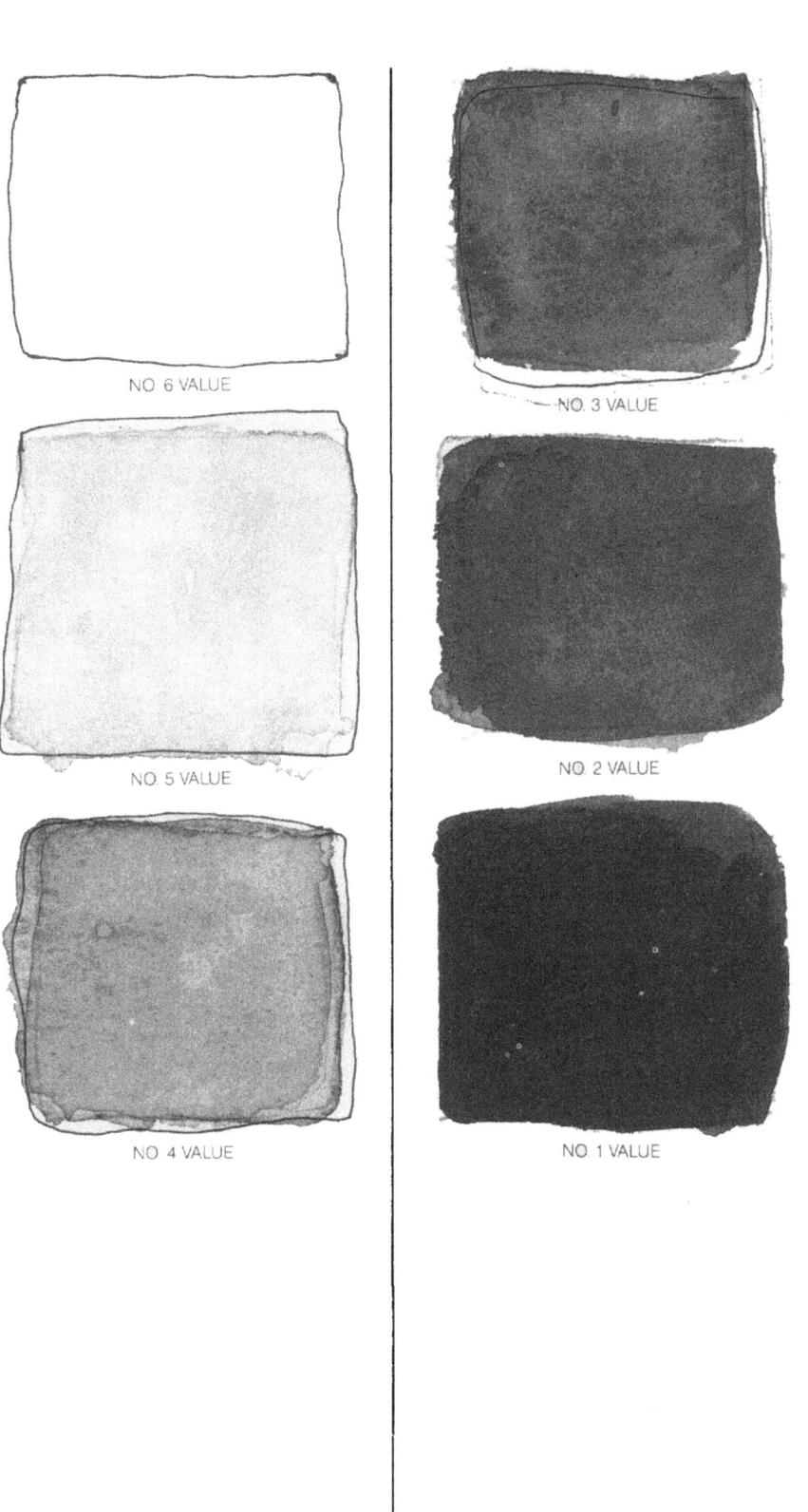

NO. 6 VALUE

NO. 3 VALUE

NO. 5 VALUE

NO. 2 VALUE

NO. 4 VALUE

NO. 1 VALUE

SEEING SHAPES

Positive shapes usually suggest an object or figure in a painting and negative shapes suggest what's behind it, that is, the background. (We will discuss more complicated aspects of positive and negative shapes in a later section.)

EXAMPLE 1

The model is sitting on a bench on the model stand and there are two stools on the right. There are also some pictures in the background and a window. In deciding which space is positive and which is negative, you must decide what items are in the object area (positive) and what is part of the background (negative). Obviously the pictures and window are objects. But they're also part of the background. The decision is one of focus.

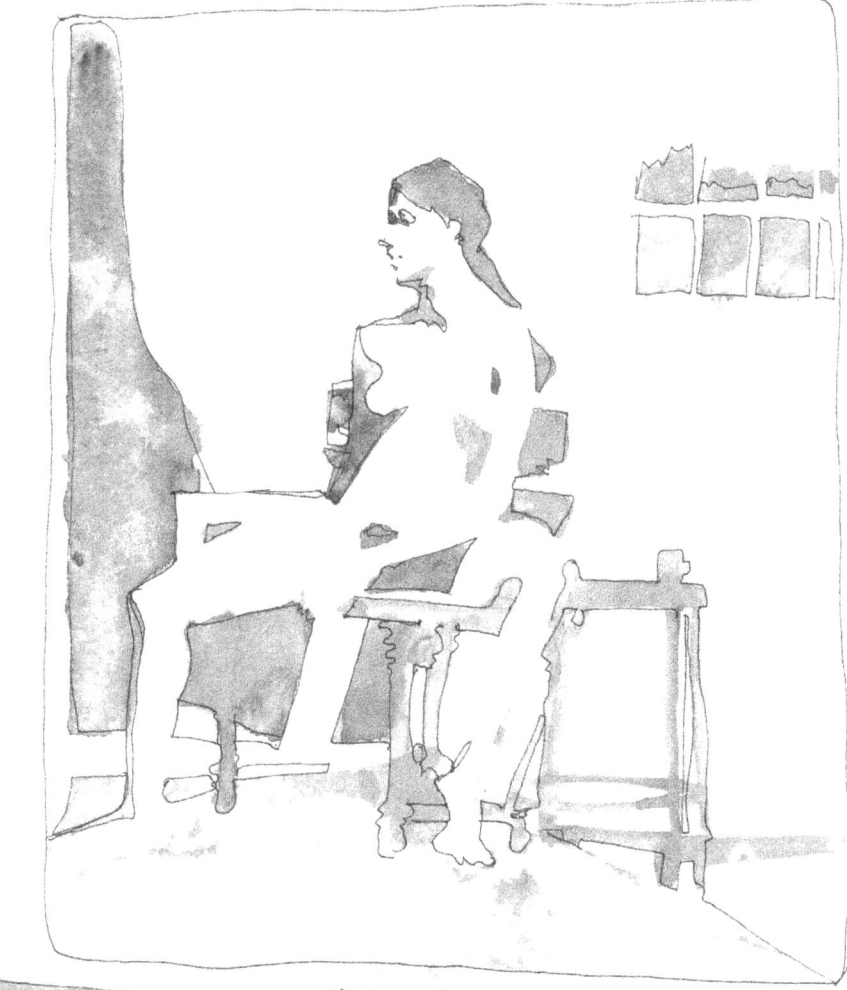

EXAMPLE 2

I find it helpful to think of negative and positive shapes in terms of value. Here I painted all the negative shapes dark and all the positive shapes light. The result is that the figure, stand, and foreground objects are positive or white shapes and all else is dark or negative space. I don't think the example here works very well as a picture, though. It lacks subtlety. But there is one advantage: simplifying what I have seen has forced me to mass the foreground figure and objects into a single large shape.

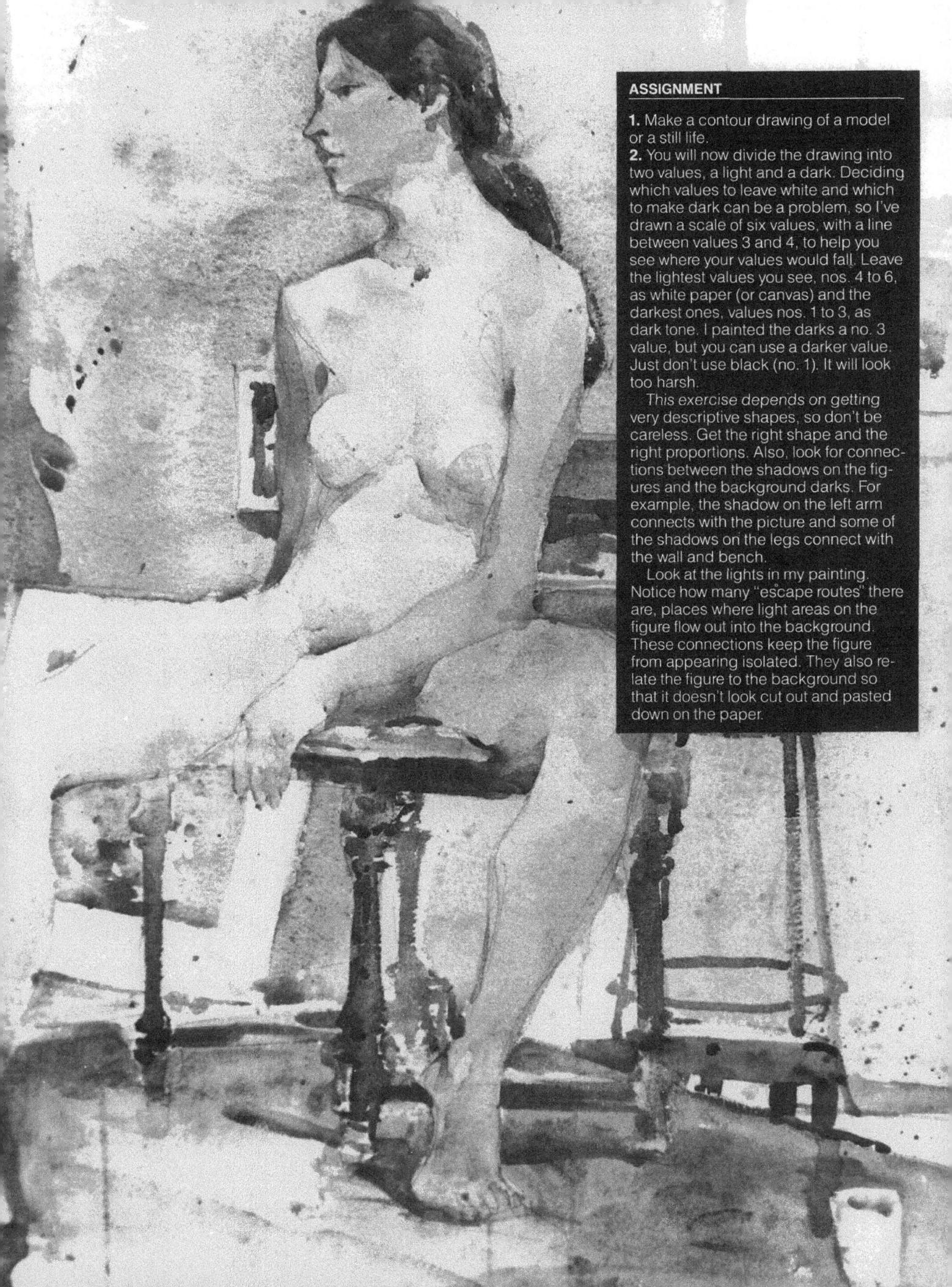

ADDING VALUES TO DRAWINGS

Now I would like to show you how to develop your drawings into six-value compositions (five values plus white). Limiting the number of values you use will force you to simplify small values into larger areas.

PRELIMINARY VALUE SKETCH

Before I begin the contour drawing, I determine the values in a preliminary sketch. This sketch describes the "big idea," the major light-dark pattern or major theme of the painting. I leave out all the small details and generalize the middle values and darks into a single value. I leave the light and light-middle values just as white paper. (Compare this sketch with the final stage of the composition and you'll understand what I'm doing here.)

FIRST WASH

Now I make the contour drawing of the subject and cover all the areas that will have tone with a light wash. I'm also careful to leave some areas white. Too often students cover up light areas in watercolor and then wish they still had the white paper when it's too late. Don't cover any area you're not sure about. You can always cover it later. (Naturally, if you're working in oil, this doesn't apply to you, since oil paint is opaque.)

I don't worry if the values aren't exactly even. There's bound to be a certain amount of variation in my wash. But I keep the wash light, though definitely darker than the white paper. I'm not ready to let any middle or dark values drift into the painting yet. I'm just deciding which sections I'll be leaving white.

Notice that I'm careful not to paint over boundaries between toned areas and areas of white paper. I keep these shapes accurate and strong. For example, the model's back has a good shape, one I don't want to lose, while on the other hand, I deliberately lose other boundaries that are less important. Remember, you don't have to worry about losing boundaries between areas of similar value, but you must be accurate in painting boundaries of greater contrast.

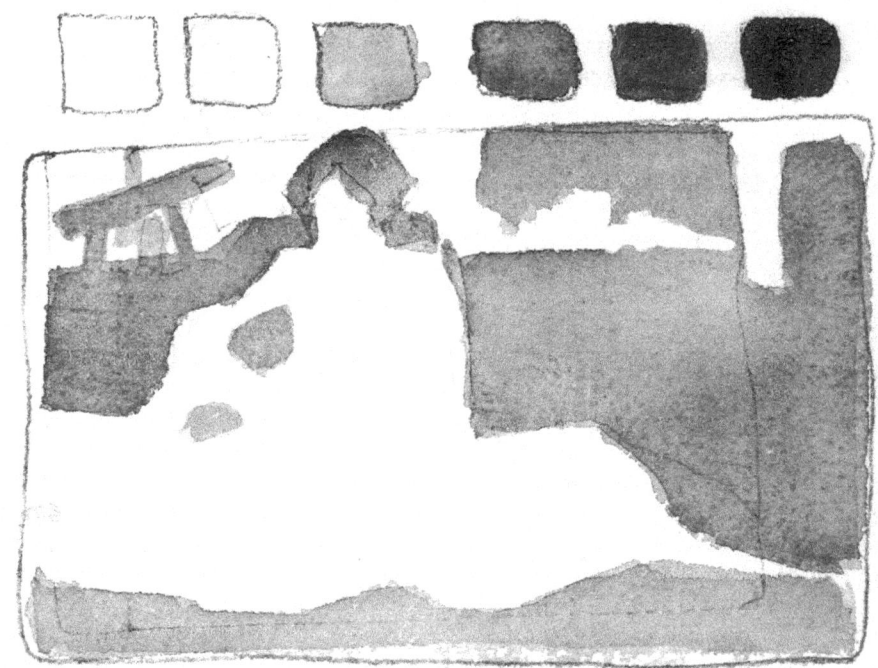

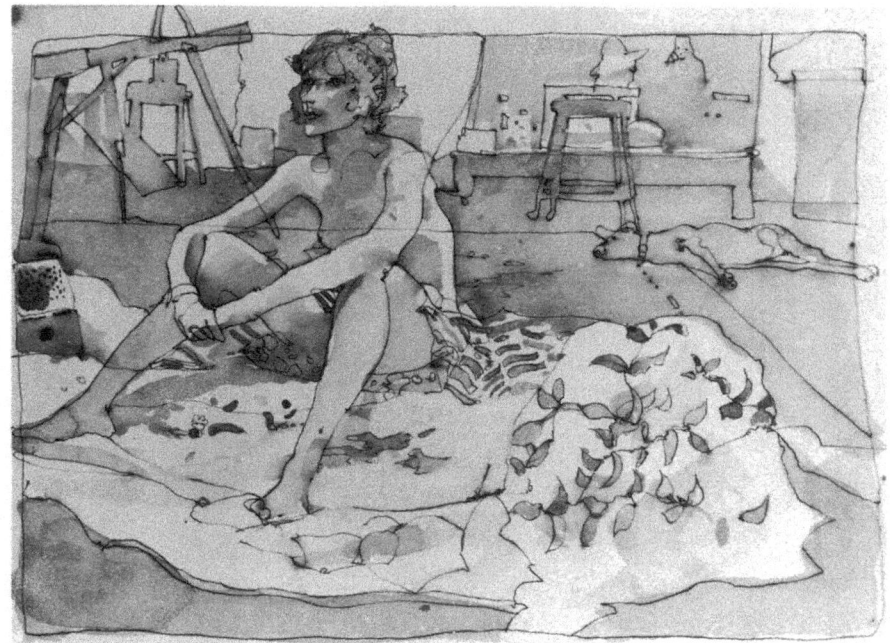

SECOND WASH

Now I add the middle values. To make the figure stand out more and the white cloth she's sitting on seem whiter, I darken the values around her. Going even one value darker can make a big difference. As I add the middle-value tones, I begin to make smaller separations between some of the values, but I still try to keep masses of the same value connected. For example, the hair and the block of dark tone above her left shoulder are connected as a single tone, and the darkest areas on the dog and the legs of the French easel are massed in with the rug. Notice how tying in dark areas has also forced many light areas to merge.

THIRD WASH

Once the major decisions are made, I begin to work in smaller and smaller areas, all the while thinking in terms of the painting as a whole. I try to keep the values balanced throughout the picture by avoiding too much weight or darkness in any one area. For example, I made the model's hair too dark and dominant for this stage—I've developed a focal point too early. Focal points and centers of interest are fine, but you can't forget the rest of the painting. Pay attention to the background and corners of your painting. That's where you'll find your problems.

To balance the darks of the model's hair, I darken the trash barrel on the upper right. I also fill in the values behind the model. Now the hair, though still dark, no longer dominates the picture. This brings me to another point. When working with a figure, it's not necessary to overstate contrasting values in order to make it an area of interest because the viewer is normally attracted to a person in a painting anyway, without these contrasts.

I darken the pattern on the robe near the model. Its small forms offer a good contrast to the large simple areas in the rest of the painting and add interest too. Even though the pattern in the striped robe is dark, it doesn't stand out too much because it's on a dark rug.

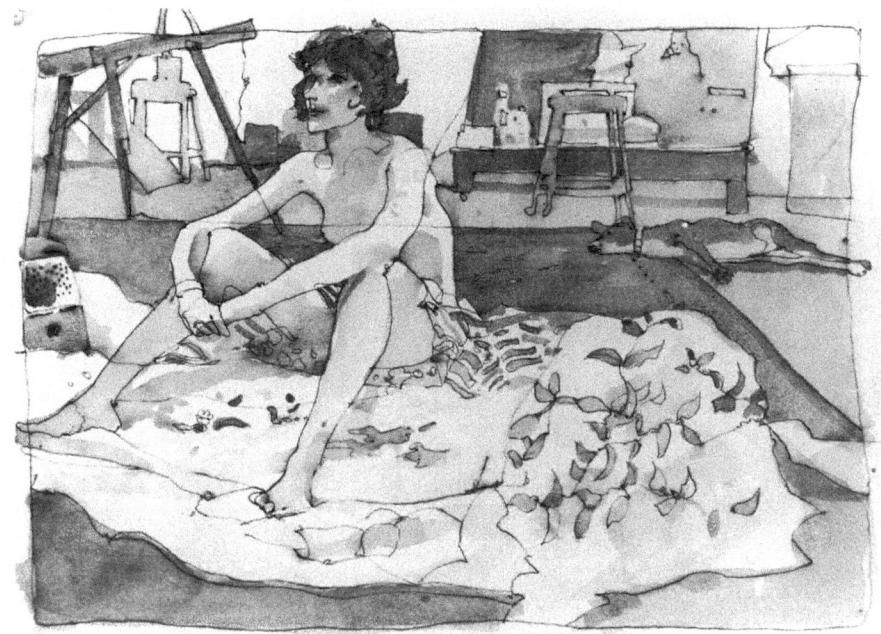

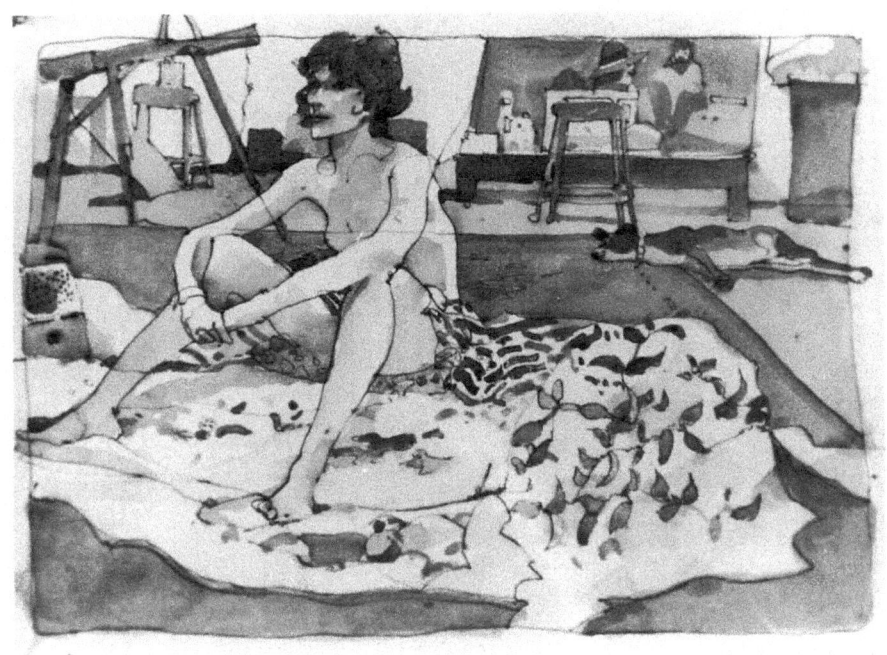

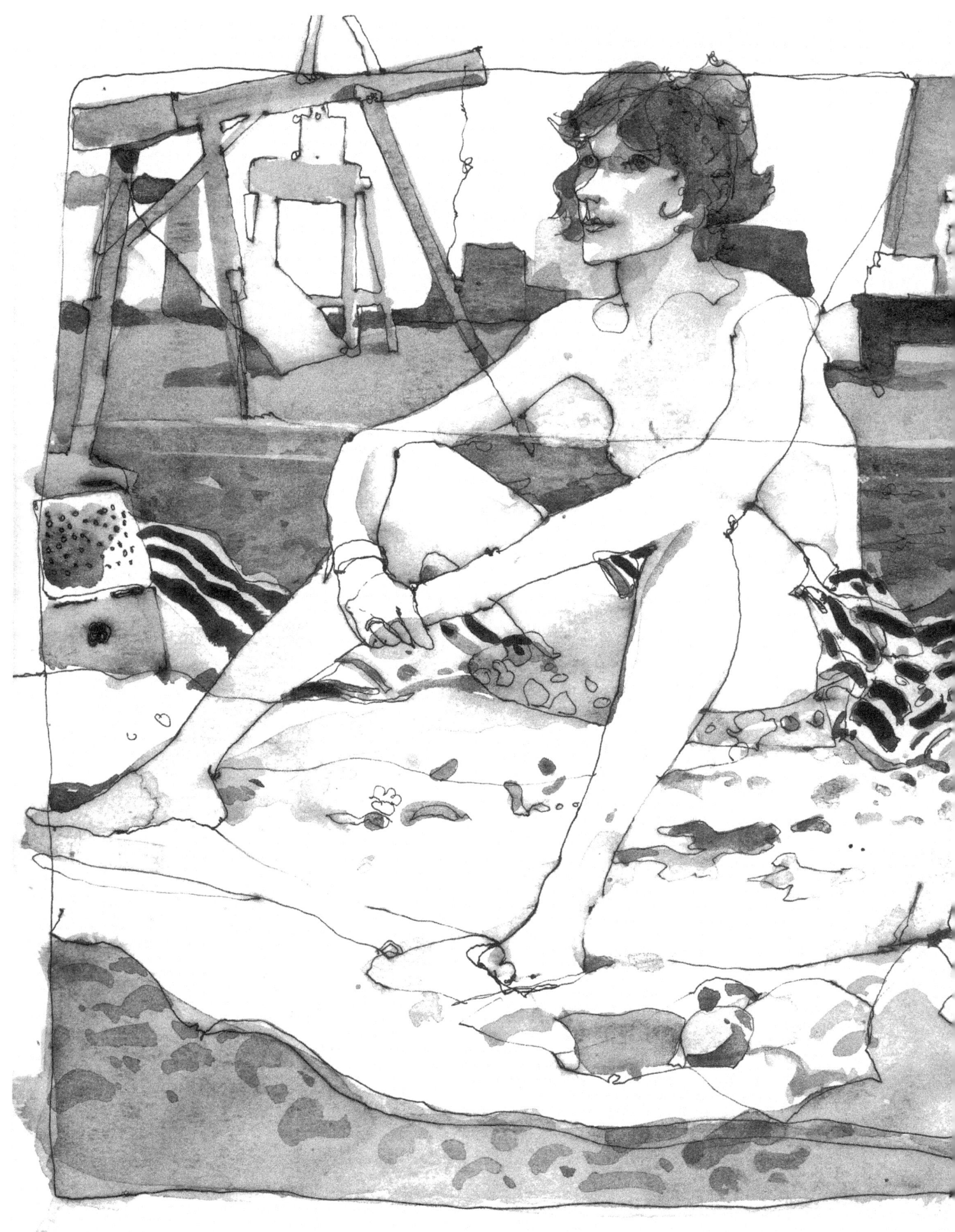

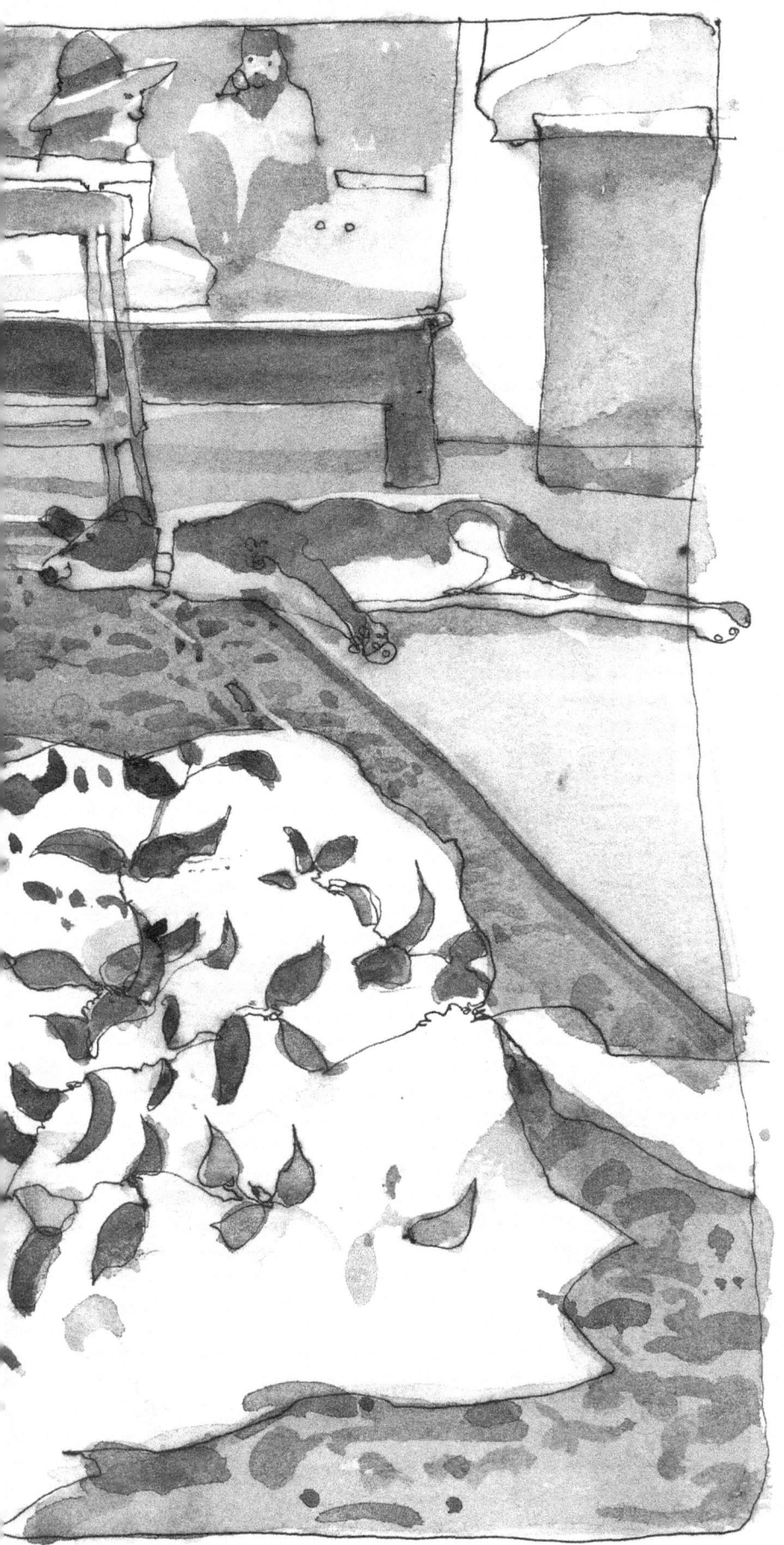

FOURTH WASH

I add the darkest values—such as the pattern on the dark rug—last. I also darken my deepest values now. Since the values are accurate, they don't jump out of the painting but keep their place, adding weight and interest to the painting as a whole. The biggest problem in the last stage is that, in an effort to make specific forms important by surrounding them with darks, I might have isolated the forms too much.

Look at the figures and the background. How many values on the figures match adjacent values in the background? Wherever they match, you have a connection or bridge, what I'll call "an escape route." Whenever you paint, you must always look for places to put escape routes. Here you'll find them where the hair meets the background darks, also around the legs and under the model's right arm. Painting demands a constant effort to make some things stand out and other things merge. Everything can't be equally important in a painting. You must decide what's really vital and make it stand out—isolate it or underline it—and lose or underplay the unimportant areas.

ASSIGNMENT

1. Make a contour drawing letting the figure or still life take up at least three quarters of the picture. (I used more space around my figure here to show you how to deal with a lot of excess background space.) I recommend working on 8″ × 11″ (20 × 28 cm) paper so you can make several copies of the drawing with a copy machine.
2. Make a six-value composition in ivory black, lampblack, or Payne's gray and white. Don't worry about light and shade, but try to get the local or overall value identity of the object you're painting. Leave at least one area left white.
3. Make several versions of your subject using different value arrangements. You might want to make one of your light-middle values a darker middle value. Or, using my composition as an example, you might switch the values in the upper right section, perhaps make the stool darker and the model stand lighter, or give the white wall a tone. Experiment. The purpose of this assignment is to show you that changing a value in one area of a picture can change the entire picture.

part two

WORKING WITH VALUES

LOCAL VALUE VS. LIGHT AND SHADE

If your painting looks muddy or confused, it's probably due to an error in value rather than one of color. Sometimes the colors are overworked due to inexperience in handling the medium. In that case, the solution would be more practice.

However, more often, a painting looks confused or muddy because of an awkward or unattractive selection and arrangement of values. You might have seen too much and tried to paint it all or tried to duplicate the effects of light and shade on objects. The result is a jumble of information. The values are jumpy and scattered and the painting lacks focus.

LIGHT AND SHADE

I don't want to underestimate the importance of light and shade. Light and shade makes objects look real. It also gives them form—makes them look round, square, or whatever. But if you add light and shade before the basic values are established, you may make the lights too light and the shadows too dark, and end up with a confused muddle of unrelated values. Because light and shade can be a villain.

A strong light may be so distracting that when it falls on a black coat, you may forget all about the coat being black and paint the light-struck section of it too light, almost as if it were white. The same may hold true for a white shirt: in shadow it may look so dark that you may paint it almost as dark as a black shirt would appear in the light. Remember, a black coat is still black no matter how much light we shine on it, and a white shirt is still white, even in shadow. You may think you know this, but you'd be surprised how often we paint not what we know but what we think we see.

LOCAL VALUE

Many years ago when I was a student in the Art Students League, my teacher Frank Reilly used to say, "The darkest dark, out in the light, is darker than the lightest light in shadow." What he meant was that the lighted side of a black object is always darker than the shadowed side of a white object because of its intrinsic nature—its local value. And the local value of the object always influences the values of light and shade on it, irregardless of the intensity or dimness of the light. Therefore, to avoid breaking up your main values, you must establish the local values of your subject first, then paint light and shade on it. Again, "local value" is the overall value of a particular object irregardless of the effects of light and shade. You can determine the local value of an object by squinting.

Normally, when you look at a scene, whether you are looking into the foreground or at a distance, your eyes focus on a fairly small area. However, the longer you look at your subject, the more detail you see. This is where squinting comes in. Squinting makes you much more aware of the shapes and silhouettes of the various objects. It also makes it harder to see the details, the unimportant little lights that complicate the true value of the objects you're painting—their local value.

Once you have established your local values as broad, flat areas and shapes, you can add light and shade. But remember the local value of each object is never changed by more than about a value either way when light and shade is added. If you go much darker or lighter than that, you will break up your painting and destroy the local value of your subject.

One final word. This information is not intended to interfere with your personal expression in any way. It is just good advice. You must separate personal expression from academic facts and rules. Many fine modern artists have deliberately disregarded traditional rules of painting—people like Picasso, van Gogh, Bonnard, de Kooning, and others. But breaking these rules was due to a conscious decision, based on what they wanted to say. They did not do it out of ignorance or ineptitude. Our goal is personal expression too, but before we can get to that stage, we need some signposts, and that is all that rules are meant to be.

The following sketches are based on an exercise Frank Reilly used to assign his students to help them understand local value and the effects of light and shade on it. He used a scale of nine values, from black to white, but for our purposes, a simplified scale of five values plus white will do just fine.

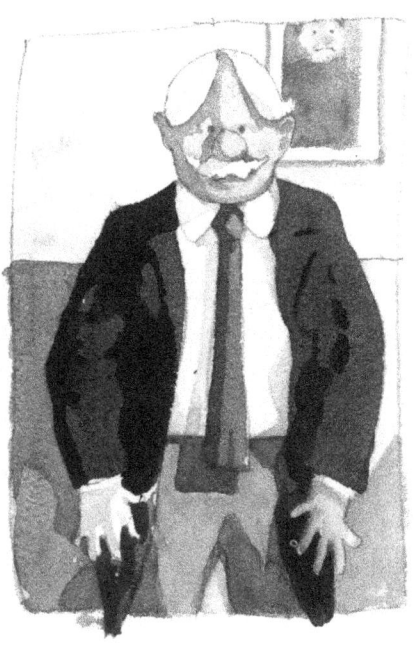

SKETCH 1. LOCAL VALUE

I have painted three versions of the same man. The first one was done entirely in local value. No particular light is visible: the coat is simply black and the shirt white. Notice that I have tried to use all six values in this sketch. Can you identify the values I've used? Matching them with the grays in the value charts in the preceding section will help you practice recognizing them. Notice the clear, simple quality of this sketch. This is not a great painting, but at least it's understandable and obvious. That's what painting in local value means—nothing complicated or difficult, just a simple, clear statement of what you see.

SKETCH 2. ADDING LIGHT AND SHADE

Now let's shine bright light on the little fellow. Notice that the local values in the light are now about one value higher (lighter) than they were in the earlier version, and the values in the shadow have become about a value darker. (I can't paint the black coat any darker, so I've simply left it black—as I've said, this is a very simplified situation!) The point of this drawing is to show you that even if you add light and shade, it should never destroy local value.

SKETCH 3. CONFUSED VERSION

The third example shows what happens if light and shade gets out of hand and destroys the local value of objects. Perhaps in the right hands this fragmented approach would be fine, and this may be the most expressive sketch of the three. But let's take a closer look. Notice that there is no real value identity in any area, no clear foundation for those slashing accents that, with a solid foundation of local value, could have been an exciting approach to painting.

CONTROLLING VALUES

Now that you understand the difference between local value and light and shade, I want you to look at a series of drawings and paintings I've done from old photographs of several subjects: Civil War soldiers, a horse and rider, and a man on a burro. Each of these series of illustrations will teach you something about values. The sketches of Civil War soldiers show how to group your values. The sketches of horse and rider describe how to connect shadow values and emphasize textures. The third group of sketches, the man on the donkey, will show how to do the assignment that follows.

CIVIL WAR SOLDIERS

Compare these two sketches of Civil War soldiers. Why is it that one appears jumbled and confused while the other has clarity and strength? I deliberately limited myself to the same three values in both sketches, so the weakness of the first sketch is not due to the selection of wrong values. So what is wrong with it?

SKETCH 1

The error lies in the arrangement and grouping of the values. There are too many small pieces of unrelated value details in the sketch, and they are breaking up the picture as a whole. This is the same mistake that created confusion in the drawing of the little man.

SKETCH 2

In this sketch, to correct the confusion, I simplified the values by grouping them into larger shapes of the same value. To do this, I looked for two different types of shapes: outside shapes (like the silhouette of the figure) and inside shapes (smaller shapes within, such as the shadow on the soldiers, their buttons and medals, and their swords). Wherever the local values were similar, I massed these shapes together. For example, I tied in the dark costume of the soldier on the right with the shadow behind him. Notice that I kept the costume dark even though light shone on it.

I also made shadow shapes descriptive—they follow the forms they are on. For example, notice how rounded the shadows are on the chest and arm of the soldier on the left, and how much more interesting its shape is than it was in the first example. Wherever there was no definite shape, I left the paper white. Halftones were also left as white paper.

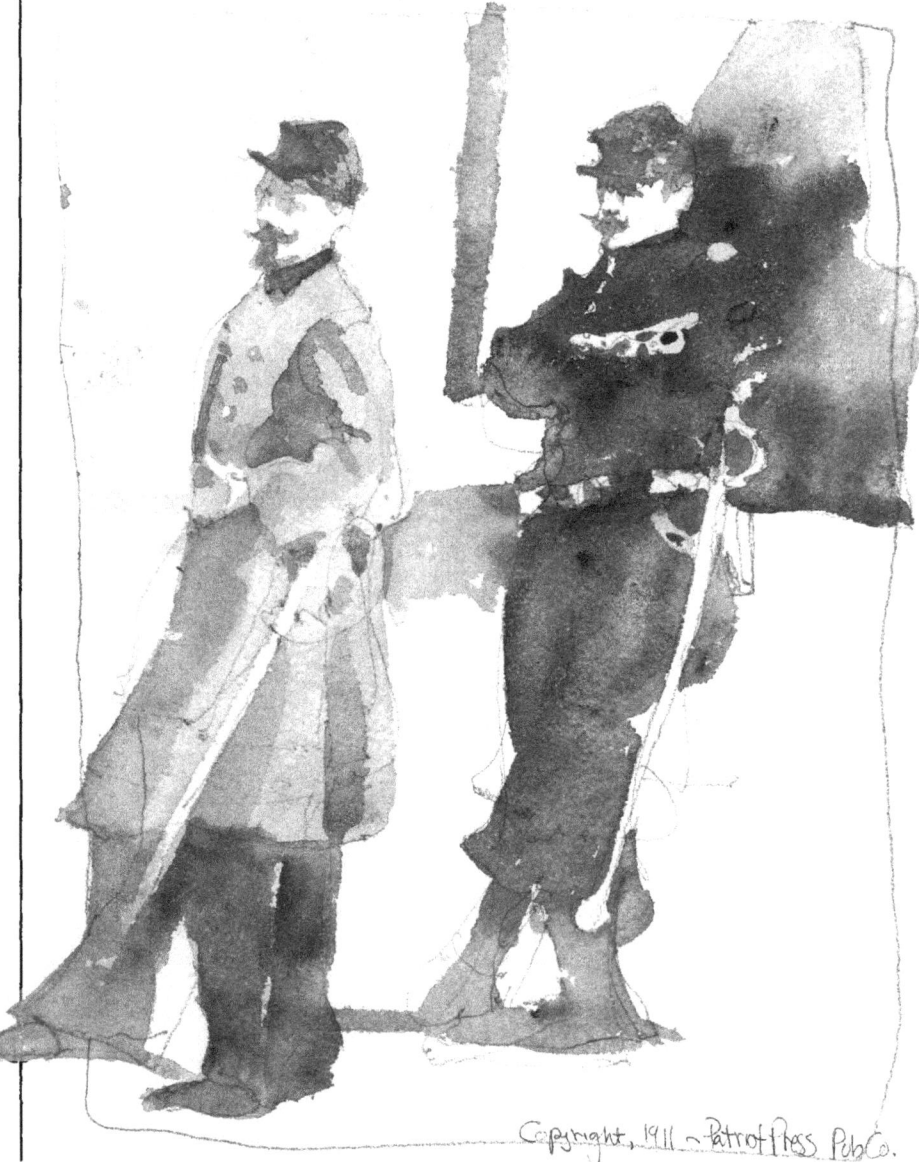

Copyright, 1911 ~ Patriot Press PubCo.

HORSE AND RIDER

These sketches were also based on an old photograph, but the point I want to make here is that a drawing done in local value alone is flat. You still need to add light and shade to it in order to describe form (Example 2) and texture (Example 3). Just be sure these values don't break up the original local value.

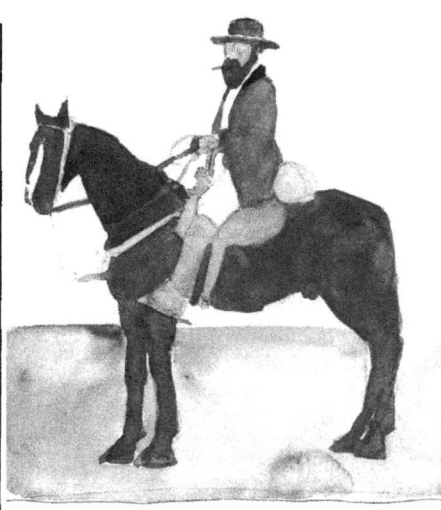

SKETCH 1

The first illustration shows the horse and rider painted in local value alone. Notice the posterlike feeling that occurs when you use broad, simple shapes of a single value.

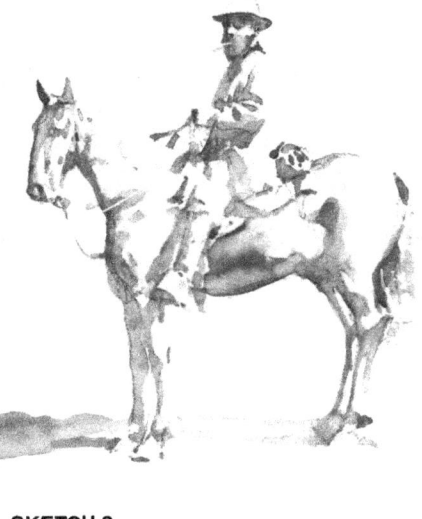

SKETCH 2

This time I painted only the shadow shapes on the horse and rider. Then I erased my drawing lines so just the shadows remained. Even with the lines erased, the painting is still quite recognizable. This is because shadow shapes can effectively tell a story without any line to help.

SKETCH 3

This version is much more complicated than the others. Even though the rider is still done in fairly simple values, the horse looks freshly groomed and shiny. Its coat reflects many small highlights, making it harder to see the local values there. This time I am describing the surfaces of the objects.

The texture of the surfaces you paint affects the way you interpret them. Local value is easier to see on a matte surface (such as a coat or hat) than on a shiny surface (like glass, water, metals, and materials like silk or nylon) because matte surfaces are closer in value between light and shade areas. On a shiny surface, the difference between the lights and shadows can be as great as four values. You must keep the nature of the surface you're painting in mind. But remember, even on a shiny surface you can't lose the local value. If you squint, you'll see a local value on the horse. It just isn't as obvious as it was in the first example.

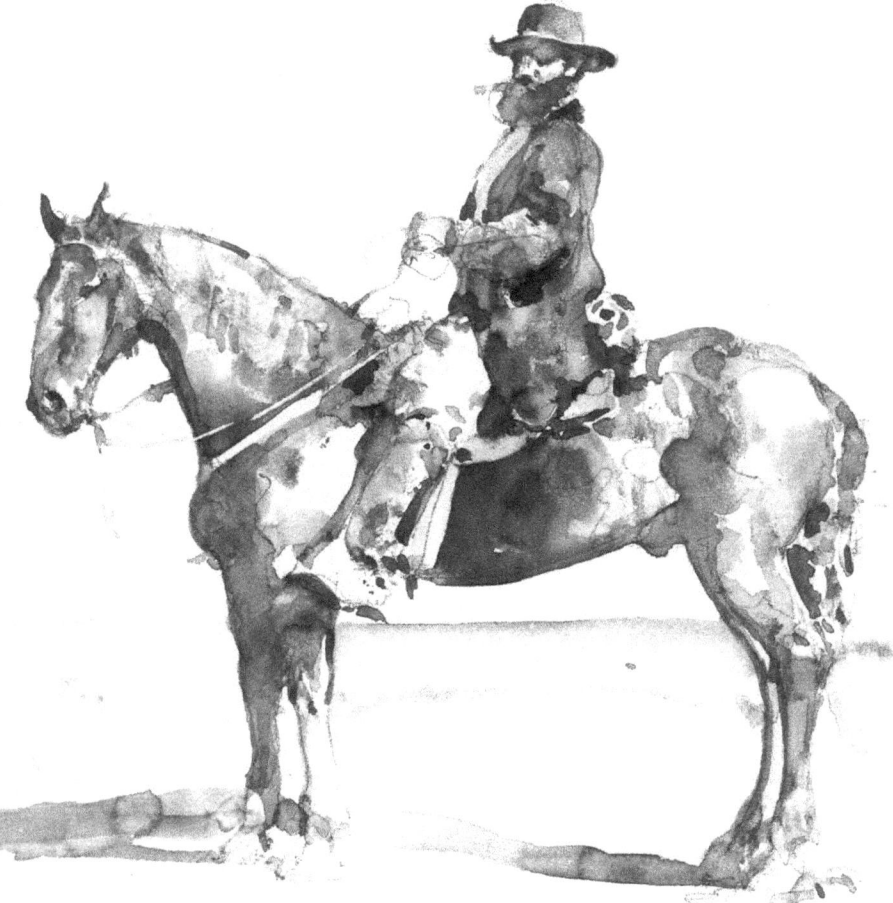

Find an old photograph to copy. Check your local library for nineteenth-century photographs like the one I used here. They make good references because their local values are easy to see. Look for a photograph where the darker middle values merge nicely with the darks. Also, make sure the photo has strong local values and obvious shadow shapes.

1. Make a simple contour drawing of the photograph. The drawing can be about 8″ × 10″ (20 × 25 cm), or if the photograph is square, 8″ × 8″ (20 × 20 cm). Be sure to put definite bound-ary lines around the shapes in your drawing. Work in pencil—you're going to have to erase some lines. A 2B graphite pencil is fine. Don't worry about the accuracy of the drawing. It doesn't have to be beautiful and the proportions don't have to be perfect. The point is that you should have defi-nite shapes to work with. Avoid scratchy, sketchy lines. They won't work for this exercise.

2. Now turn your photograph upside down. This will prevent you from seeing the actual outlines of your subject. In-stead you'll be more aware of the light and dark shapes and less conscious of their specific identities. Take a kneaded eraser and erase all the out-lines that are hard to see when you squint at this upside-down photograph. Remember, you are separating various areas because one is light and the other is dark, not because of the divi-sion between actual objects. Don't be afraid to erase for fear of losing your drawing. I want you to be more aware of the outlines of light and dark shapes and less worried about losing the shape of an arm in shadow.

3. Make several copies of your contour drawing, either with a copy machine or by tracing it onto another sheet (or sheets) of paper. You will be painting it in black and white for this exercise, but you will color them later (when we get to the color section).

4. Now paint the drawing in black and white. To start, note your values—light, middle, and dark—in a small value scale. If you're working in watercolor, your lights will be the white paper and you will be painting your middle and dark values around them in several washes, laying one tone over a pre-vious layer of dry tone until you reach the darkest value you need.

As you paint, try to connect the shad-ows—don't skip from one section to another, leaving spaces. Notice that mine flows from one area to another as though I had painted them all without lifting my brush from the paper. There are so few isolated spots of shadow in my painting that you can almost count them on one hand. The rest are con-nected.

Don't worry if your values aren't ex-act. Just aim for a generalized value. What is important is finding simple, broad, obvious shapes. Make your shapes as descriptive and articulate as possible.

We'll be discussing color in the next
section, but this painting will give you
an idea of how I transformed these
values into color.

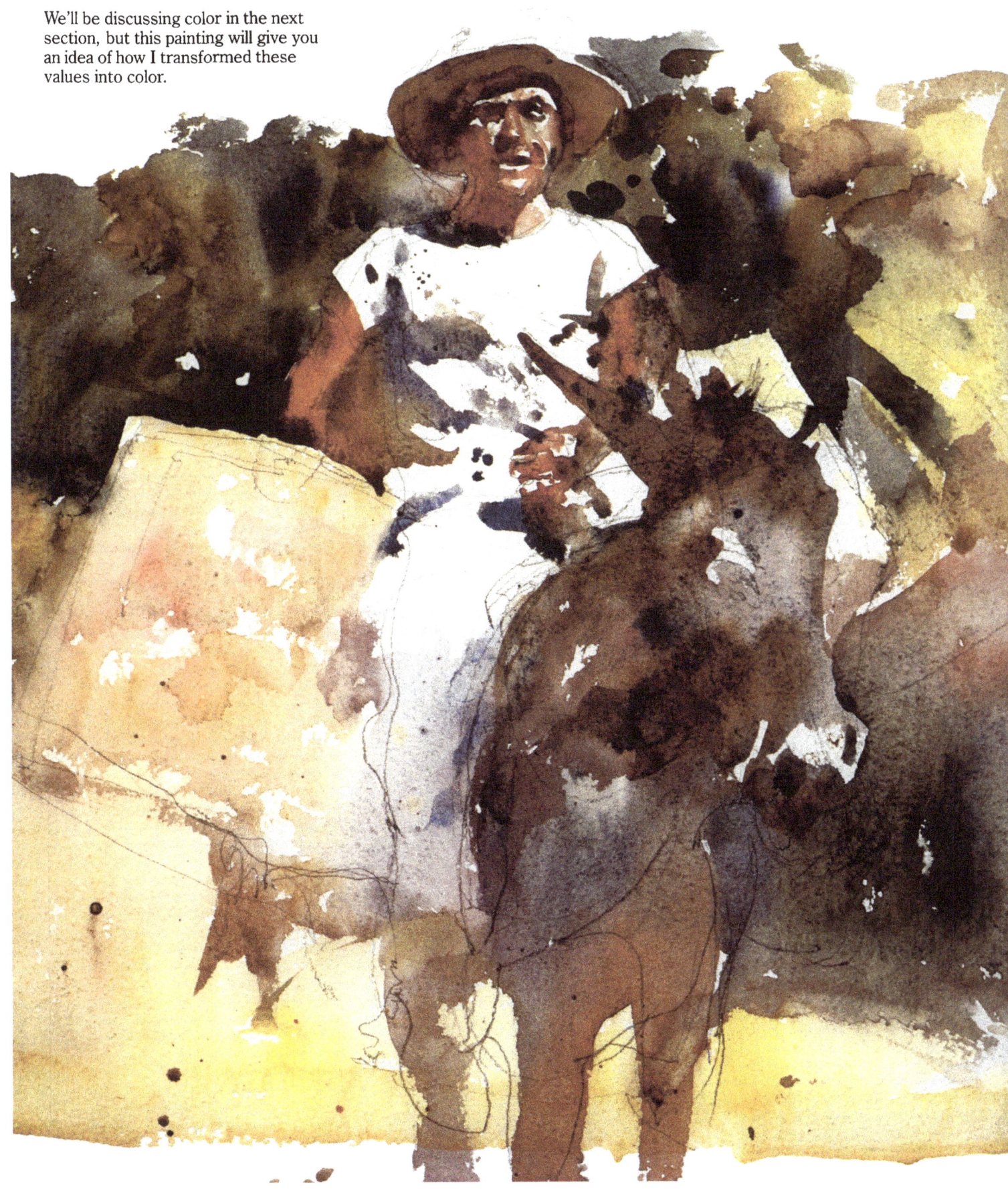

SIMPLIFYING VALUES IN SHADOW

In the next illustration, the fisherman is in backlighting. Light is only seen around the edges of his form, with some light catching the side of his face and hand. Everything else is a shadow.

Just as in painting the lights, simplicity is the key to painting shadows. Even though there are a few minor variations of value within the shadows, we essentially have a dark silhouette against a light background. Had I added a lot of small details and halftones to the figure, I would have destroyed its impact. The fewer value changes in the shadows, the better. You must forget reflected light for the moment and just record the essence of the shadow.

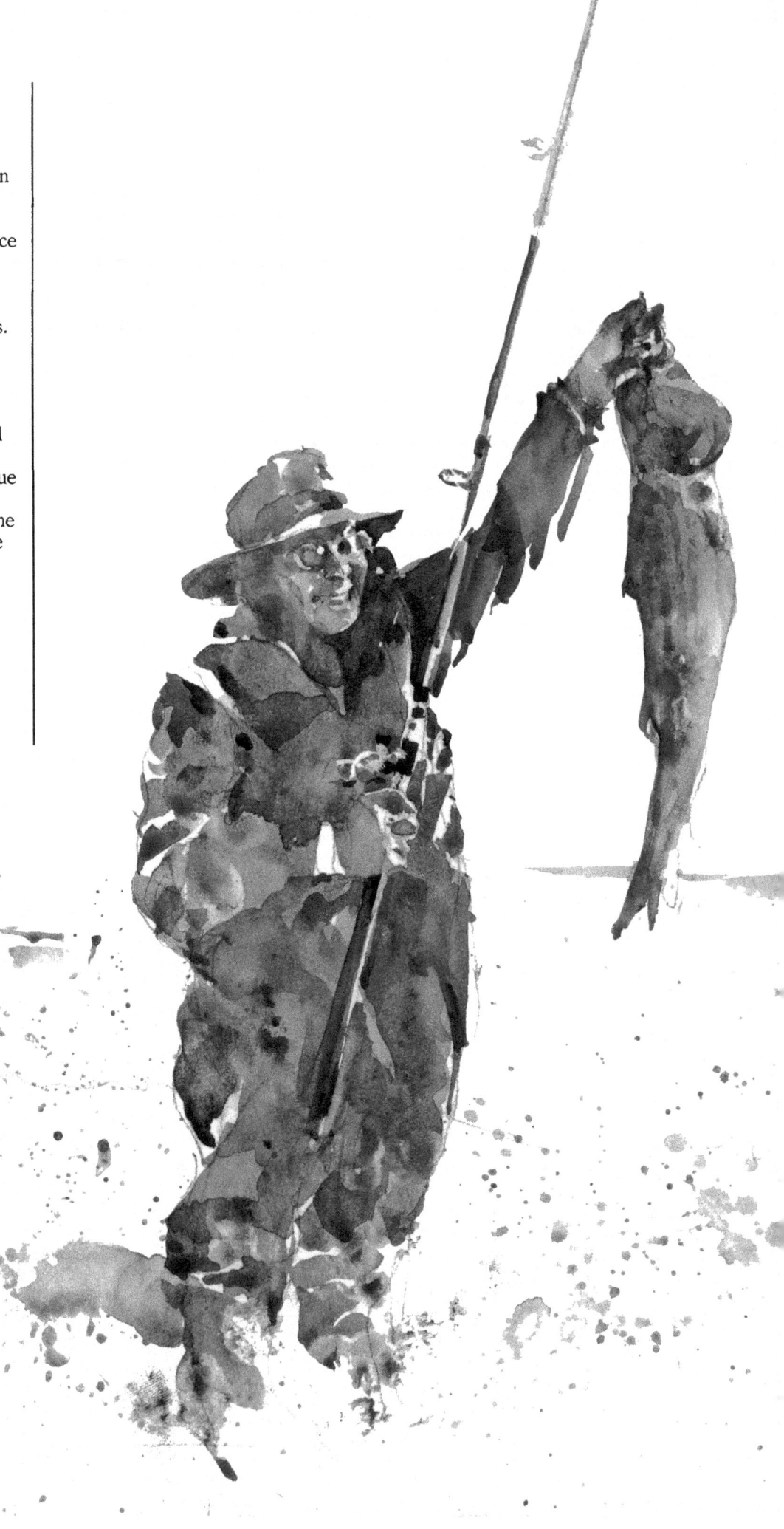

SIMPLIFYING VALUES
IN THE LIGHT

Perhaps by now you're beginning to
see how important it is to simplify
your values. Strong values can hold a
painting together, direct the eye to
specific areas, and create a beautiful
abstract pattern. And you can get
these strong values by constantly
averaging minor variations into a sin-
gle value shape.

To show you how simplified light
values can carry a painting, let's look
at an illustration I did for *Sports Afield*
magazine. Notice that the sky has
been left untouched while the water
has a minimum of detail, just enough
to show that it is indeed water. Had I
added any more detail in either area, i
would have confused and cluttered up
the painting. Now look at the light-
struck areas on the men and the boat.
There are some small darks on the
clothing of the man steering the boat,
but essentially the light values there
are quite simple and easy to see.
Cluttering up these light areas with
middle values or halftones would have
destroyed the strong effect.

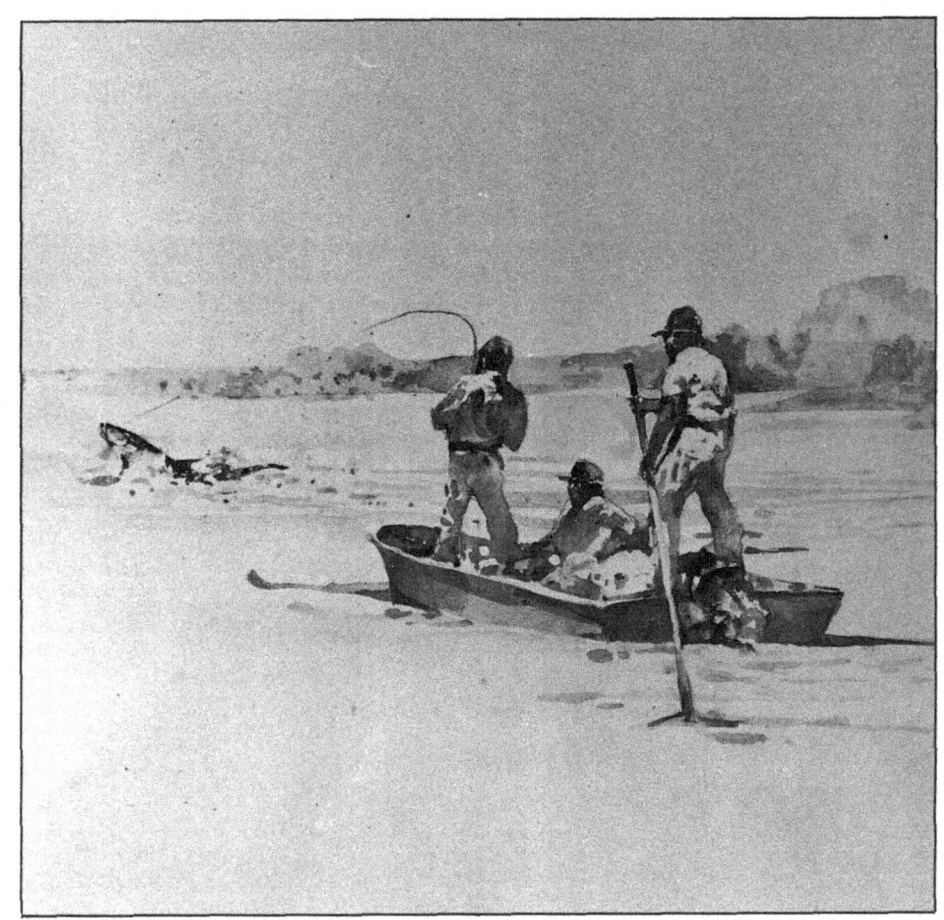

PAINTING IN A LOW KEY

Strong, simple value patterns add impact to a painting. To simplify values, you must constantly decide how to group the minor values within each area. Do you put them with the lightest values, or with the darker ones? These decisions also determine the overall key of your painting—light (high) in key or dark (low) in key.

A painting's key affects its mood. A work that is low in key is generally dark, somber, serious, and heavy in feeling. One that is high in key is light-hearted and airy. But a low-key painting can still have light or middle values too—it's just a question of how many and where they are that determines the key.

PETER
oil on canvas,
9" × 12" (23 × 30 cm).

This is an early painting of my son, Peter—who is now 6' 2"! It's not really a low-key painting in the sense of being a dark painting—there are some very definite light areas here. But that's just the point. A painting with predominantly darker values still needs some very definite lights, otherwise the picture will seem murky.

SKETCH

To show you the basic idea of the painting, I've simplified the composition into two values and made it primarily low key—that is, with more dark values than light ones. Notice how this simplified sketch captures the essence of the original painting. In fact, because of its simplicity, it seems even stronger than the original. One reason for this is that as I worked on it, I realized that the floor might look better as a dark than as the light-middle value of the original painting. This is why analyzing the values in your compositions can be helpful.

I also decided to make the middle values in my sketch white because I wanted the upper section of the painting to be predominantly light. Of course dark cast shadows should be massed with the darks, but subtle shadows, such as those on the white wall in my painting, are best left out in a simple diagram. Remember, you don't want to confuse the issue. You're just trying to create big, connected groups of lights and darks.

ASSIGNMENT

Choose a subject where the lights or darks make up about 75 percent of the scene. Make an 8″ × 10″ (20 × 25 cm) sketch of it, then reduce what you see to only two values—a light (the paper) and a dark. This means that you must decide which direction the middle values lean and force yourself to mass them with either the light areas or the dark values.

PAINTING IN A HIGH KEY

Paintings in a high key also need to be simplified. To show you how I broke down the values, here are two sketches of a painting. As you study them, notice how the values and their distribution affect the mood and interpretation of the scene.

SKETCH 1

The first sketch looks muddy and weak. The middle-value areas are too large and the dark values aren't strong or dark enough to add interest.

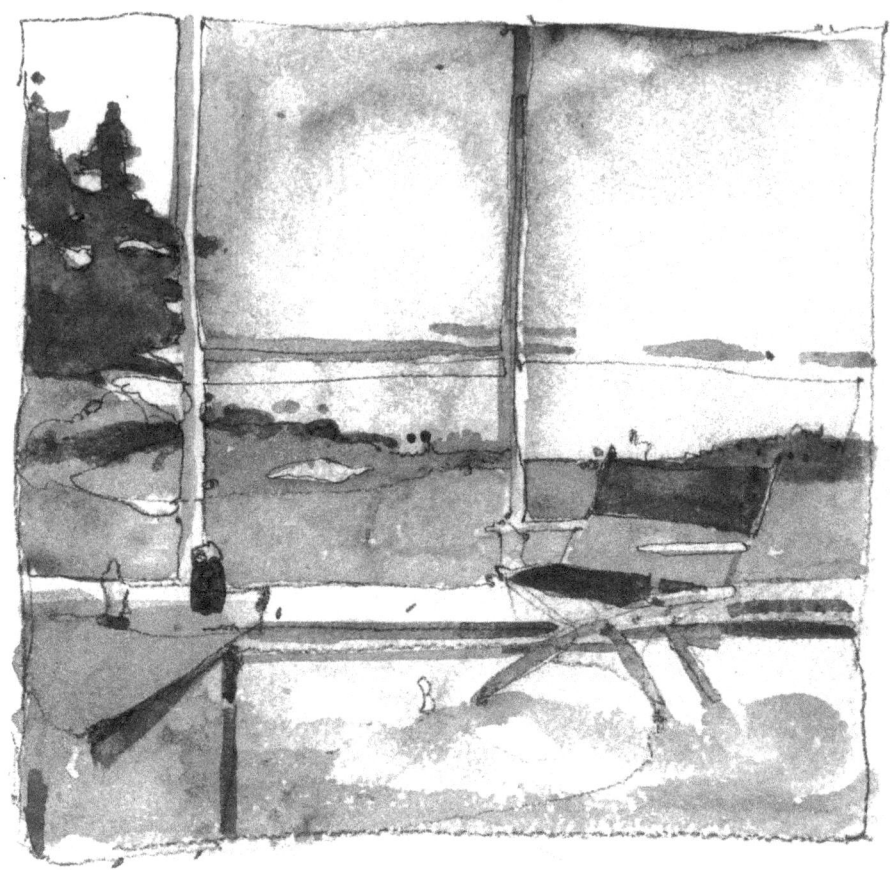

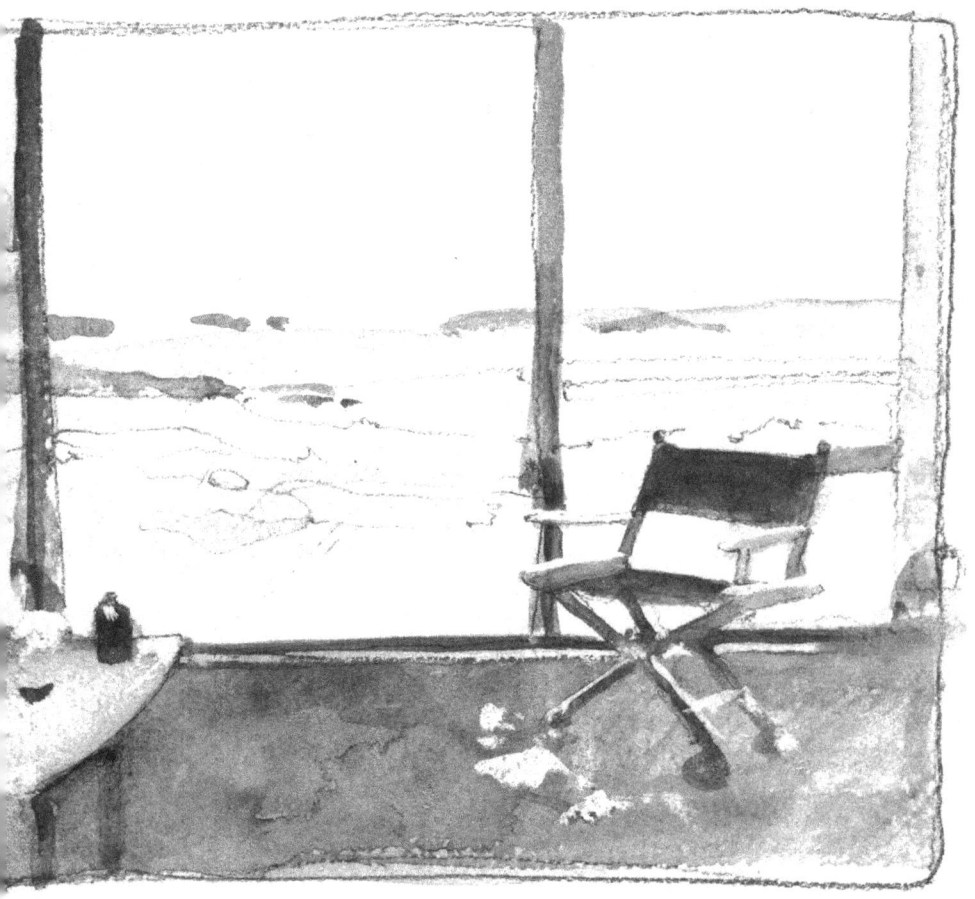

SKETCH 2

The second sketch, on the other hand, contains large, simple masses, and even where the value differences are close, they are clearly separate. Large, simple value changes, no matter how subtle, can make the difference between clarity and confusion in a painting.

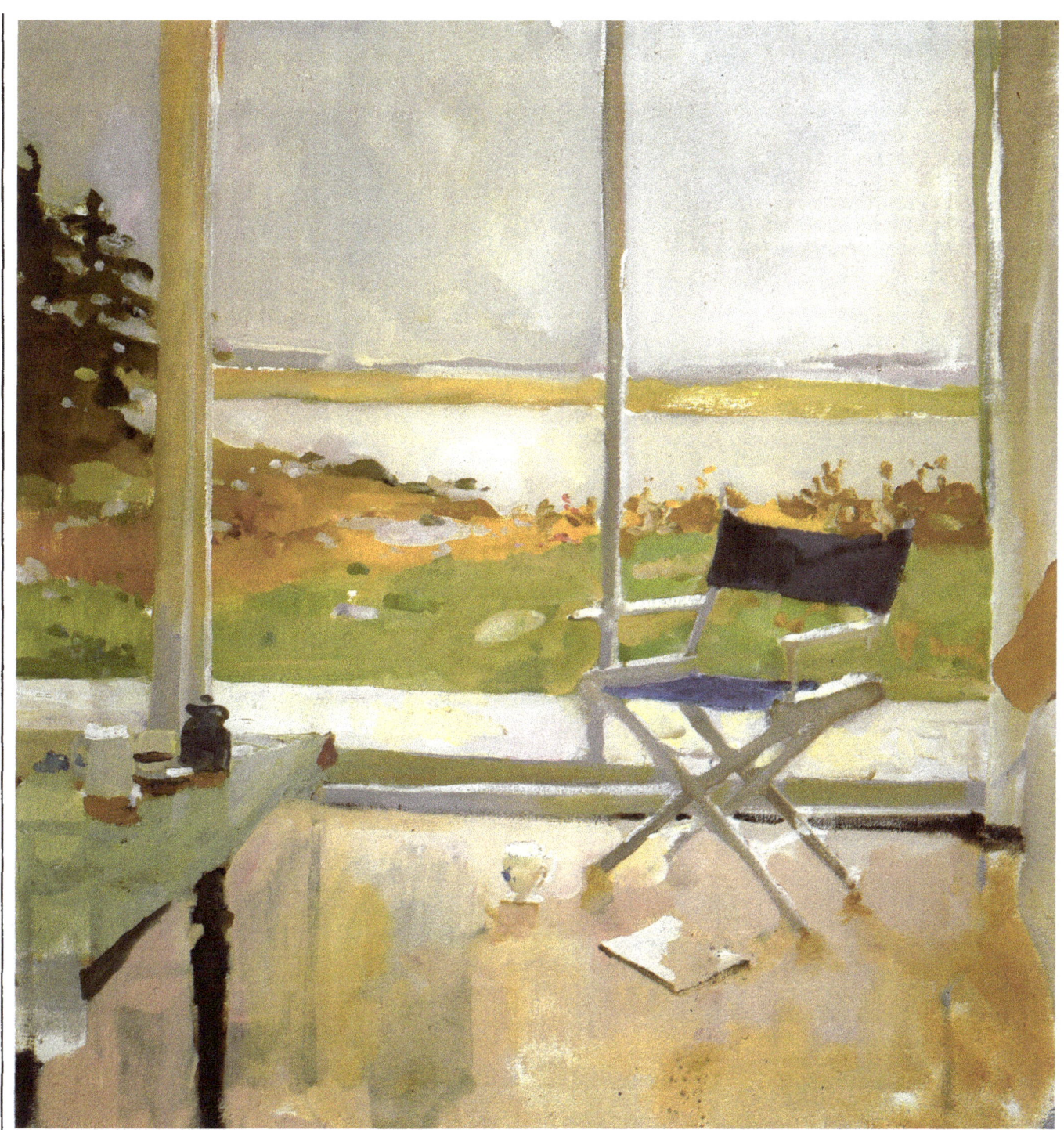

BLUE CHAIR, NOVA SCOTIA

watercolor on paper,
22″ × 22″ (56 × 56 cm)

The final painting resembles the first
sketch, but the second sketch helped
me to see and correct some basic
errors. Notice that I added more
darks to the painting. Darks bring
what could be a "muddy" or weak
picture into focus. Also, the intense
blue of the chair, though not really a
dark value, acts like one because of
the strength of its color.

PLANNING A BASIC
VALUE SCHEME: PORTRAITS

Most of us think of composition in terms of objects. We worry if the subject is too close to a corner or too much in the center of a painting. It's true that sometimes the placement of your subject is very important, but I've always been surprised at how important *value* is in composition. For example, when you put a dark object against a light background, you make it seem very important, but if you place it next to another dark object, it doesn't seem important at all.

JUDY

acrylic on Masonite,
12″ × 12″ (30 × 30 cm).

This portrait of my wife was done a long time ago. In those days I wanted to paint like Andrew Wyeth. But there is only one Andrew Wyeth, and so I went on to try and find "Charles Reid." However, I still think Mr. Wyeth is a first-rate artist. One of the things I admire most about his work is the abstract foundation of his paintings. His compositions can often be broken down into two or three major value areas. I think that's what I was trying to do here.

SKETCH 1

Even though the actual painting contained five or six values, they could easily be reduced to two basic values. To do this, I forced the darks and middle values together as one value, and massed the light values together as a third group (left as the white paper). This is not as difficult as it seems. You just group the halftones (values between the lightest and darkest areas) with either extreme, according to the effect you want. For example, if you wanted to concentrate attention on the form of the face, you would group the halftones with the darks. But if you wanted to stress the eyes, you'd want a flatter, more two-dimensional effect. In that case, you would group the halftones with the lights. The important thing is not to confuse your value areas by stressing minor variations. You must make your shapes very strong. Thus you wouldn't make the darks in the

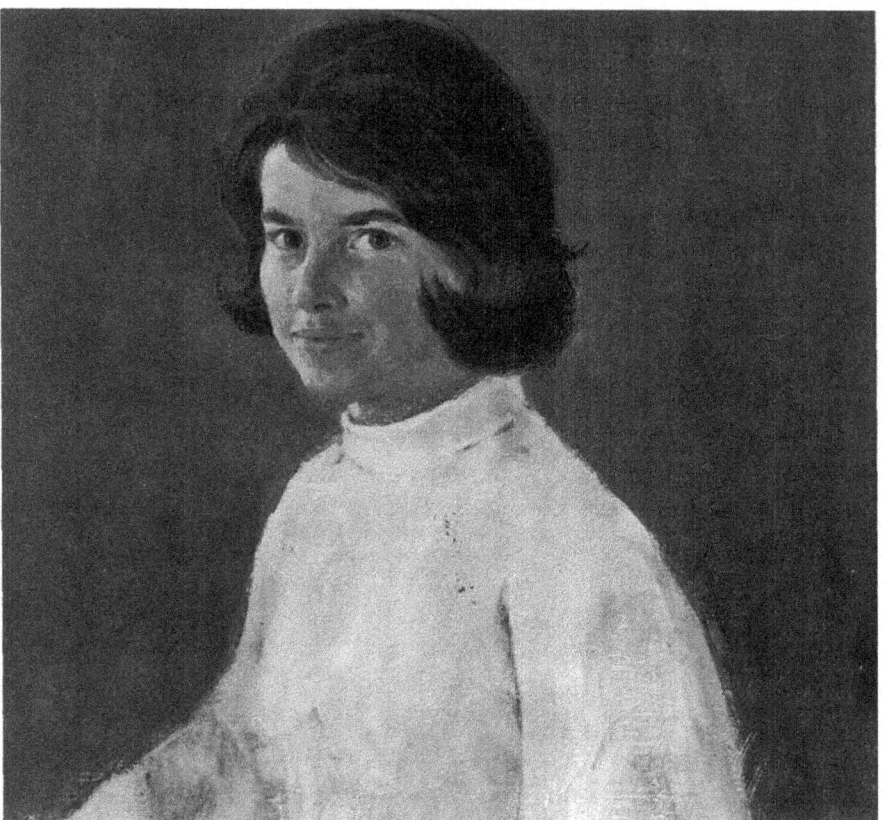

sweater as dark as the background or hair, and you wouldn't want to complicate the dark hair mass with small, unimportant highlights.

The point here is to be aware of economy of means and simplicity. These two values make us establish the "big idea," the major theme of the painting. Of course, hue and intensity also help show variations between areas—and we will be discussing that in the next section. But since we are concentrating on values now, I hope you will start thinking in terms of simplifying them into large masses.

SKETCH 2

Now I've added a third value to the sketch, a middle value. Notice how it helps strengthen the composition. Of course we need more than three values to make a decent painting, but that's not the point. These sketches are to show you how to plan a basic value scheme.

JUDITH WITH SARAH

oil on canvas,
22″ × 30″ (56 × 76 cm).

This is another portrait of Judy—this time she is about to produce our daughter, Sarah. To show you how values can balance a composition, I've also included two sketches of this painting. The first one illustrates the unorthodox placement of my subject on the canvas, and the second one shows how the arrangement of my lights and darks has made it into an acceptable (and interesting) composition.

SKETCH 1

Normally a face and hands are considered the main focus in a portrait and are therefore usually positioned in a central area in the painting. But here I put the face in the upper center and the hands in the lower right-hand corner. Theoretically, this was an error. You're not supposed to center a subject and you're not supposed to put a focal point near a border or corner. But I find it fun to ignore rules (at least in painting), and proper subject placement is one rule I particularly enjoy disregarding. In fact, I rather like this composition. I think that placing a person near and facing into the border creates a certain tension in a portrait. It also eliminates "background worry." Had I placed her further to the left, I would have had to create a lot more background on the right-hand side of the painting. Besides, this compositional device is not without historical precedent—Degas used it, too!

SKETCH 2

Here we're no longer aware of the problems of figure placement. Now you can see that the painting has been balanced by shapes of different weights and sizes. Notice how important negative shapes are. They literally carry the whole painting. Now compare these two sketches to the finished painting. The "incorrect" composition has been balanced entirely by the abstract arrangement of the value pattern.

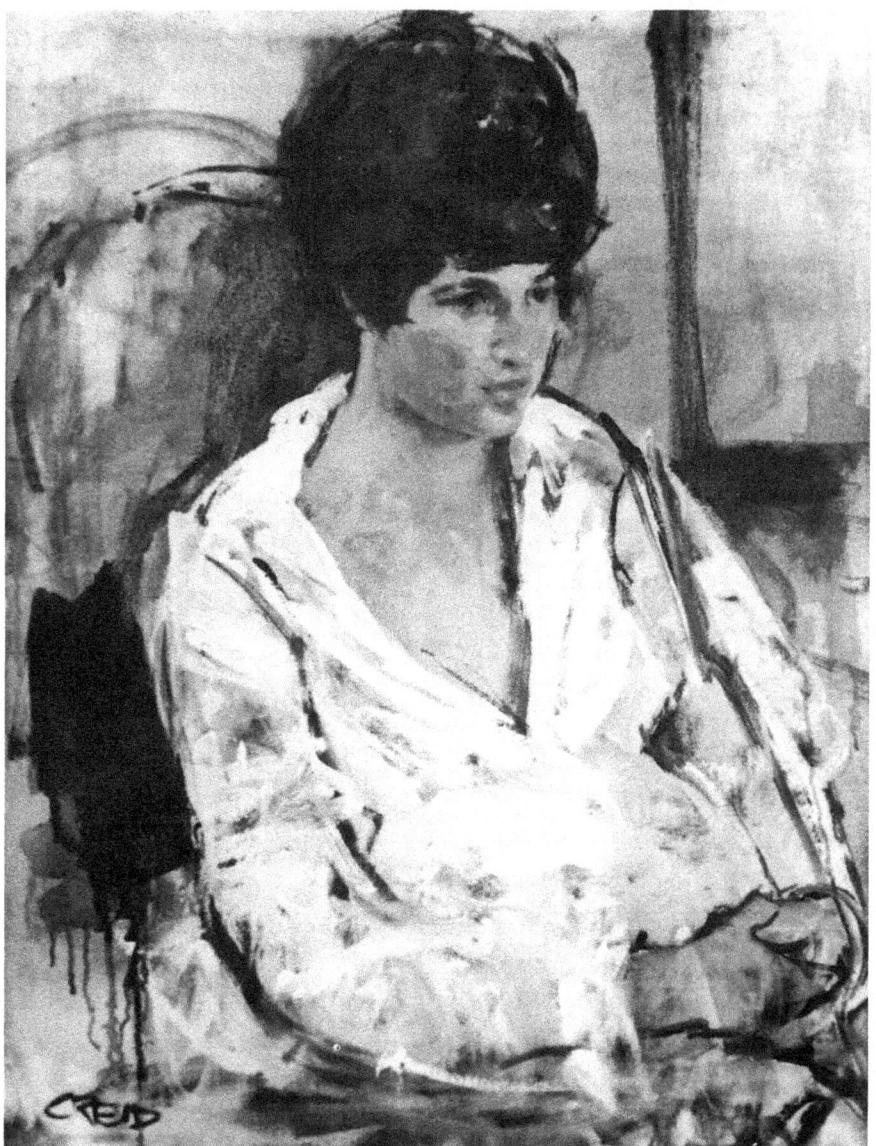

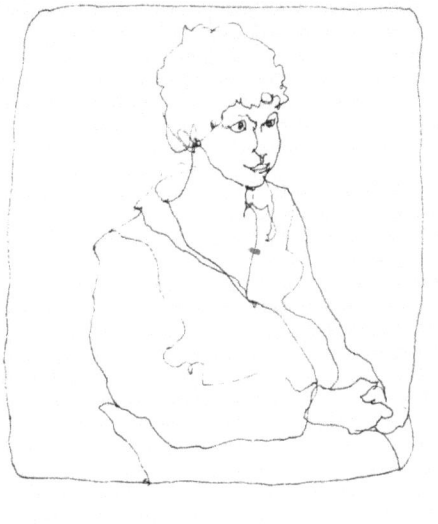

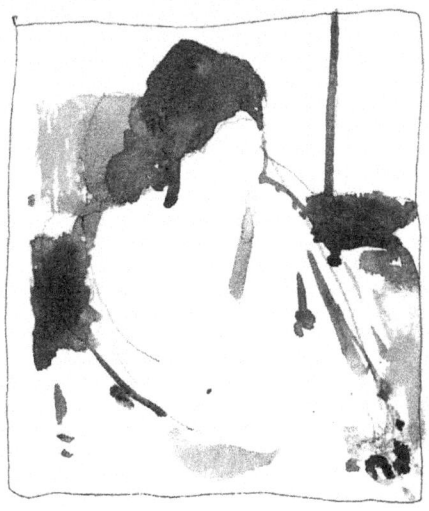

PLANNING A BASIC
VALUE SCHEME: LANDSCAPES

To make a strong statement, it's necessary to simplify our values, although it may be difficult for many of us to reduce a landscape to only two or three values. It's also hard to start thinking in terms of value shapes rather than specific objects because we've been taught since childhood to make our drawings look real. Our teachers would object to the strange,

awkward shapes that flew across our pages—we were encouraged to be accurate. And now that we're adults, it's hard not to see how objects look. But we must learn to ignore the objects and see the scene as a whole in order to paint. Shapes, good, accurate shapes, are the key to realism.

I want you to take a look at four landscapes—finished paintings—and

see how I broke my sketches of them down into broad shapes of two and three values. As you examine them, ask yourself how you would have broken down the values in these paintings. Would you have seen the same shapes I did? Try to see why I made these simple, yet important, value decisions.

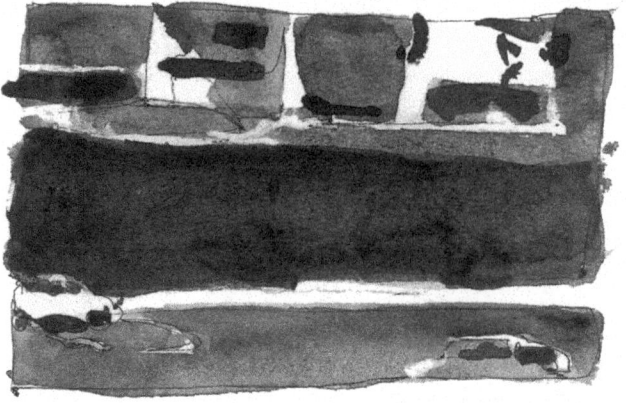

FAMOUS ARTISTS PARKING LOT

oil on board,
9″ × 12″ (23 × 30 cm).

This was already quite abstract as a painting, and so it is easy to see how I arrived at these value breakdowns. Notice how adding the darks strengthens the painting. Also notice how the sketch contains something of the essence of the final painting. (The subject of this painting is the parking lot of the Famous Artists School in Westport, Connecticut.)

36

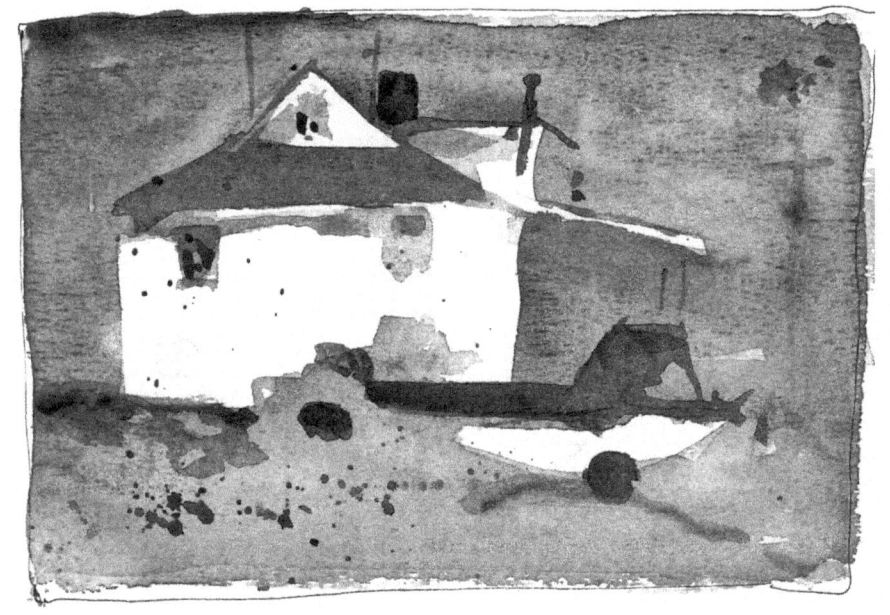

RACE POINT

watercolor on paper,
21″ × 26″ (53 × 66 cm).

I broke *Race Point* first into two values, then added a third value with some important darks: the chimney, left window, some small shapes in the grass, and darks in the "DUK W"— the amphibious creature in the middle distance.

The main point is that the first two or three value decisions make the picture. I could have added many small value changes after that, but they probably wouldn't improve the painting—in fact, they even might have hurt it!

PORT CLYDE, MAINE

oil on board,
9″ × 12″ (23 × 30 cm).

It wasn't really necessary to make an abstraction of this painting because it is already quite abstract. In fact, this little oil was originally done as a sketch for a proposed larger painting. Notice how all the darks are massed together and how the lights balance the darks. Of course, you're seeing this in black and white. In color, you would see much more area definition because even though the values are very close, there are warm and cool color changes.

This brings up another point. I've often thought that if we cut down on our value changes and stressed color changes instead, we would have simpler and stronger paintings. I hope you'll see this when we get into the color section.

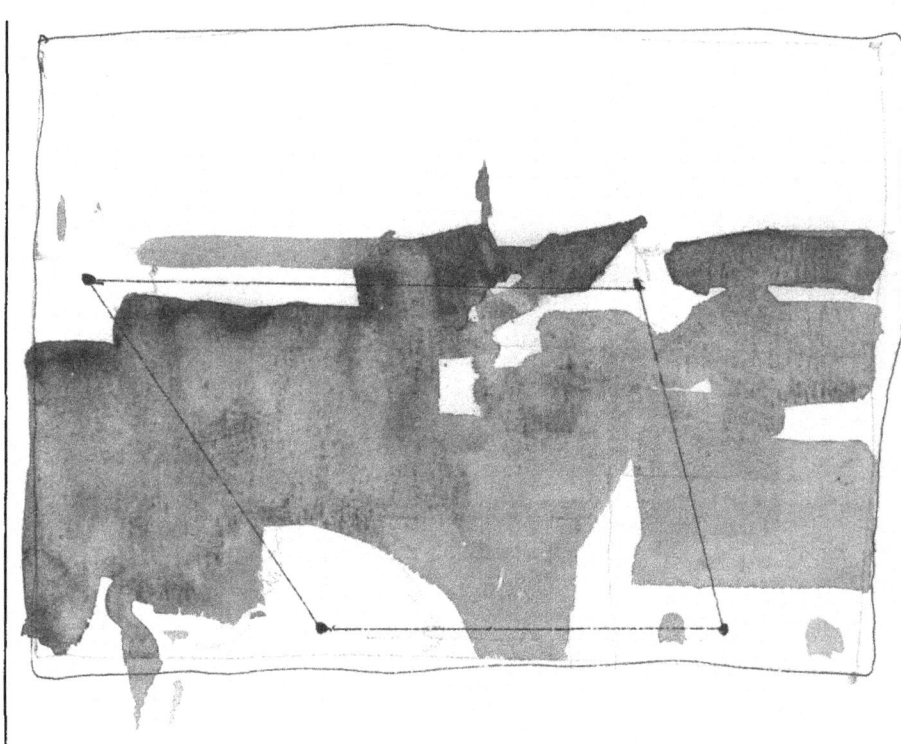

BLOCK ISLAND, R.I.

watercolor on paper,
21″ × 28″ (53 × 71 cm),
private collection.

The composition of this painting of buildings on Block Island is different from the other examples. The light-and-dark breakdown was arranged not according to local values, but according to the way the light was falling on these buildings and casting deep shadows. Because of these massed values, it's sometimes hard to see where one building or grassy area ends and another begins.

I've also included a sketch done in local values to show you how the scene really looked. I hope you can see how different the composition looks when we see it in terms of value rather than in terms of objects.

The important difference between the two interpretations is light. The painting was done in two sessions, under strong morning sunlight, whereas my sketch was based on imagining how the same scene would look under cloudy skies. Neither one would make a bad painting, but the point is that even though the objects are in the same exact place, these are two different pictures, two different interpretations of the same scene.

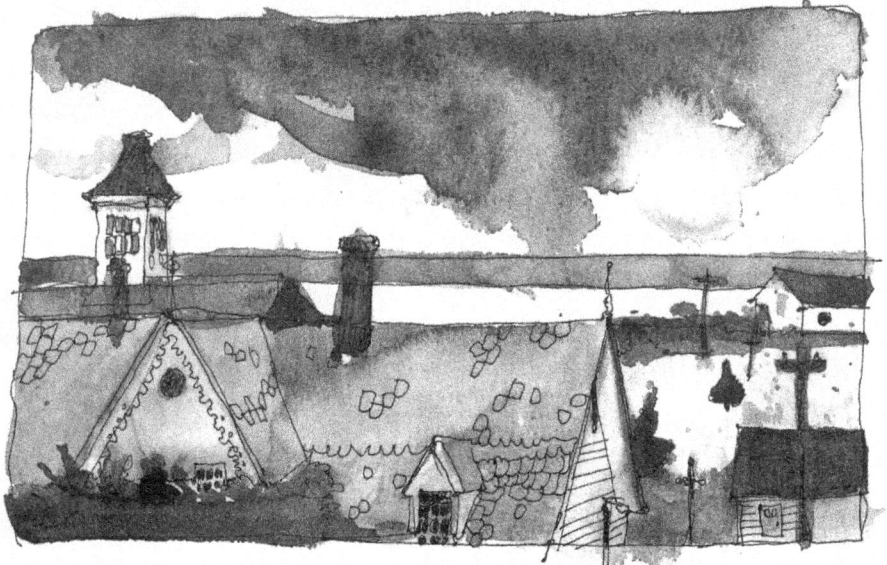

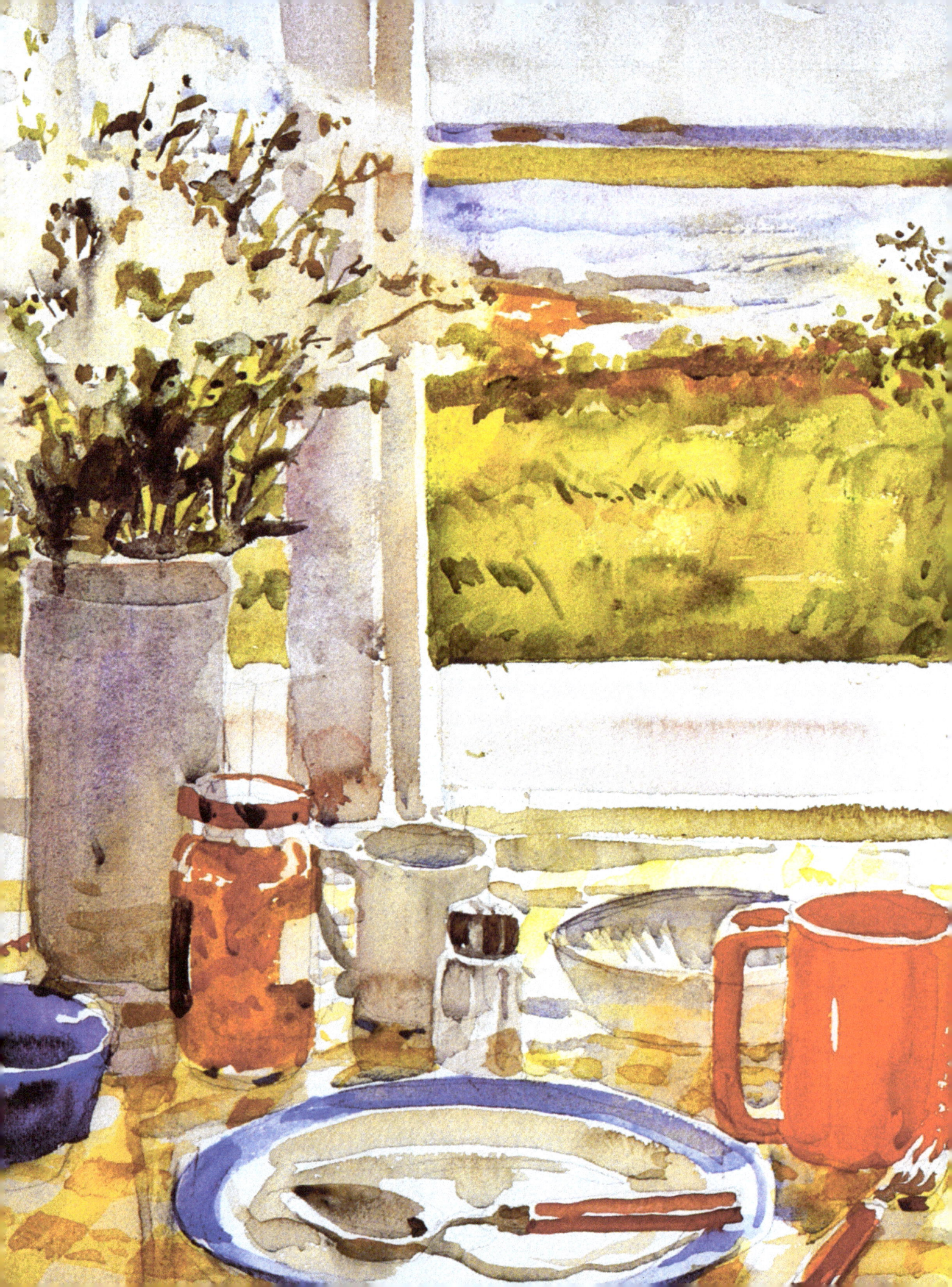

part three

HANDLING COLOR

EXPRESSING A COLOR-VALUE

I've been trained to think of "value" as meaning how light or dark something was. Indeed, that's what I still think. But I also think that the word is misleading. Shouldn't color have "value" too? That is, shouldn't color have as much *worth* as lights and darks?

The idea of "chiaroscuro" (the strong contrast of lights and darks in a painting) still dominates realistic art. But light and dark colors don't have to be dull to be effective. For example, Rembrandt was a chiaroscuro painter, yet I don't think he would be happy being thought of as a painter of murky darks and washed-out lights, which is what student colors are often reduced to. Colors should have an identity. They should lean toward specific hues, and not be vague. They should, in short, have a certain definiteness.

In *Art in Its Own Terms*, edited by Rackstraw Downes, Fairfield Porter says of a painter, "His [treatment of the] light shows why Impressionism began. At a distance across the room the color vanished, and what remains is tone." Porter's use of the word "tone" is interesting. It's one of those anonymous art terms that means something different to everyone. And I think that's just why Porter chose that term. Because he was referring to a color that was generalized and bland, one without color identity.

SARAH

oil on canvas,
48" × 50" (122 × 127 cm),
collection Judith Reid.

My painting of Sarah will show you what I mean by color-value. There are no strong light-dark contrasts here. Instead I tried to think of the painting in terms of color. I even lightened some of the darks on the couch and table to give them more specific color identity. The idea was to see a specific color in each section, with no area looking neutral or purely tonal.

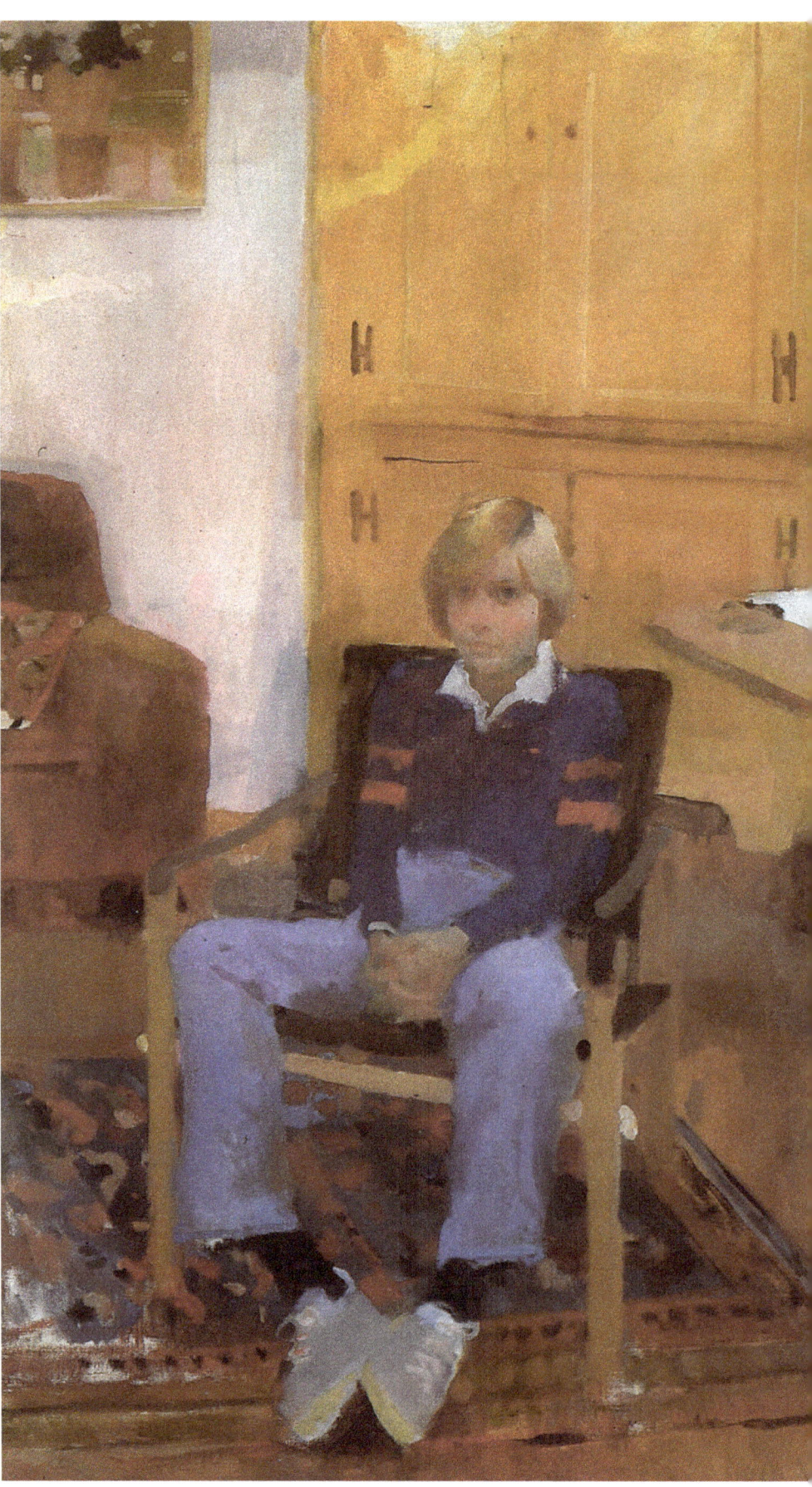

CLASS PROJECT

To get my class thinking about color-values, I asked my students to consider each area within a confined picture in terms of color "pieces." The model was sitting on a white wicker chair with a plant next to her. I suggested that the class make small paintings, 8″ or 10″ × 12″ or 14″ (20 or 25 cm × 30 or 36 cm), in a format where the figure-chair would take up three-quarters of the picture area. I also wanted the class to connect the chair-figure and plant to the picture border on all four sides. This would cut down on extra background space and force the students to think of the remaining background in terms of definite shapes.

In addition, each negative shape (supporting background) and each positive shape (subject) was to have a color-value. I wanted the negative or "supporting" elements in the painting to be more important than the figure itself. The figure was to be painted simply as a piece of local color, a flat shape, rather than rendered in terms of light and shade.

I also want the painting to contain some pure white shapes, areas with no tone at all. This was easy, since our model was sitting on a white wicker chair. But the idea was to make the students see the chair as a positive shape set off by the surrounding negative shapes. Modeling within the shape of the chair was discouraged.

When everyone had finished, we looked at the paintings from across the room, about 30 feet (9 meters) away. Those that were strong in color-value thinking stood up well, but the paintings that were involved with modeling forms fell apart at that distance.

SAMPLE SKETCH

This is an example of what I expected the class to do. A good sketch should "read" clearly from across the room. The farther away you get, the better it should look.

STUDENT PAINTING

This student's work is a particularly good example of strong color-value thinking. There is an excellent value range here, but color identity is just as evident. Notice that each dark negative shape has a specific color. The one on the upper right is a warm purple, the shape on the upper left is a cooler, more neutral blue, and the one on the lower left is a rather intense blue. The light colors aren't washed out "tones" either. They, too, have specific color-value.

When I use the term "color-value" I don't mean intensity. What I mean is that these color areas have an obvious, apparent color. They all express an unequivocal color idea.

43

LEARNING TO USE STRONG COLOR

I'm sure we've all experienced a twinge of envy after seeing an exhibition of paintings done by a group of young children. Their work has a strength, directness, and simplicity that many of us wish we could manage. One of the reasons for the strong graphic quality in children's art is that they see objects in terms of color rather than value or form. In fact, children don't seem to be aware of light and shade or roundness until they're older—and then their paintings tend to go downhill!

Most older people are afraid of using strong colors. Also, in an effort to make something look "real," they muddle about with small details. The result is that they overmix their color so it gets gray where it shouldn't and the values become muddy and confused.

I want to get you to see color freshly and directly. I also want to force you to concentrate on getting the correct color-value without having to worry about edges and details. To do this, I'd like you to paint a group of objects just as a child might, with a color that comes right out of the tube that matches the color-value you see before you.

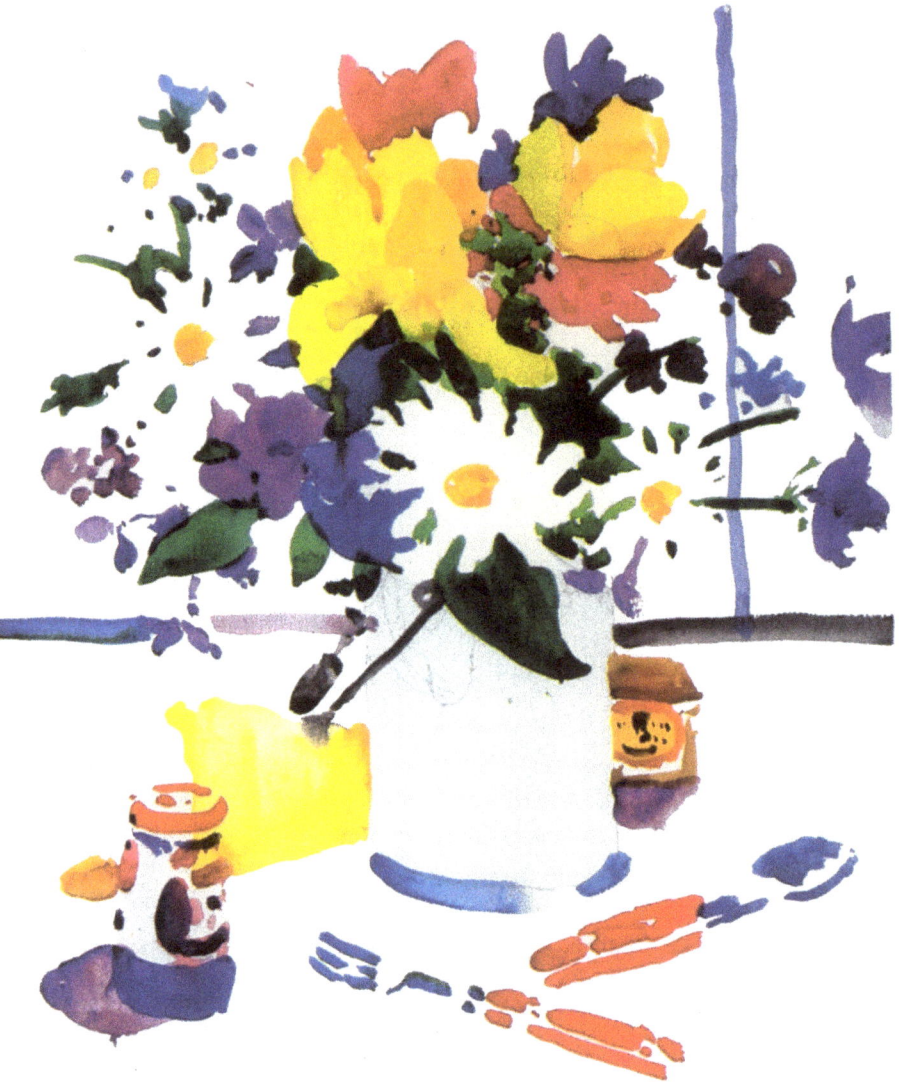

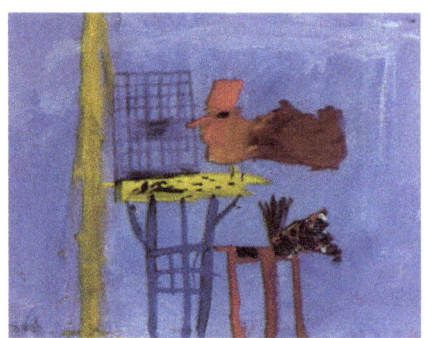

PAINTING BY SARAH REID

Here is an example of how I want you to see local color. My daughter did this when she was seven. There is no doubt that she was painting a rooster next to its cage on a blue stand. But she got confused about something on a red table under the rooster. I believe it's a hen? Like most youngsters, Sarah used her colors just as they came from the tube in order to get the color *and* value she wanted.

SAMPLE PAINTINGS (WATERCOLOR)

To illustrate how I want you to do this very simple and basic exercise in watercolor, here are two paintings. The first one is a sketch using pure color. The subject was a bouquet of silk flowers. I placed them on my kitchen table and painted each flower with a color just as it came from the tube, making each color as intense as possible. I didn't mix any colors, soften any edges, or show any form in terms of light and shade. In the second painting, I showed how I would carry the idea on to a finished painting.

Although I worked in watercolor, I handled the medium the same way I would oil. That is, I put in the local colors first and left the highlights for last. For the sake of simplicity, I left the background white (the table actu-

ally is white). I tried to use the watercolor full strength.

My palette for the watercolor sketch was as follows:

Lighter yellow: cadmium lemon

Darker yellow: cadmium yellow medium

Green: Hooker's green dark

Lighter blues: cerulean blue

Darker blues: cobalt, ultramarine, Winsor (phthalo) blues

Purple: Winsor violet

Red flowers: alizarin crimson

Red on jar top fork and spoon: cadmium red.

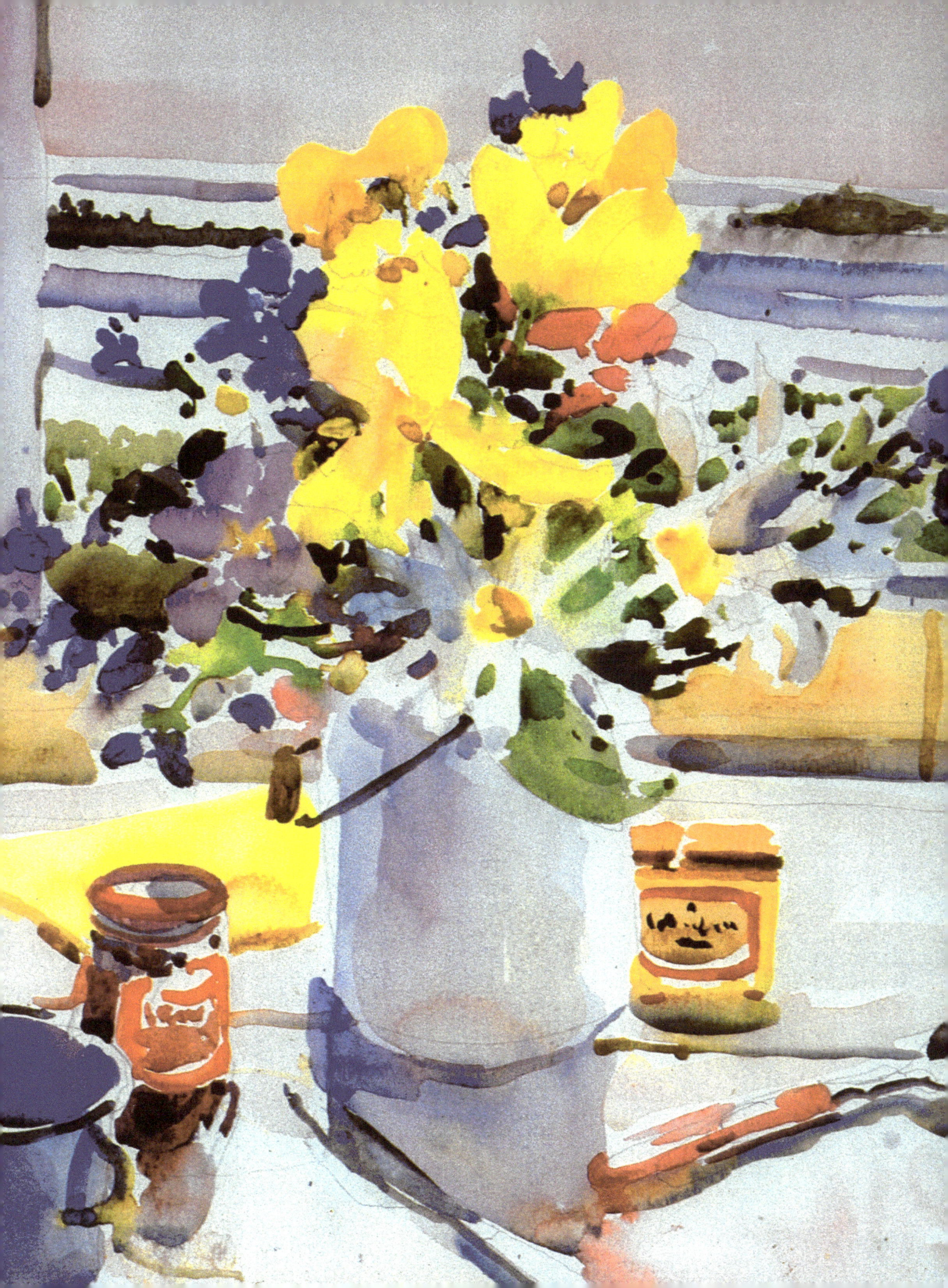

SAMPLE PAINTINGS (OIL)

For those of you who prefer to work in oil, this is an example of how to do the assignment in that medium. This isn't a very good painting, but it does have value and color differences. The point is that it's not muddy or confused, and that's all I wanted to show. Each area is painted in a single color value, just as it comes from the tube. I allowed myself to add *one* highlight on some of the objects—but that was all.

Here are the colors I used:

Coffee can: cadmium yellow light, ivory black, cadmium red

Aspirin bottle: titanium white, cobalt blue

Orange: cadmium orange

Salt bottle: permanent green light, titanium white

Apple: alizarin crimson

Wall: raw sienna

Table: permanent green light.

My color sketch doesn't match the black-and-white value sketch exactly. The intense greens and oranges look lighter in black-and-white. But the purpose of this exercise is not to match a color sketch to a black-and-white value sketch. It's intended to train you to match color and value to simple objects.

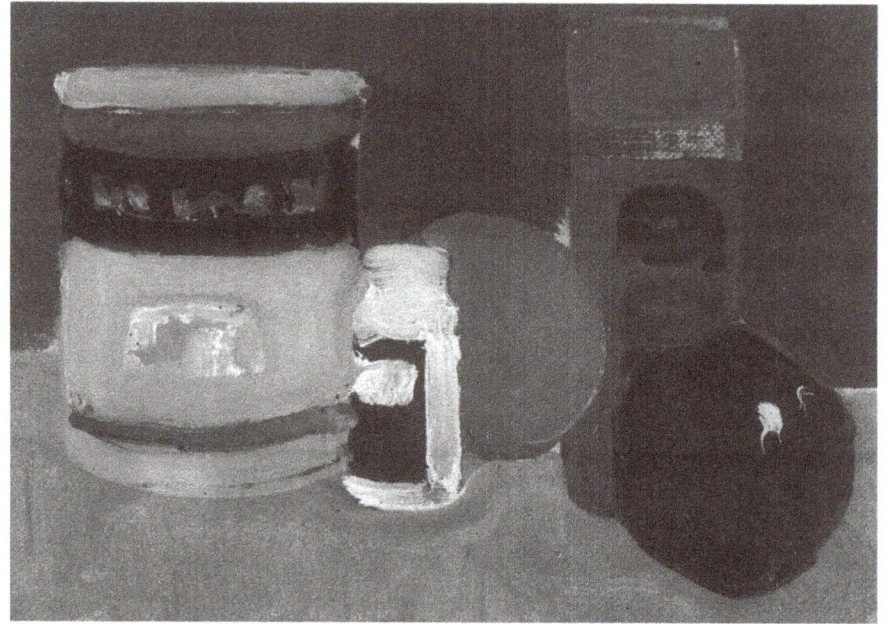

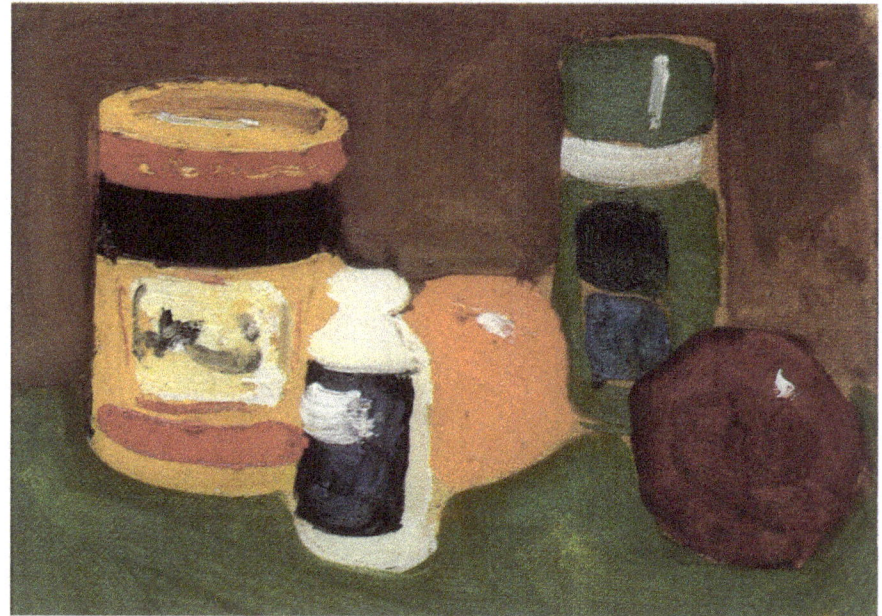

ASSIGNMENT

I want you to make a sketch like mine using pure local color.
1. Set up a still life of four or five objects with an obvious color identity. Fruits and vegetables are always good to paint, or flowers or objects you may find around your kitchen. You may also want to paint packaged goods, since most typical containers have pure, strong colors on their packages. Stay with the primary and secondary colors, colors that correspond to tubes of paint you already have on hand. Remember, you're not going to be mixing your colors.
2. Place these objects under a diffused light, one with no strong shadows. You're not to be concerned with light and shade, just local color. Before you paint in color, make a value sketch of your set-up using only ivory black and white (to make shades of gray). Concentrate on local value only, and paint the objects as flat shapes, working in a flat, posterlike fashion. Come in close to your objects. Crowd them into the picture surface so you'll have almost no background to worry about.
3. When you have finished your value sketch, switch to color and paint the objects again with pure, flat color.

Whether you are working in oil or watercolor, you must use full-strength colors. This is less of a problem in oil because, unless you add white or another color to your tubed color, the color is always at its strongest intensity straight from the tube. But in watercolor, you must add a certain amount of water to your color in order to manipulate it. And the more water you add, the lighter and weaker your color will be. Also, watercolors dry lighter than they look when wet, and there's a danger that your subject will end up looking washed out. So, if you're using watercolor, while you shouldn't work drybrush, be careful to add enough water to manipulate your paints. And make your colors slightly darker than you see them, so that they'll match the local color of the object when they're dry.

SEEING PURE COLOR AS VALUE

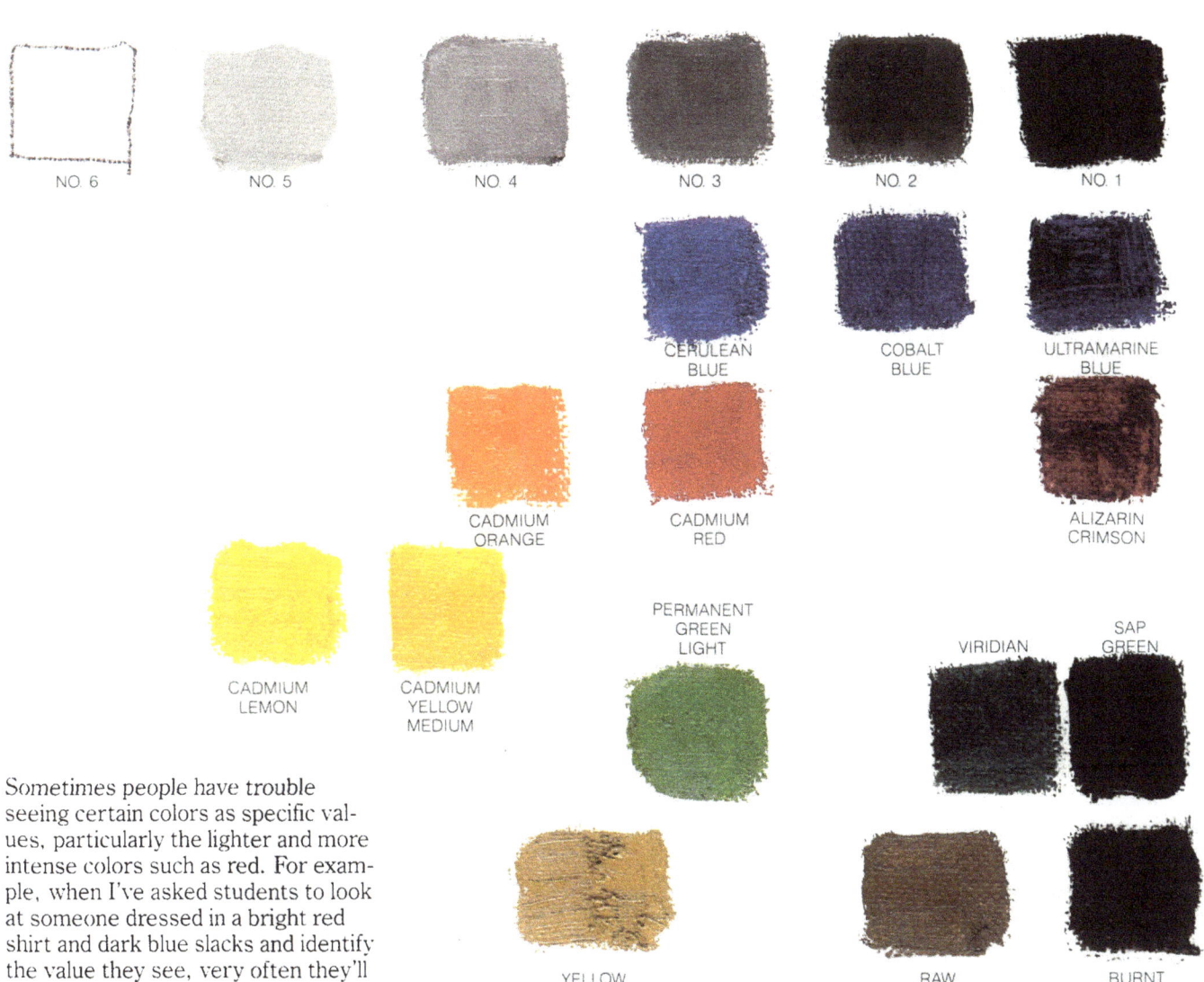

NO. 6 NO. 5 NO. 4 NO. 3 NO. 2 NO. 1

CERULEAN BLUE COBALT BLUE ULTRAMARINE BLUE

CADMIUM ORANGE CADMIUM RED ALIZARIN CRIMSON

CADMIUM LEMON CADMIUM YELLOW MEDIUM PERMANENT GREEN LIGHT VIRIDIAN SAP GREEN

YELLOW OCHRE RAW SIENNA BURNT UMBER

Sometimes people have trouble seeing certain colors as specific values, particularly the lighter and more intense colors such as red. For example, when I've asked students to look at someone dressed in a bright red shirt and dark blue slacks and identify the value they see, very often they'll say "dark" for the slacks, but "red" for the shirt!

When you're painting a scene, it's important to be able to identify each color you use as a specific value. Bright, strong colors often suggest a light value to people, while grayed, less intense color may suggest a darker value. But they are confusing value with intensity. Remember, each color has a specific hue, value, and intensity as it comes from the tube. Try to keep them separate.

VALUE CHART

To show you what I mean, I've made a value chart of the colors I use most frequently. Of course, individual perceptions may vary slightly and you may disagree with some of my values, but as long as you get the idea, you shouldn't have too much of a problem charting your colors.

ASSIGNMENT

Since this will be a color chart for oil paint, we will use a canvas panel for this exercise. I've used an 8″ × 10″ (20 × 25 cm) panel, but if you have more colors than I do, a larger size may be better. (You can also use watercolor and white paper, if you prefer. Just keep your colors strong.)
1. Paint a black-and-white value scale across the top—five values plus white. I find it easier to start at the left with ivory black and then add more and more white to it as I work to the right, but you can start with white and work down to black, whatever is most comfortable.
2. Now, put the colors you normally use—you don't have to use the ones in my chart—in their usual order around the edges of your palette. Then match each color with one of the black-and-white values. Don't adjust the tubed color by mixing it with another color or with black and white, but use it just as it is when you squeeze it out of the tube. It might be hard to judge the values at first, and you may mess up several panels in the process, but in the long run the practice is worth it.

Notice that several colors on my chart fall between two values. Cadmium yellow, for instance, seems to be between 4 and 5 on the scale, yellow ochre between 3 and 4, and viridian between 1 and 2. This is fine. As I said earlier, you can make a value scale that contains nine or more values plus black and white once you can discern subtle value differences. Meanwhile, for now, just place the color values between the two values, as I have done.

PAINTING LOCAL COLOR

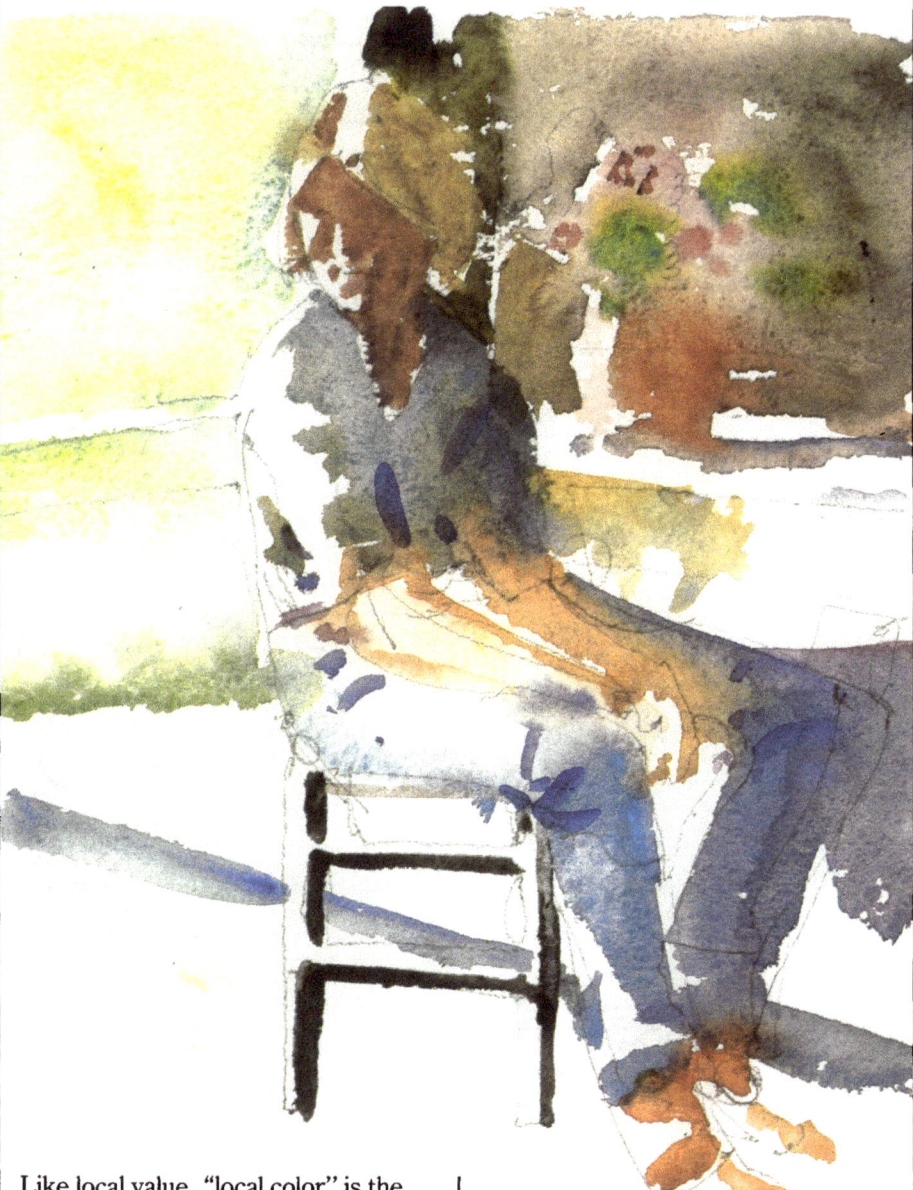

Like local value, "local color" is the overall *color* of a particular area independent of the effects of any light that falls on it. Local color also behaves like local value when light is added—a strong light that makes values look lighter will also bleach the color out of objects, and so an intense red might appear as a weak, washed-out pink. You must always be aware of the effect of light and compensate for it accordingly. If you don't—if you paint only what you see—you will paint all the strongly lit areas the same washed-out, tired-looking neutral color.

To show you how local color changes under conditions of strong lighting, I want you to take a look at a sketch and painting of my daughter, Sarah.

SKETCH

In this sketch of Sarah, I deliberately let the bright sunlight dominate, allowing it to wash out the local color and value. Now, despite the difference in color, the areas in the light look pretty much the same. We can no longer identify the actual (local) colors or values of the clothing, skin, or grass. The shadows look pretty similar, too. The overall look is spotty and disconnected.

SARAH AT HIGH HAMPTON

watercolor on paper,
22½" × 30" (57 × 76 cm),
collection Judith Reid.

When I painted Sarah's portrait, on the other hand, I was careful to make the overall local color and value of each area more important than the light that fell on the figure and chair. You can tell that Sarah is in sunlight. But you also know that she is wearing a white shirt and blue jeans, and is sitting on a gray chair. You are thus aware of both the local color *and* the effects of light.

Even though you can still see a definite light and shade on her face, notice that the area in the light is not washed out. It has a very distinct fleshtone. It is also a bit darker than her white shirt in the light. Actually, the sun was so strong that this section of her face looked as white as the shirt. But because I wanted to show that this was skin and not a white shirt, I didn't paint what I saw. Instead I made the light-struck section of the face a bit darker and richer in color.

There is also another reason for underplaying the light on Sarah's face. Since this is a portrait, it is more important to describe her features than to express the feeling of light and shade there. Also, strong light and dark shadows can be too harsh and hard-looking for young people.

The texture of an object also influences the way it should be painted. Matte or dull surfaces reveal more of the local color and value of the object than shiny surfaces, which are more affected by the light. (Remember the way the light affected the well-groomed horse?) To see this for yourself, put a piece of dark silk next to a piece of dark wool or cotton. Notice that the light areas on the silk are very light and the darks very dark, while the contrasts are much less obvious on the cotton or wool. The point is that it's harder to see local color and value on shiny surfaces because the effects of the lighting are so prominent.

Notice the way I painted Sarah's hair. Because hair, expecially on a recently shampooed teenager, is a shiny surface, it reflects the light strongly. Therefore I have "lost" the local color and value there and instead have stressed the feeling of light and shade on it.

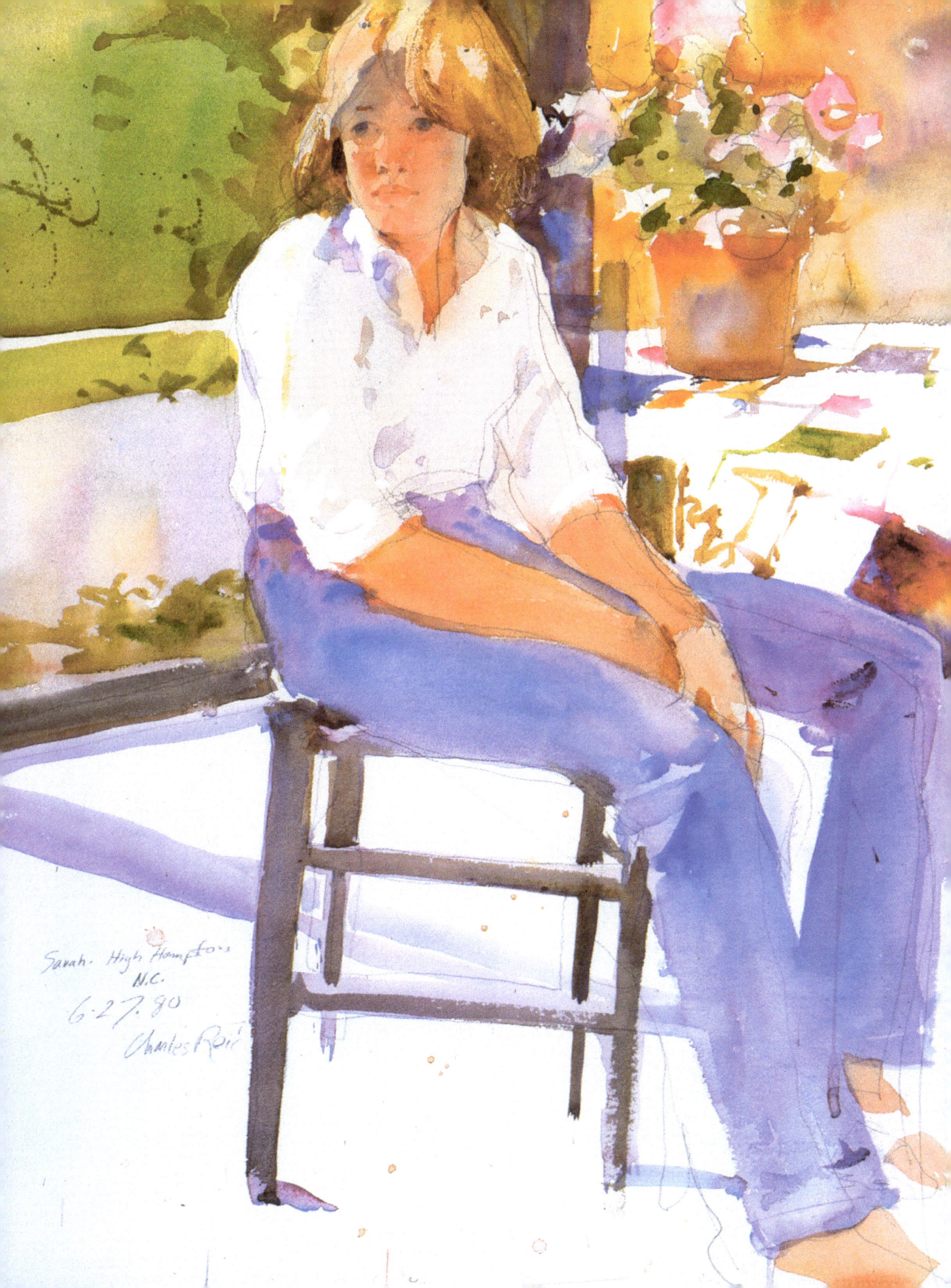

Sarah. High Hampton
N.C.
6·27·80
Charles Reid

ASSIGNMENT

The purpose of this assignment is to train you to see local color and compensate for the lightening of your watercolor washes as they dry.

1. Choose some simple objects for your set-up with a definite local color such as the vegetables here.

2. Study the set-up carefully. You will be painting it in only two washes, each of which will have a different purpose, and so you must plan these washes accordingly. The first wash will define the local colors of your objects and the second is for the shadow shapes only. You are not to restate any areas out in the light, but are to aim for a final statement in all areas with each wash.

Local Colors (First Wash): To determine the local value of an object, don't look at the lightest part of it. Instead, look at the color of the halftone area, the border between the light and the shadow. This is the color least affected by the light and by reflected color, and is thus truer in color. Ignore highlights! Many students think of the highlight area as the value in the light and end up with a washed-out local color. After you study specific areas, try to get an overall view of the entire set-up. This will also help you to assess the local color.

I expressed the local colors of the various vegetables in my sketch by using several colors in different areas, but you may find a single color much less complicated at first. For example, in painting the carrots I added a bit of cerulean to the orange. But cerulean blue may cause problems if you're not used to mixing colors, so you might want to use cadmium orange by itself at first.

Shadow Shapes, (Second Wash): As you can see, my shadow shapes are darker on some objects than on others. This is an artistic decision. I didn't want dark shadows on my "white" areas because I like to keep the local value of my whites. This is a personal decision.

Another artist might prefer more contrast and might therefore make the shadows on the white objects darker. It all depends on the "look" you're after.

As a general rule, I make my shadow shapes at least two values darker than the light areas on any given object, but as you can see, I don't always follow this rule—here I darkened shadow and cast shadow shapes only where I felt they needed more weight. If you find making such decisions confusing, then just go back to the general rule and make all shadow and cast shadow shapes two values darker than the lights.

I want to add one very important point. Make your shadow and cast shadows simple, connected masses wherever possible. Of course, you won't be able to connect all your shadows, but if you have too many small pieces you'll end up with a mass of spots scattered about, causing much confusion.

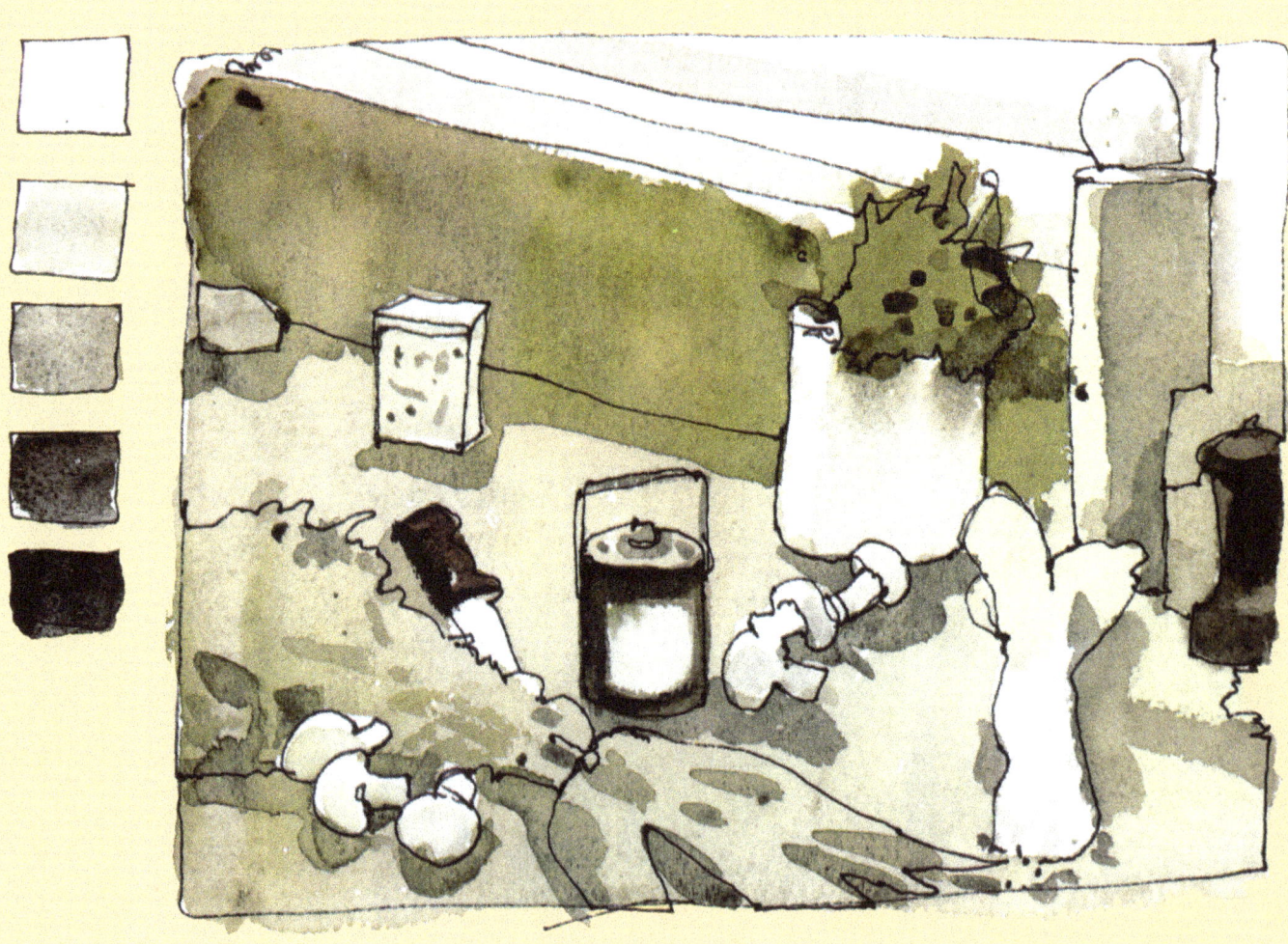

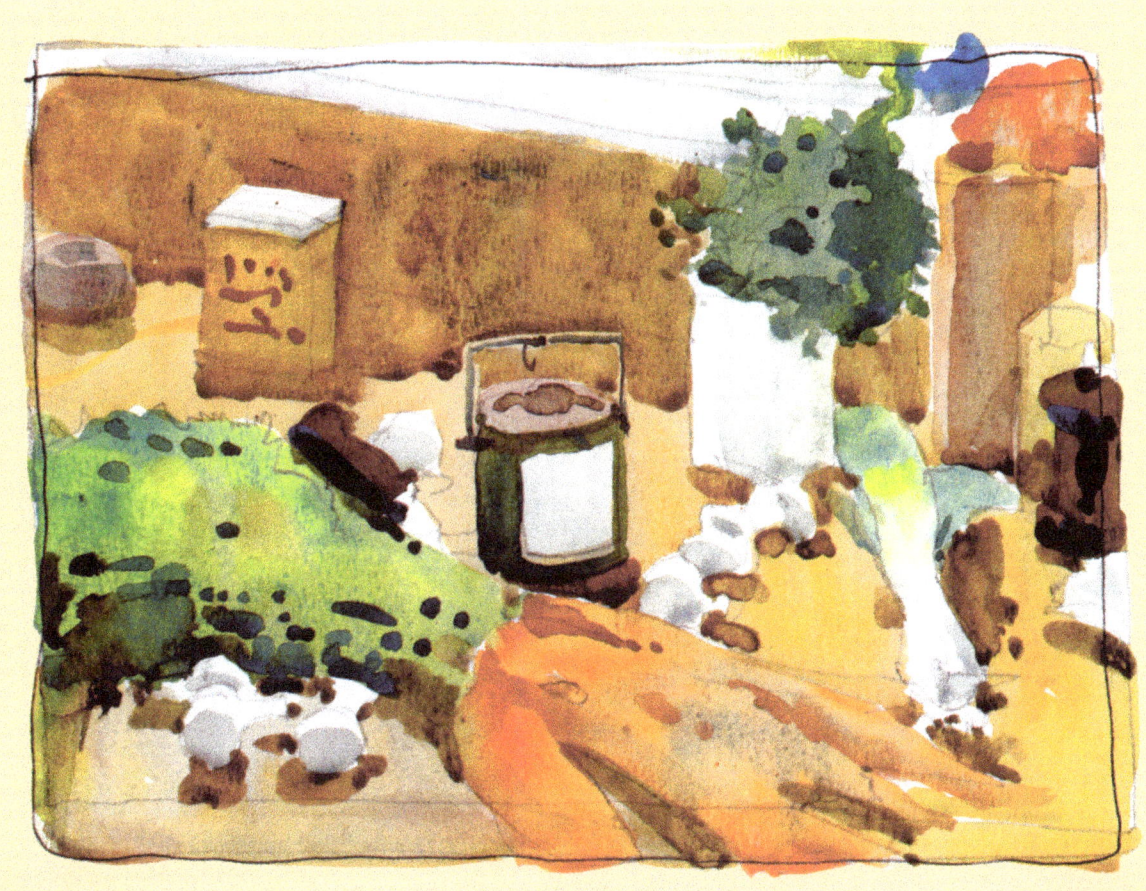

COLORING SHADOWS

Somebody once said that lights should be warm and shadows cool. While this is true in general, and a painting of a model in strong, warm sunlight will have warm lights and cool shadows, there are also other factors that complicate this simple rule.

First of all, you must consider the local color of the objects in the painting. For instance, a yellow object will still have a warm shadow, even though it will be cooler than its local color.

You must also consider the color balance of your painting. A painting must be in harmony and the colors there must work together as a whole. Splitting it into warm lights and cool shadows can be too disruptive.

There is also the issue of color variety. A painting that follows a simple rule like "have warm lights and cool shadows" may end up being too boring to be good. Furthermore, the rule does not account for the possibility that the subject may be lighted by a cool indoor light (such as a fluorescent lamp) or by cool daylight (skylight) instead of warm sunlight or incandescent light. In that situation, the lights are not only cool, but the shadows may also be warm.

If, in addition to being cool, your shadows are also muddy-looking, there may be other reasons:

1. Your palette may be dirty. If you're using the dark-valued "glunk" that has accumulated on your palette to express dark shadows instead of mixing fresh, clean color, your shadows will look muddy. Whether you work in oil or watercolor, you must constantly clean your palette. Experienced oil painters may keep oil color on their palettes, but they don't smear it together into a neutral mess.

2. You may not have looked closely at the local color of the object before painting it. Just because a shadow *looks* cool doesn't mean you must paint it that way. You must also consider the local color of the shadow area.

SKETCH

Here is a sketch with the shadows as cool as I could make them. I wasn't deliberately trying to do a bad sketch. I simply wanted you to see what a model would look like painted according to the rules, with warm fleshtones and completely cool shadows. I also generalized the darkest areas by using a dark value of the same cool color. This is not an unusual way to paint. I see many student paintings with a similar color scheme, and there are also some very fine master paintings done with such cool shadows, such as those of Picasso's harlequin (blue) period. Picasso deliberately used a limited color idea to tell his story, and it worked. But you must make sure you have a good reason for painting cool shadows. Don't just paint them because you're too lazy to think about the needs of your painting or because you're following a simple rule.

CARRIE

watercolor on paper,
22½" × 29" (57 × 74 cm),
private collection.

This model actually had very fair skin and if I'd been literal about painting what I saw, both the lights and the shadows would have been cool. (I overdid the coolness on her torso, though. I made it almost pure cerulean blue.) I really couldn't see any definite warm areas. Even her hair was blue-black. But there was some warmth in the background and to work it into the painting, I decided to put some warm areas on the figure, too. Wherever I saw even a hint of warmth, I "pushed" the color and made it much warmer than I actually saw it. You can see this on the left-hand side of the figure. Notice that I also mixed warm and cool areas within a shadow (such as the one on her hand and right arm) or within one area such as the hair. This is known as "hedging your bets." I also often mix warm and cool versions of a local color. The dark that encircles the arm on the right is an example.

I tried to create some tension in this painting by placing the model at the left so she was looking back into the picture. When you place a model close to the foreground, don't worry about cutting off a section of her figure—though you wouldn't want to crop her at the ankle or wrist. In fact, cropping is a good idea, since one of the most common faults in picture-making is having too much space around the figure.

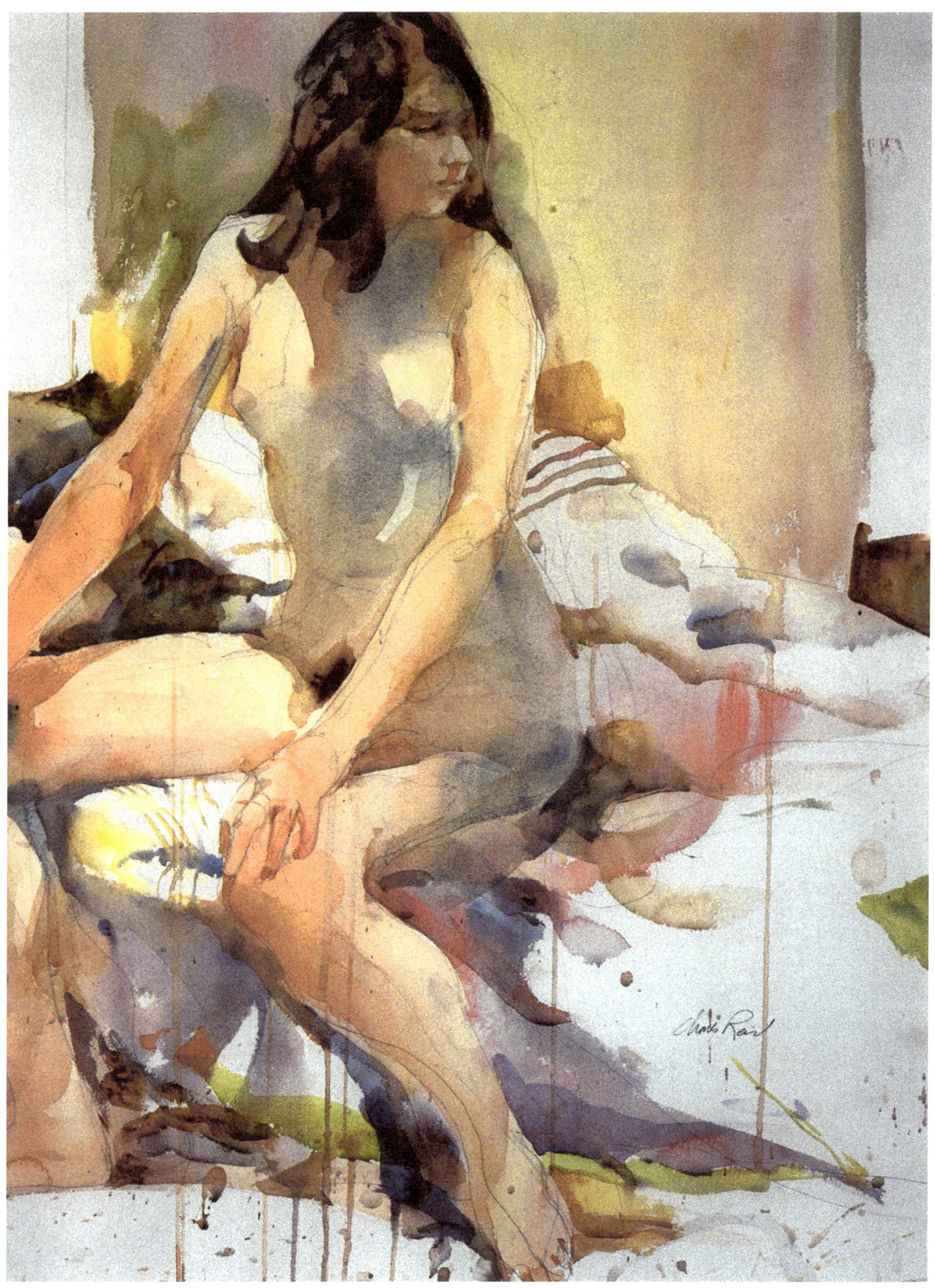

NASHVILLE

watercolor on paper,
22½″ × 30″ (57 × 76 cm),
private collection.

I always treat my models as if they are partners in the project, and I like them to be comfortable. But when I suggested that the model of *Nashville* take an easy pose, she lay down and went to sleep! Her legs were particularly difficult to paint. There was a subtle shadow shape on them that was hard to see because the lighting was diffused. Usually I stress the local color of my subject, but in this case I exaggerated the light and shade on her form so I could emphasize the shadow shape on her body and legs—otherwise they would appear shapeless. Nonetheless, I had a lot of trouble with her upper legs. I had to rub them out several times. Finally, I left them simply stated like this.

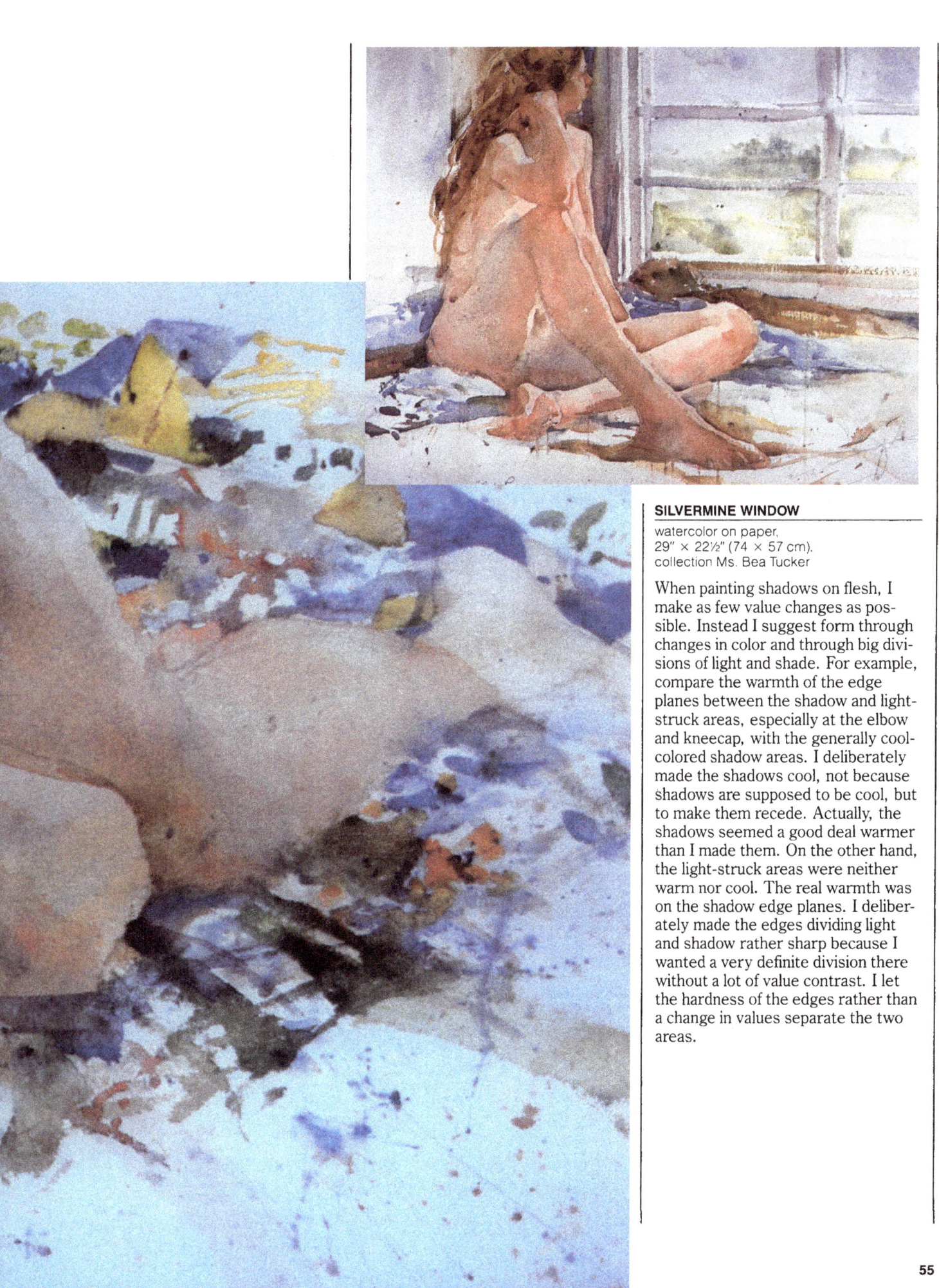

SILVERMINE WINDOW
watercolor on paper,
29″ × 22½″ (74 × 57 cm),
collection Ms. Bea Tucker

When painting shadows on flesh, I make as few value changes as possible. Instead I suggest form through changes in color and through big divisions of light and shade. For example, compare the warmth of the edge planes between the shadow and light-struck areas, especially at the elbow and kneecap, with the generally cool-colored shadow areas. I deliberately made the shadows cool, not because shadows are supposed to be cool, but to make them recede. Actually, the shadows seemed a good deal warmer than I made them. On the other hand, the light-struck areas were neither warm nor cool. The real warmth was on the shadow edge planes. I deliberately made the edges dividing light and shadow rather sharp because I wanted a very definite division there without a lot of value contrast. I let the hardness of the edges rather than a change in values separate the two areas.

STILL LIFE EXAMPLES

I did these two sketches in Minnesota after a day of teaching a workshop. I was surprised that day by my students' concern with subject matter. They seemed to think there was a distinction between painting a figure, flowers, or a landscape. So when I returned to my cabin, I found some objects in the kitchen; added a piece of watercolor paper, a book, and some paint tubes; and arranged them in a set-up. I found these simple things very challenging and very difficult to paint. I was also struck by the fact that the problems the set-up presented were the very same ones I would face in painting a figure or a floral still life.

Notice in the first example that the peppers are slightly different—the one on the right is warmer and the one to the left is cooler. Also, none of the cast shadows are the same color. Notice the warm and cool variations there.

I deliberately included paint tubes in the other set-up. Painting their shiny crinkled forms is marvelous practice. They're hard to draw and you must make them interesting, too. Notice how I showed the wrinkles on the tube without destroying the local value of the metal. Also, notice that each of the gray tubes is a slightly different color either in its local color or in the shadow or cast shadow area.

PAINTING NEGATIVE SHAPES

The term "negative shape" is a difficult one to define. Usually, anything behind or around an object is supposed to be "negative," while the object itself is "positive." But the problem is that "negative" and "positive" are only relative terms. A positive object in relation to one background area can become a negative shape when another object cuts in front of it. Look at how this works in *Rupert's Chair*.

RUPERT'S CHAIR

watercolor on paper,
22″ × 22″ (56 × 56 cm).

I painted this in strong sunlight and so it seemed "washed out" when I brought it into the house. It also seemed a lot better when I was painting it than it seems to me now. This often happens to me. I'm always worried when things seem to be going well and I'm having fun because I'm so often depressed with the finish. It's sometimes better to have your problems and minor disasters early in the painting. They keep you on your toes!

You can see the confusion between negative and positive shapes here, especially in the case of the white and blue cereal bowls. The blue bowl is a positive shape, but it becomes a negative one in relation to the spoon. The flower container is also a positive shape, but it is negative in relation to the white bowl. In the long run, I think it's better to forget what's negative and what's positive and just concentrate on painting the areas around certain objects instead of the object itself.

In this case I didn't touch the white rocker—or the flowers, for that matter—until I had painted the grass. And I had to finish the chair and grass before I could add any of the shadows. I left the deck white until the end because in order to establish its value I had to paint what I hoped was the right value in the grass. Then I painted the deck with a very light wash of alizarin crimson and cadmium yellow with a touch of cadmium orange.

As a general rule, I make my lightest washes warm. Thus, I would rarely use a light blue wash in a very light area without adding to it a bit of cadmium orange with alizarin crimson. (I'd choose alizarin rather than another red because it's so transparent.)

MIXING GRAYS

Certain color areas always seem to present a problem—for example, mixing good fleshtones, putting enough variety into summer greens, making grays interesting, or getting darks to look colorful. The next few lessons will therefore be devoted to mixing difficult colors. I'll show you swatches of the mixtures I use, both in oil and watercolor (since the color looks a bit different in each medium), and I'll show you how these mixtures work in actual paintings.

Before I discuss specific mixtures, I want to stress the fact that the color I end up with is as much the result of the *proportions* of colors in the mixture as the specific colors there. So try to train your eye to see proportions, too.

GENERAL ADVICE ON MIXING OILS

When you mix your oil colors, I suggest that you use a brush and blend them on the palette. Use only small amounts of each color until you get the right mixture. (Of course, you'll have larger amounts of fresh colors around the edges of the palette, but you'll only take small dabs of them for mixing.) Be sure to clean your brush in turpentine or mineral spirits before touching another color or you will dirty it. Also, never squeeze your tubed colors into the middle of the palette. Arrange them in an orderly fashion around the edges. And put *all* your colors out—not just the ones you think you'll use.

I think that the fact that I use a brush rather than a knife to mix colors probably has a lot to do with my particular style of painting—I like the broken color of the Impressionists and post-Impressionists. I also think that students waste a lot of paint when they mix it with a knife. But if you like working in broad areas of flat color, you may find a knife preferable. It's up to you.

OIL PAINT SWATCHES

I used the following color mixtures:

 a. Sap green,
 cadmium red light,
 titanium white.

 b. Viridian,
 alizarin crimson,
 titanium white.

 c. Sap green,
 burnt sienna,
 titanium white.

 d. Ultramarine blue,
 cadmium orange,
 titanium white.

 e. Cerulean blue,
 cadmium orange,
 titanium white.

 f. Phthalo blue,
 alizarin crimson,
 cadmium lemon.

 g. Ultramarine blue,
 alizarin crimson,
 yellow ochre.

 h. Cobalt blue,
 burnt umber.

 i. Ultramarine blue,
 raw umber,
 titanium white.

Of course, these are only some of the combinations I use. I also mix cool complements like viridian or phthalo blue and alizarin crimson along with a cool cadmium lemon for cool colors, and I use warm complements like sap

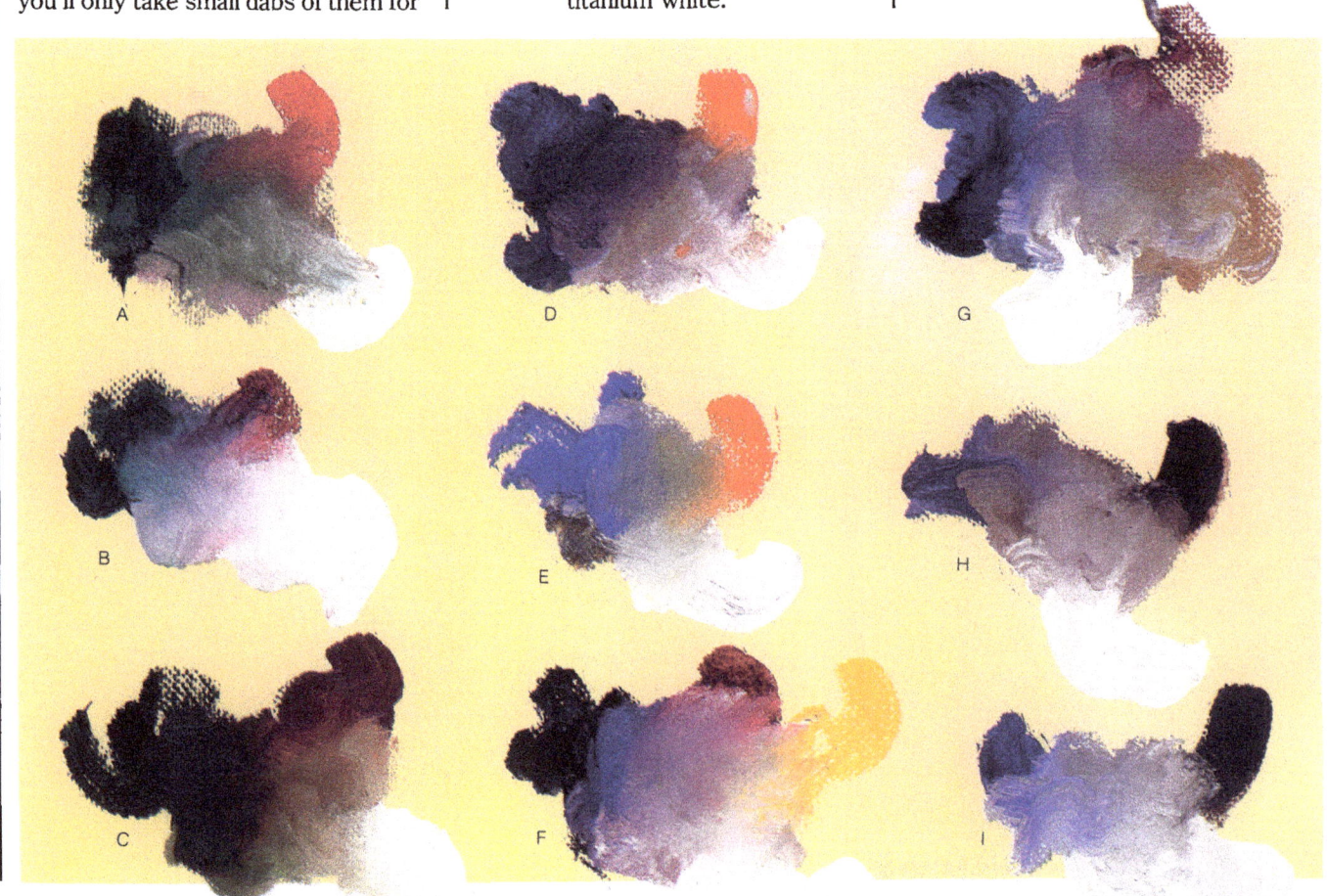

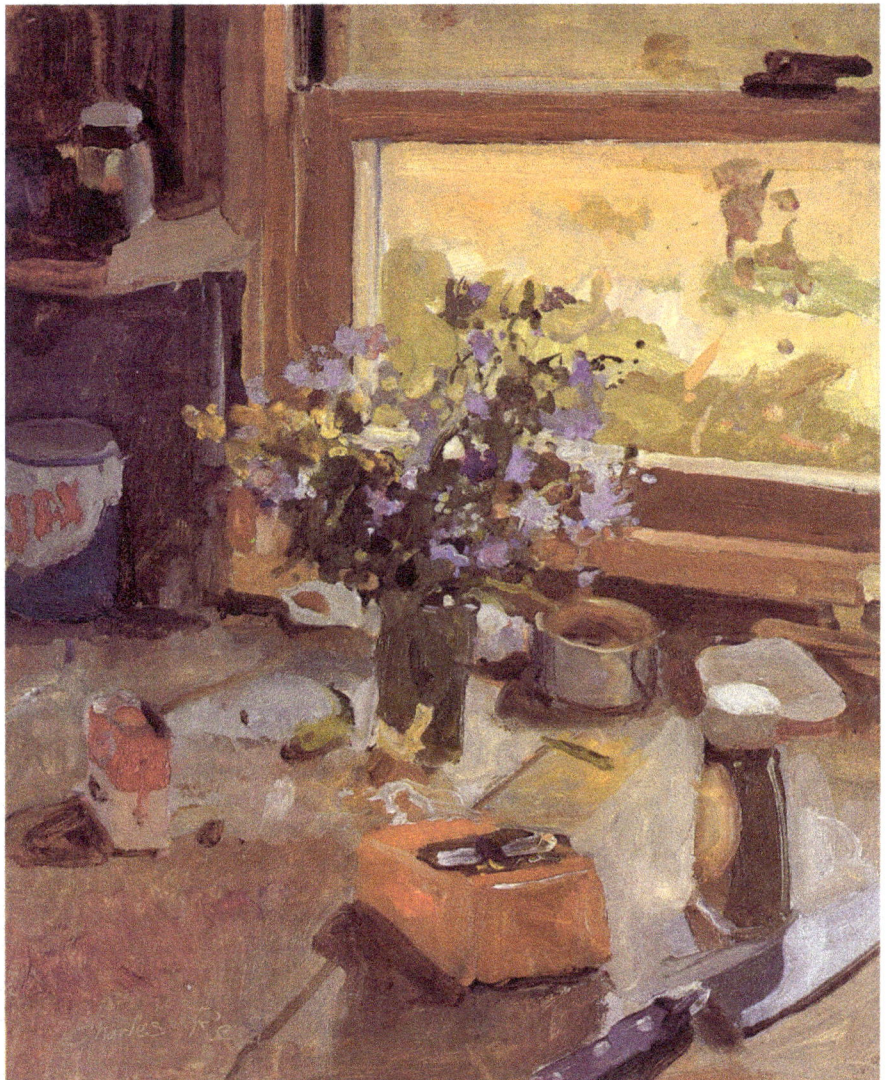

FIELD FLOWERS AND CHEDDAR
oil on board,
24″ × 20″ (61 × 51 cm),
collection Judith Reid.

I tried to treat each area here as a more neutralized version of the color I actually saw. Because there are so many grays there, the reds, yellows, and blues look intense. Yet they've also been "cut." I added a bit of white and cerulean to the reds and some raw umber and white to the ultramarine blue.

Although mixing complementary colors is the usual way to make grays, there were so many earth tones here that I didn't need to use too many complements. (The earth colors are already grayed, and so, while I normally add cerulean blue to my mixtures, I used it in very small amounts here.) The cheese was a mixture of yellow ochre, white, and raw sienna mixed with cadmium orange for the more intense color. The countertop contained varying proportions of most of the colors in the painting: alizarin, cobalt blue, cerulean, cadmium orange, titanium white, cadmium lemon, yellow ochre, and raw umber.

Study the painting and see where you can find hints of the colors I've mentioned. Alizarin, for example, is apparent on the lower left. And there is some raw umber lightened with white there, too. The shadow under the cheese looks like raw umber with a bit of alizarin and a touch of white. Notice that the white doesn't take over. Each area has a different color feeling—there are only a few areas that don't remind you of a color. And remember, grays should never be gray. They should be a color that's rich even though it's subdued.

It's hard to reconstruct how I mix my colors, but in general I use earth complements such as yellow ochre or raw sienna for my yellow when I mix it with alizarin and cerulean blue. I might also use burnt sienna with a little cadmium red and lighten it with yellow ochre or raw sienna. The herb jar on the lower right was ivory black, cadmium lemon, yellow ochre, and titanium white. My outdoor greens are cadmium lemon, permanent green light, cadmium orange, alizarin crimson, cerulean blue, and titanium white. The purple flowers are alizarin, cerulean, and white; with leaves of permanent green, cadmium lemon, cerulean, and yellow ochre.

green or ultramarine blue and cadmium orange for warm mixtures. You must begin to become aware of the relative warmth and coolness of colors within the same color family. For example, all blues are cool, but phthalo and cerulean blues tend to be cool blues, while ultramarine blue is warmer. Alizarin crimson is a cool member of the red family, and cadmium lemon is cooler than cadmium yellow light. Of course, you don't have to mix only cool complements. You can intermix warm and cool complements, too. For example, swatch c is a cool cerulean blue and a warm cadmium orange.

Look at the swatches and see which combinations tend to be warm and which ones are cool. Notice that within each swatch there are warm areas as well as cool ones, depending upon the color that dominates the mixture there.

LESSONS FROM PAINT SWATCHES

Swatches like these, I think, look lovely in themselves. I guess it's the pure color seen next to the partially blended color, together with the resulting gray—all in one miniature "color-field" painting.

These color swatches will teach you two things. The first is that a combination of pure color against more neutral color suggests a richness that wouldn't be possible with a combination of colors of equal intensity. The second lesson is that partially mixed colors are often more interesting than thoroughly mixed color, which is why I mix most of my colors (both oil and watercolor) right on the painting surface. Of course, I also mix my colors on my palette. But I never completely blend it. You can always see the individual colors that have gone into a particular mixture.

GENERAL ADVICE ON MIXING WATERCOLOR SWATCHES

There are several things to keep in mind when you mix your watercolor swatches. First, try not to overblend your colors. Leave the swatch alone, even if it doesn't look right, and allow it to dry before judging it. Also, don't use too much water or your colors will lack richness. Finally, make several swatches at a time—maybe groups of four, as I have—going directly from one to another without fussing over them. When you've done a batch, drop your brush and stop for a cup of coffee or a beer while the swatches dry. Then come back and evaluate your work.

If they don't look right, try to analyze where they're off. Are they too watery? Then use less water next time. Are some of the colors not blending well with the others? Make a note of which ones and see if you can substitute other colors for them. Cerulean blue, for instance, can be a problem if the brand of paint you're using is too opaque. Winsor & Newton's cerulean blue is always good, so you can switch to that. Or try cobalt or phthalo blue instead in mixtures (or do both).

The main idea is to get to know the right ratio of water to pigment for just the right consistency of paint, and that simply takes lots and lots of practice. But if you're willing to put in the time, you'll be okay. So if you're having trouble with the blue or green part of the mixture, try using the red-yellow or yellow ochre part alone. Then, only after you can make a decent, simplified swatch of the red-yellows, should you add the blue or green. You have to get the feel of the right consistency first.

Here are the watercolor combinations I use most often in mixing grays:

 a. Alizarin crimson, phthalo blue, cadmium lemon.

 b. Cadmium red, viridian.

 c. Cadmium orange, cerulean blue.

 d. Cerulean blue, yellow ochre, alizarin crimson.

 e. Ultramarine blue, cadmium red, raw sienna.

 f. Phthalo blue, burnt sienna, yellow ochre.

I rarely use black, Paynes gray, or Davies gray to make gray. I do love black, however, and sometimes use it in a mixture along with burnt sienna and perhaps a dark blue, but I wouldn't mix it with water to make a gray because it would lack interest. Of course, if you like black or Paynes gray and want to use them, that's fine. I'm sure they have their merits.

My mixtures are rather simple, but I can make just about any gray (warm or cool) I want from these colors. Notice that each swatch contains both warm and cool areas—warmer next to the warm master color and cooler next to the cool master color. Some combinations are also basically warmer than others—such as the cadmium red and viridian mixture. Had I used sap green instead of the viridian, which I sometimes do, the swatch would have been even warmer. On the other hand, other combinations—for example, alizarin crimson, phthalo blue, or cerulean mixed with cadmium lemon—tend to make cooler mixtures overall. The point is, when mixing grays, always feel free to interchange any of these colors. Just make sure they're complements. If you don't mix complements or near complements, you won't get a gray.

WILD ROSES

watercolor on paper,
24" × 24" (61 × 61 cm),
collection Marworth, Waverly, Pa.

The objects on the white table were painted in the morning sun. I wanted to keep everything high in key, so I decided to lighten the shadow shapes and try to give the picture substance (weight) through the notes of color in the carrots, cup, scissors, and other objects, instead of stressing the darks. (I usually prefer to stress color rather than value contrasts.) To do this, I made the shadow shapes into a color idea—that is, I wanted to stress the warmth or coolness of the shadows and the specific hue that I saw rather than describe the generalized dark shapes there.

In choosing a shadow color, I'm governed by two factors: the color the shadow actually suggests and the color I need in my painting. All the shadows here were painted with the same colors, though I used a bit more of the combination in some spots than in others. The basic mixture was alizarin crimson with phthalo and cerulean blues. Those two blues seem to be the best mixing blues in watercolor, but of course this is purely a personal reaction. I seem to interchange the phthalo blue and the cerulean depending on the value and intensity I want. The cerulean is much lighter, less intense, and less obtrusive—but it is opaque. The phthalo blue, on the other hand, is transparent and, diluted with water, it makes a lovely, transparent crystal blue.

I usually use cadmium yellow pale as a complement to the blues, but I also use cadmium orange and cadmium yellow light at times. I'm not really conscious of when I use which yellow. It really depends on whether I want a more impressive yellow or a weaker one. The cadmium yellow light is certainly more dominant than the pale. (I never use earth colors in mixing light grays—they don't have any power in light washes.)

To introduce color variety into each shadow shape, I vary the proportion of the mixtures. For example, I made the rim on the plate at the right-central area a cool purple (alizarin and cerulean), then switched to a warmer gray (adding some cadmium orange to the alizarin) at the base of the plate. If you look at each of the shadow shapes, you'll see where the alizarin dominates, where the blue takes over, and where the complement comes in. The important point is that you can get a variety of color with the same basic combination of primaries.

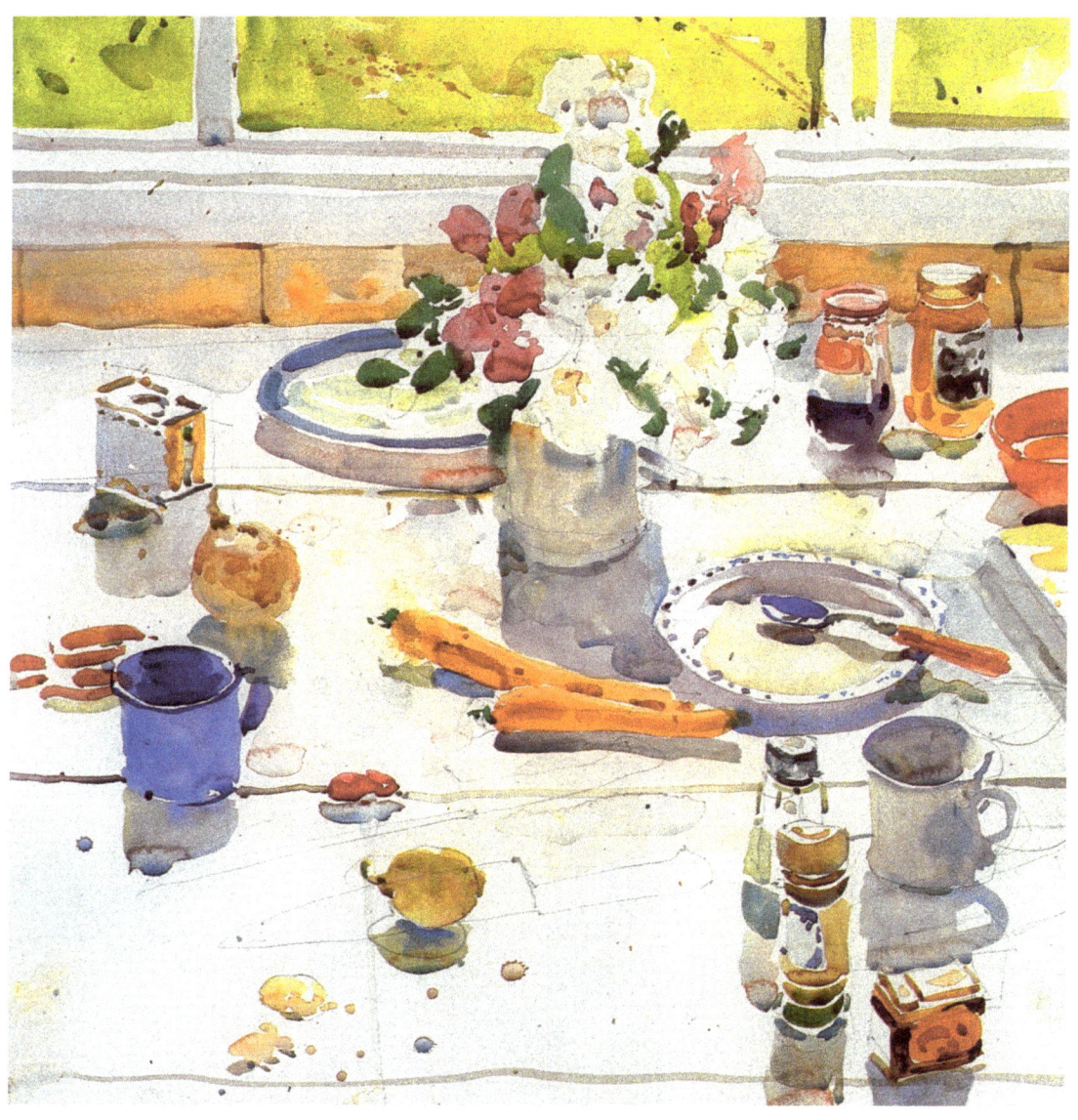

MIXING GREENS

Perhaps because I paint mostly figures and still lifes where greens are limited, I find green the hardest color to mix, and those of you who have done a good deal of landscape work should find this section very elementary. Sometimes I don't think there's any such color as green. Right now, I'm looking at a leaf outside my window and, as I stare at it, I'm reminded of other colors—purple blue-grays in the distant trees and cool, milky grays in the bush I'm watching. Indeed, I do see some definite greens in some of the light-struck areas, but certainly painting the entire bush "green" wouldn't be the answer. That's why experimentation—and that is the point of this section—is so essential.

OIL PAINT SWATCHES

I have set up a chart showing my mixtures in oil paint. They range from the obvious green-yellow blends, through blue-yellow mixtures, to more complicated combinations involving the addition of a complement with white. These are the mixtures I use:

a. Permanent green light, cadmium lemon (cool).

b. Permanent green light, cadmium yellow light (warmer).

c. Sap green, cadmium yellow (still warmer).

d. Viridian, cadmium lemon (cooler).

e. Cerulean blue, cadmium lemon (cool).

f. Ultramarine blue, cadmium yellow light (warmer).

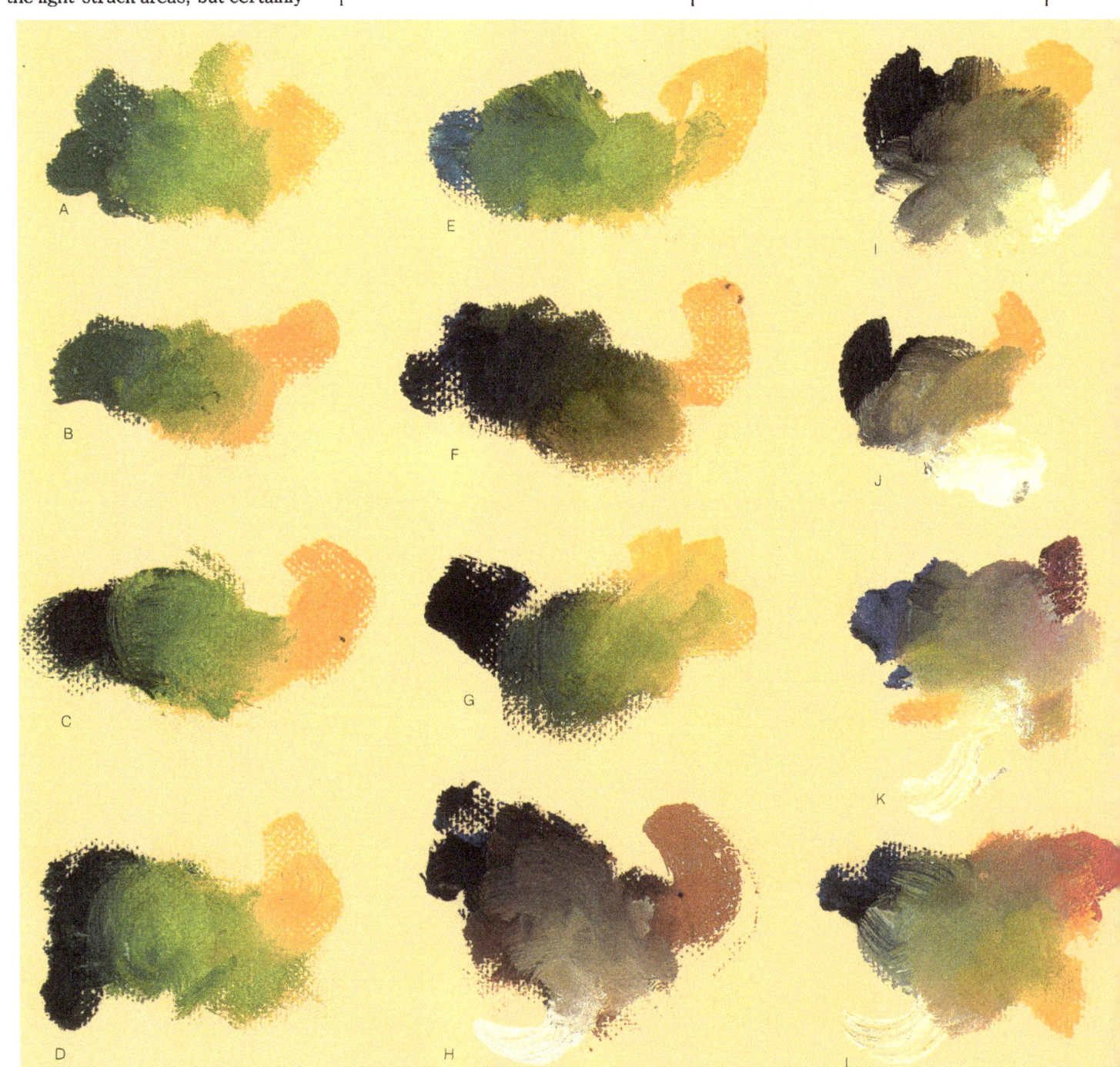

g. Phthalo blue,
 cadmium lemon (cool).

h. Ultramarine blue,
 yellow ochre
 (warm and neutral).

i. Ivory black,
 cadmium lemon
 (cool and neutral).

j. Ivory black,
 cadmium yellow light
 (warm and neutral).

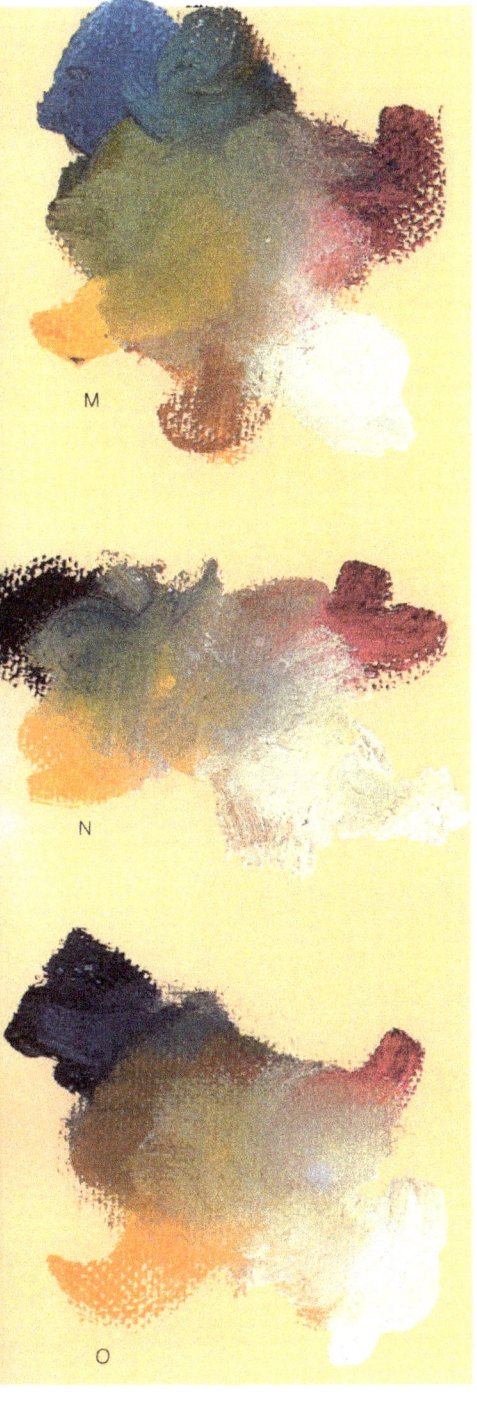

k. Cobalt blue,
 alizarin crimson,
 cadmium lemon,
 titanium white
 (mellow, somewhat cool).

l. Ultramarine blue,
 cadmium red,
 cadmium yellow light
 (warmer and a bit harsh.
 I find cadmium red more difficult to
 mix than alizarin crimson for darks.
 And phthalo blue seems easier to
 use in mixtures than ultramarine
 blue—it seems cleaner. The reason
 is probably that phthalo blue and
 alizarin crimson are both trans-
 parent colors).

m. Cerulean blue,
 alizarin crimson,
 cadmium lemon,
 yellow ochre.
 (The ochre is more to experiment
 with than be one of my regular
 mixtures. I'd probably leave it out
 as a rule, since it adds an opaque
 heaviness to an otherwise nice
 combination.)

n. Phthalo blue,
 alizarin crimson,
 cadmium lemon,
 titanium white.
 (These colors are good, clean mix-
 ers, though you might try a cad-
 mium yellow in place of the
 cadmium lemon.)

o. Ultramarine blue,
 alizarin crimson,
 cadmium yellow light.
 (Because of the warmer yellow and
 blue, this combination tends toward
 a warmer green.)

When you make your own swatches, you can experiment by subsitituting several yellows for the one I suggest. Don't worry too much about what they're called. Just notice whether they're warm or cool, and whether they appear to be real or dominate a mixture. Naturally this applies to all colors, not only yellow. Every company has different formulas for their colors, just as they have different numbers for their brushes. So one company's cadmium red might look almost like an orange, while another company's might look more like the cooler vermilion red. Yellows especially seem to vary a lot. As for blues, Grumbacher's cerulean blue is

very opaque, while Winsor & Newton's cerulean is much more transparent—and, may I add, much better!

WARM AND COOL GREENS

When you mix greens, you must be aware of which of your tubed colors are warm and which ones are cool. Naturally it would make sense in mixing warm greens, for example, to start with a set of warm yellows and warm greens, and in mixing cool greens, to start with cool colors. To show you what I mean, let's look at the swatches.

Swatches a-d were mixed only with warm and cool versions of green and yellow. Swatches e-h were mixed with warm and cool blues and yellows. (Of course all blues are cool, but some are relatively warmer than others.) Swatches i and j were mixed with ivory black and yellow. I deliberately omitted white from all these mixtures since white cuts the intensity of the color. Also, I think you should first see how the mixtures look with pure color before lightening or otherwise changing the mixture.

The rest of the mixtures, swatches k-o, consisted of three colors plus white. I think it's safe to say that this final grouping makes the most interesting color combinations. Notice that within each of the three-color mixtures there are possibilities for both warm and cool greens, depending on the amount of yellow. The white lightens the mixture as well as making it more neutral. Of course, these mixtures represent only a few of the possibilities. You can find many more by interchanging the colors or trying other colors and combinations that might work even better for you. So don't look at these swatches as "rules for painting greens." See them as tools to help you start experimenting. Never feel you must always use a certain yellow or a certain green or blue.

As in any mixing situation, you must get to know which colors dominate in a mixture and which colors are weak. A little bit of cadmium yellow, for instance, goes a long way. And since cerulean blue is a comparatively weak color, when you mix the two, you'll need to add more cerulean blue and only a little bit of the cadmium yellow to make a green.

LOOKING FOR SAM

oil on canvas,
14" x 14" (36 x 36 cm),
collection Judith Reid.

The typical morning mist in Nova Scotia suggested very muted greens to me. I had just cut the lawn with a scythe and the cut grass had turned to ochre. It's always hard for me to remember the specific colors I use, but I would think that the greens here were mixed with cerulean, cadmium lemon, alizarin, permanent green light or cadmium green light, and titanium white. The cut grass contains varying amounts of cadmium orange, yellow ochre, cadmium lemon, cerulean, and white. Again, I'm not sure that the specific colors matter. What does interest me is how well the rather neutral blue-greens work. I wish I could always get this look, but it usually eludes me.

AUDI
oil on panel,
24" x 24" (61 x 61 cm),
collection Mrs. Charles Hendrickson.

I painted this on an untempered Masonite panel primed with a polymer *gesso*. Because this surface is slippery, you can't use too much medium. In fact, looking at it now, I think that I probably didn't add any medium to it at all. The paint was used in the

consistency right from the tube.

The painting *Audi* was done in the fall, which is a nice time for me to make a painting of my yard. Normally, in summer, it resembles a tropical rain forest and the abundance of green destroys me. But because it was fall, I tried to combine almost equal areas of warm and cool color in the grass and trees. Try to envision this painting without these warm ochres and yellows. On the other hand, the cool,

distant trees act as a nice relief to the warm yellows and cooler greens. I couldn't begin to analyze this painting in terms of the actual colors I used, but I tried to vary the greens within small areas, introducing more cerulean blue in some places and more cadmium green light in others. The shadows contain a good deal of ivory black mixed with cadmium lemon.

WATERCOLOR SWATCHES

In painting these watercolor swatches, I've deliberately omitted tube greens mixed with yellow or used alone because they're obvious solutions and are probably not very satisfactory. For me, the answer is variety—using some tube greens, but also using warm and cool grays. On the other hand, Neil Welliver, an artist I admire, paints all his greens in what seems to be the same cool, almost neutral color—sort of a viridian with a little white. It sounds terrible, but he can paint about a thousand trees in one painting with this color and it looks great. Actually, his values are so perfect that it doesn't matter what color he uses. It all comes down to *how* you do something—not the color or brush or paper you use. Sad, but true.

The greens in these swatches are made with the colors I normally use in my palette. As in all of the swatches in this book, I'm never rigid about interchanging colors from various combinations I've shown. In general, for mixing, I find alizarin, cadmium lemon or cadmium yellow light, cerulean, and phthalo blue are the easiest colors to blend. Cadmium red, cadmium yellow medium, and ultramarine blue, on the other hand, are a bit more difficult to mix. This isn't a rule, just an observation. Experiment with these mixtures, try others you can think of, and then make up your own mind about mixing greens and the way the colors behave in mixtures.

Here are the combinations of colors I used to make greens in watercolor:

a. Cerulean blue,
 cadmium lemon.

b. Ultramarine blue,
 cadmium lemon.

c. Phthalo blue,
 cadmium lemon.

d. Cerulean blue,
 cadmium yellow medium.

e. Ultramarine blue,
 cadmium yellow medium.

f. Phthalo blue,
 cadmium yellow medium.

g. Cerulean blue,
 cadmium lemon,
 alizarin crimson.

h. Ultramarine blue,
 cadmium red,
 yellow ochre.

i. Phthalo blue,
 cadmium lemon,
 alizarin crimson.

(*Note:* Cadmium yellow and cadmium yellow medium can be the same color, depending upon the brand you use. As with many colors, you'll have to look at what's in the tube—not what's on the label!)

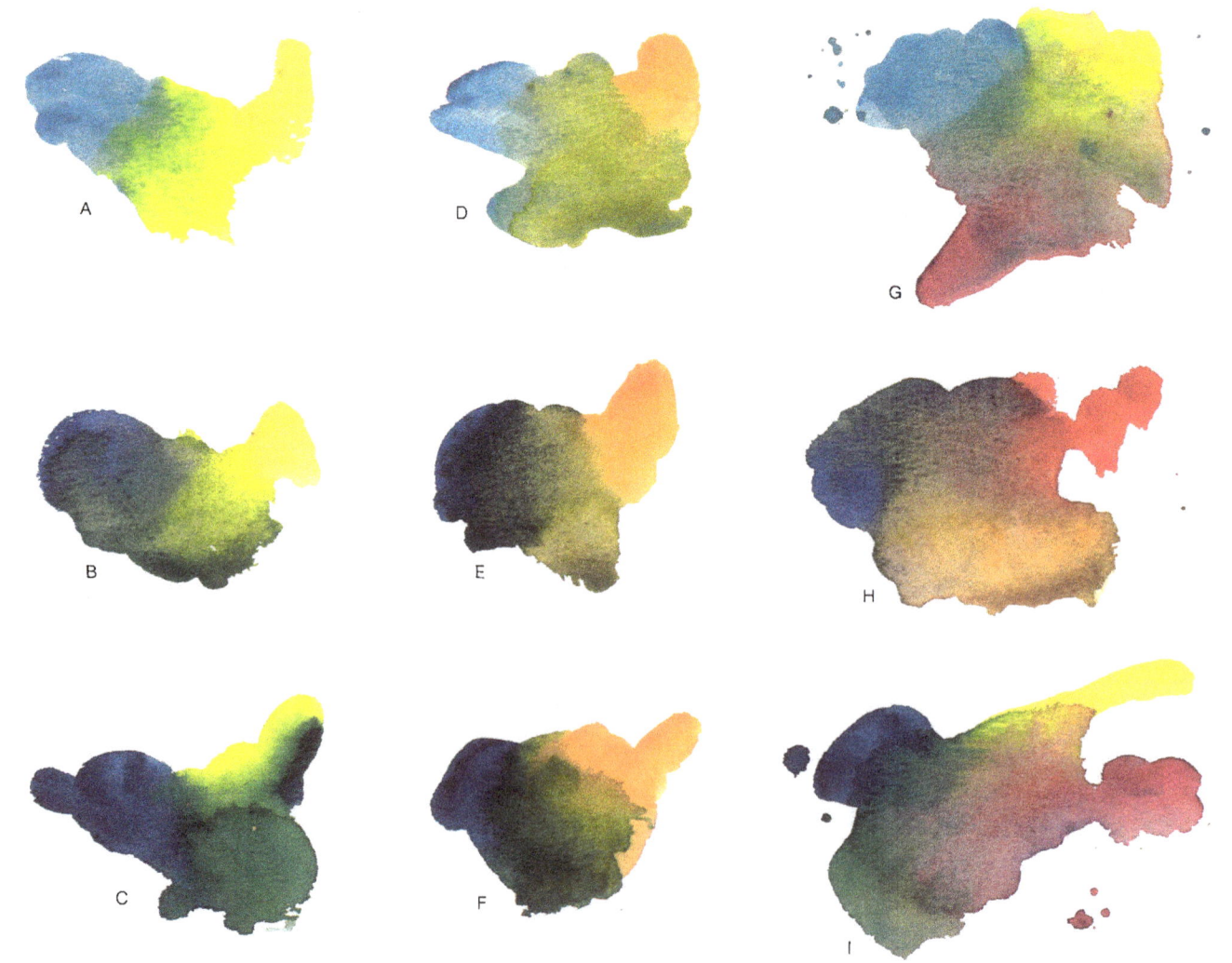

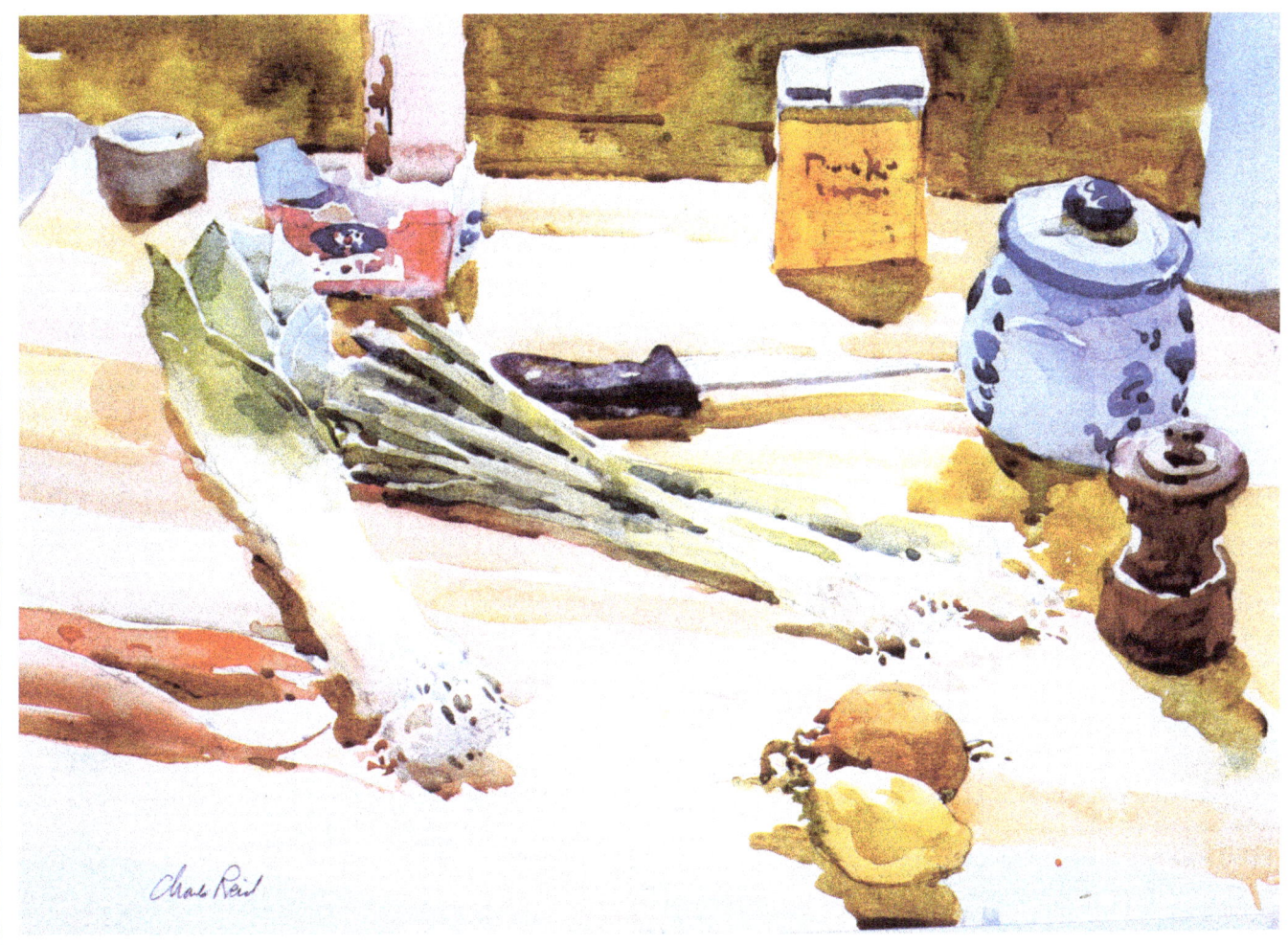

LEEKS AND SCALLIONS

*watercolor on paper,
16" x 12" (41 x 30 cm),
private collection.*

Vegetables are fun and excellent practice to paint. Their hues are bright, and you can often paint them with colors right out of the tube. I used pure cadmium orange on the end of the top carrot here (notice the intensity of the color), then added some cerulean blue to the orange on my palette and painted the rest of the carrots. I deliberately dulled the orange so the carrots wouldn't detract from the delicate, cool greens of the leeks and scallions.

I usually use the same colors in both light and shadow, using less water when I want a darker value. However, I sometimes add a darker color from the same color family when I need a really dark value. In this case, I used cerulean blue and cadmium yellow for the greens, using less water for the darks—though I might have also added a touch of cobalt blue, too. I painted the shadows and cast shadows wet-in-wet with the same color, making them one connected shape. I added the darks in the leek greens wet-in-wet too, but I put the shadows on the scallions wet-over-dry. There was no particular reason for doing this—I just felt like it at the time.

MIXING LIGHTS

Pure white or a cool white often appears less white than white paint with a touch of warmth. So if a white looks dead, a touch of cadmium orange will give it life. Even if the area is cool, if you really need a light light, add a touch of warmth to the white.

Look at my swatches and note the large proportion of white pigment there compared to the small amounts of strong colors like cadmium orange, cadmium red, and alizarin.

MIXING WARM LIGHTS IN OIL

To mix warm lights, always start with white, then add the smallest touch of color to it. If you add too much of a strong color like cadmium orange, for example, you'll just end up wasting a lot of white paint to get the white you want. If this should happen, rather than try to add more white to the mixture, just start a fresh pile of color—but this time take less cadmium orange, or add a touch of the first mixture instead of the pure color to the white paint.

My swatches are just examples of the colors you can add to white and still have it read as "white." I expect you to interchange the colors I use in your own swatches and try adding other pigments that might work better for you. Here are my suggestions:

 a. Titanium white,
 cadmium lemon,
 cadmium orange.

 b. Titanium white,
 cadmium yellow light,
 cadmium lemon,
 alizarin crimson.

 c. Titanium white,
 cadmium lemon,
 cadmium yellow light,
 cadmium red.

 d. Titanium white,
 cadmium lemon,
 alizarin crimson,
 cadmium orange,
 cerulean blue.

Sometimes adding only one warm color to white is enough. You don't have to add several colors—it all depends on what you want. On the other hand, the last swatch is a nice combination of colors that suggest both warm and cool tones. Try this one without orange, too.

Here are some ideas for mixing cool lights:

 a. Titanium white,
 cerulean blue,
 alizarin crimson.

 b. Titanium white,
 ultramarine blue,
 alizarin crimson.

 c. Titanium white,
 phthalo blue,
 alizarin crimson,
 cadmium lemon.

 d. Titanium white,
 cerulean blue,
 alizarin crimson,
 cadmium orange.

Also try the last two examples without the respective complements, yellow and orange. These colors add a nice mellow quality to the white, but they also neutralize the color. (For example, swatch a is the same as swatch d, but without the orange).

In making your swatches, try not to overmix your colors. Keep the color identity of individual hues visible in some areas of the swatches, along with a small area of completely blended color.

FRIENDS

oil on canvas,
50" × 50" (127 × 127 cm),
collection Smith College,
Northampton, Mass.

Friends started as a painting of a young woman seated in front of a dresser. I was nearly finished when I realized that something wasn't right—the painting seemed empty and meaningless. So I scraped whatever paint I could from the dresser and decided to add another figure to the painting. A young man happened to be passing by my studio and agreed to pose.

Except for seeing each other in the painting as I was working, the two people had never met. Oddly enough, despite this, people have noted a connection—or the lack of it—between the two that has added interest and

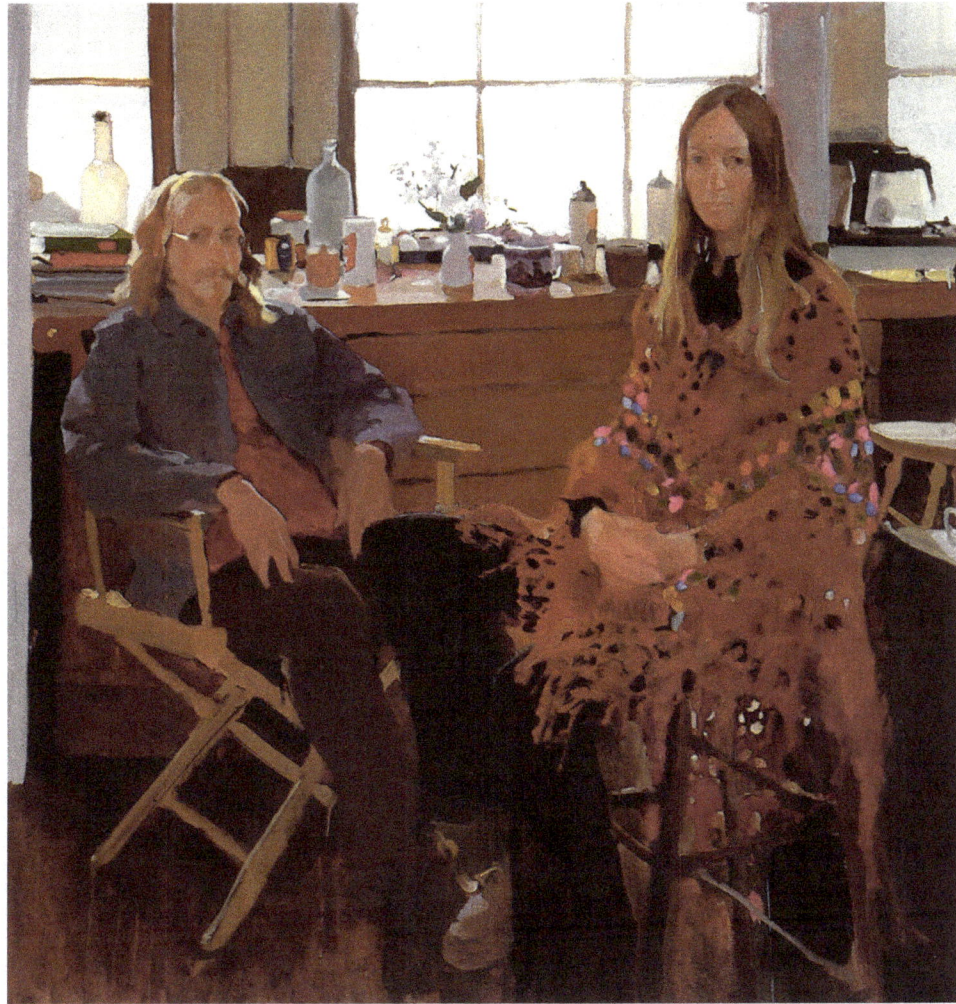

some tension to the work. And someone even commented, "I can see that they're not getting along!"

I established the color scheme early—I was using Indian red at the time, and this is a dominant color. I tempered it with raw sienna, yellow ochre, and viridian (I wasn't using sap green then). I spent a long time deciding the color of the windows. I ended up making them a cool white with alizarin, a little cadmium lemon, and cerulean blue because I needed a cool white to balance the young man's jacket. The jacket was basically cool, but I added some yellow ochre to the cool gray mixture to tie it in with the rest of the surroundings, which were warm.

The young woman's trousers are a

dark blue mixed with ultramarine blue and alizarin. I didn't want them too dark, so I added some cerulean or cobalt blue to the mixture to lighten it. I try never to add white to very dark colors (see the next section on mixing darks). Instead I look for a color in the same family that will lighten it at the same time. In the same vein, I lightened the shawl with yellow ochre (not white). But I did add white to lighten the gray jacket because white was already in the gray and adding more wouldn't damage the color. In short, the main idea is to use a specific color (not white) to lighten any dark area that has a definite color idea. Since white tends to neutralize color, add it only to a neutral or gray area.

WATERCOLOR SWATCHES

I aim for warmth in my lightest lights in both oil and watercolor because cool lights can look pasty, weak, and dull. Therefore, even on a cool object, I often cheat and add some warmth to the very lightest areas.

Here are two swatches made with both warm and cool colors. Study them, especially where the various colors merge. The washed-out areas of cerulean blue in swatch a, for example, remind me of a typical dull, cool light.

a. Cerulean blue,
 alizarin crimson,
 cadmium lemon,
 cadmium yellow.
 (Phthalo blue could be substituted for the cerulean blue if handled with skill and used in moderation.)

b. Cadmium red,
 cerulean or phthalo blue,
 cadmium yellow.

Remember to make a whole group of swatches, working around and toward the center. Allow the colors to blend together with as little brushing as possible. Avoid correcting, lifting out, or blotting your colors. You must get used to seeing what wet-in-wet does on its own.

JOHN AT SILVERMINE

watercolor on paper,
22½" × 26" (57 × 66 cm),
private collection.

My watercolor class meets once a week and individuals there take turns providing the set-ups. The idea here was to suggest a 1920s-type man sitting in a garden in the sun. The painting was done in the studio under a bright spotlight. Since I wanted to convey the idea of strong sunlight, I stressed the light and shade in the face. But notice how light I made the shadows there.

On the other hand, I didn't want to show any significant light and shade on the figure. Instead I stressed local color-value there. Notice that the stripes in his shirt are "found" in the light and "lost" on the shadow side, where detail tends to disappear. The contrast between the blue stripes and the white shirt brings his shoulder forward and suggests a presence. I also painted his trousers in local color, without light and shade, because I wanted a rich, dark value there to act as a contrast to the white shirt. Had I made the trousers as light as I actually saw them (they were under a strong spotlight), I would have lost the effect of the white shirt.

MIXING DARKS

I like to stress color in my darks. In fact, I think that a "color" feeling is more improtant than a "value" feeling. Even if a good, rich dark is a value or two lighter than a monochromatic dark (a neutral dark of no particular color), the slightly lighter but more colorful dark will appear deeper and richer. Darks need to have a feeling of luminosity and atmosphere, and getting some color into them is the best way to achieve this.

You probably have a number of dark colors on your palette—Prussian blue, sepia, and Paynes gray are the three common ones in watercolor. Don't be afraid to use them. In fact, you should get used to using them, so that when you need one you feel comfortable using it and know how it behaves both alone and in mixtures.

WATERCOLOR SWATCHES

Here are the mixtures I used to get darks in my watercolor swatches:

a. Ultramarine blue,
 alizarin crimson.

b. Phthalo blue,
 alizarin crimson,
 burnt sienna.

c. Viridian (left) or
 sap green (top),
 cadmium red.

d. Ultramarine blue,
 burnt sienna (top right)
 or burnt umber (lower right).

e. Ivory black,
 viridian,
 burnt sienna.

There are also other alternatives. For example, Paynes gray mixes beautifully with burnt sienna. These darks are also better in mixtures with a dark complement than used out of the tube with just water.

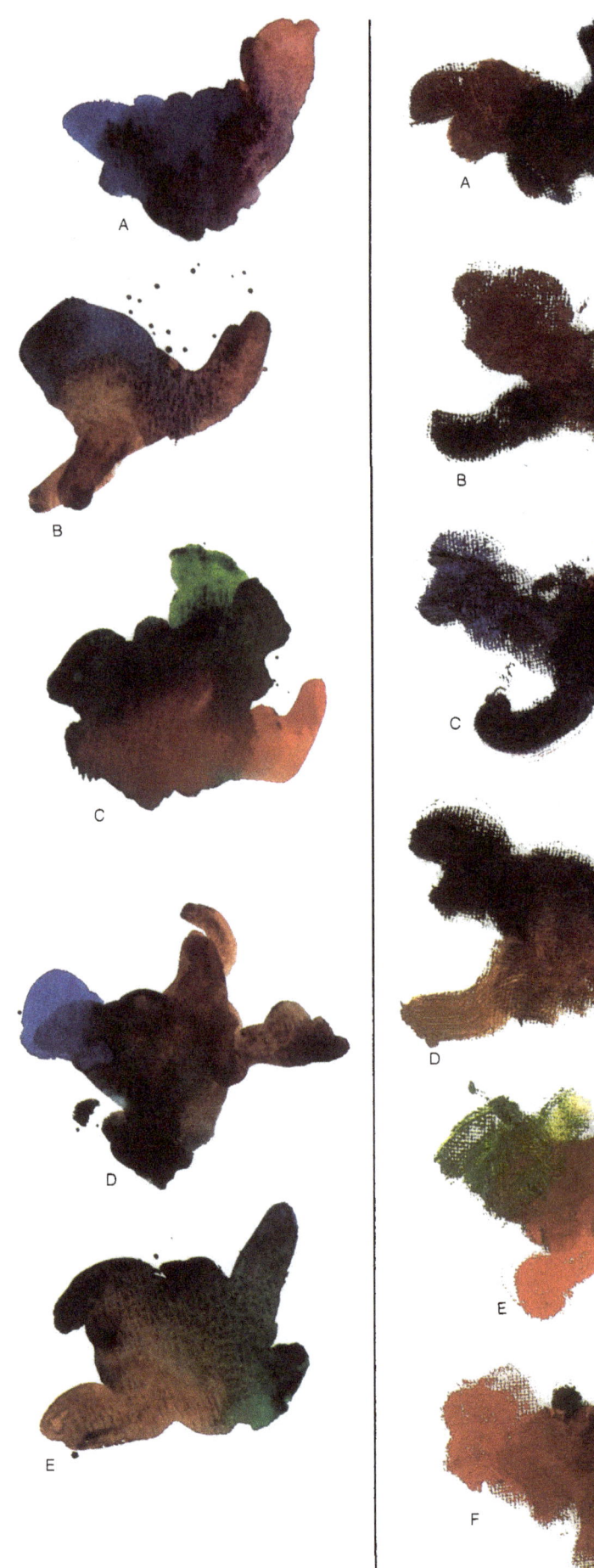

OIL PAINT SWATCHES

When I want a "color" dark, I might use one of the combinations listed below. Many of these colors can be interchanged, so try these mixtures first, then experiment by switching the individual colors around.

a. Burnt sienna,
 ultramarine blue
 or phthalo blue.

b. Burnt sienna,
 viridian,
 burnt umber.

c. Alizarin crimson,
 ultramarine blue
 or phthalo blue.

d. Ivory black,
 burnt or raw umber,
 burnt sienna,
 raw sienna.
 (You can also mix phthalo blue or ultramarine blue or viridian with the ivory black.)

e. For lighter darks:
 cadmium red,
 permanent green or
 permanent green light.

f. Cadmium red,
 viridian.

When I want a dark dark but I don't want a color, I use ivory black. It might be necessary to do this, for example, when a painting is filled with color and I need a dark—and a pure black (rather than a mixed black) can be just the right touch. This is a little hard to explain, but if you look at paintings by Manet or Gauguin I think you'll understand what I mean.

LIGHTENING DARKS

In oil, I lighten my darks with a warm color, not white. Actually, I try to use white as little as possible to lighten middle and dark values because it makes them muddy and heavy-looking. Naturally I use white for light values, but even then I try to make sure each light area contains a "color idea"—a slant toward a particular color. I rarely use white alone, but add a touch of cadmium yellow or orange to even the lightest lights to give them some spunk. Naturally white is necessary for lightening colors. It just shouldn't be the *only* way to lighten them.

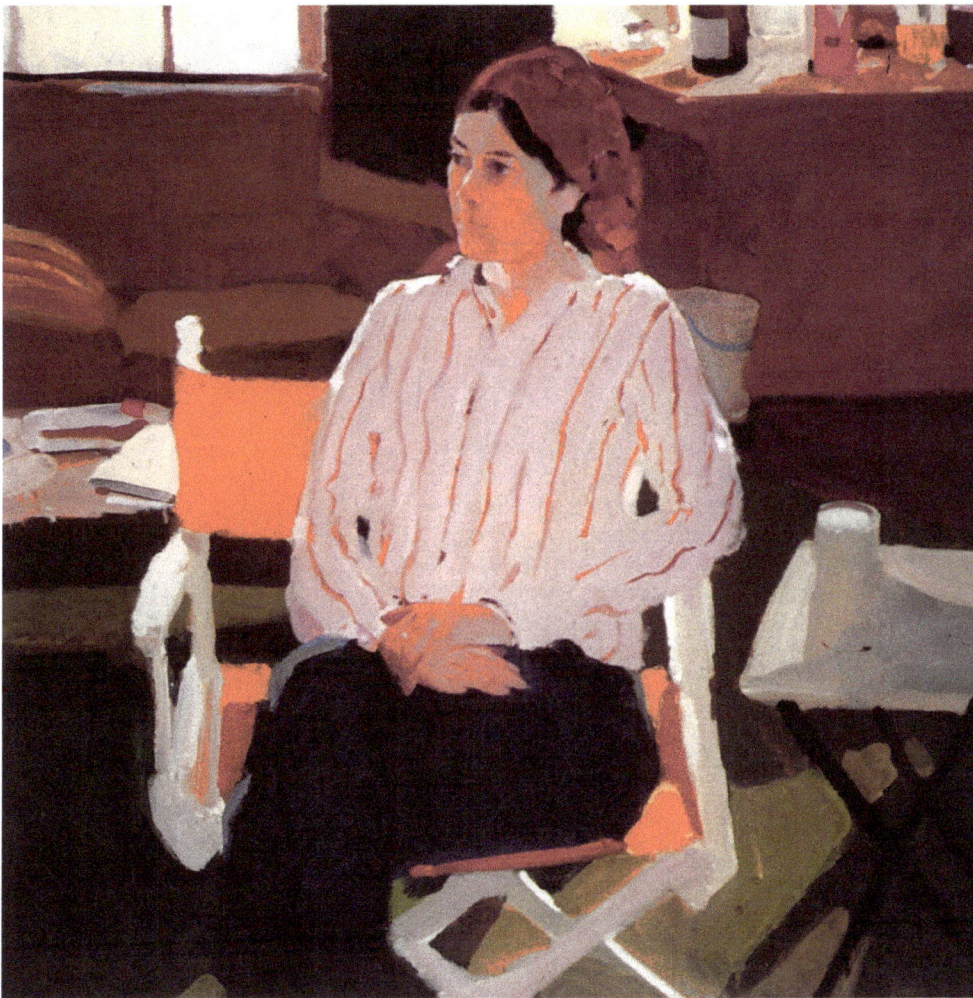

DEBBIE

oil on canvas,
40" × 40" (102 × 102 cm),
collection Mr. and Mrs. Alfred Chadbourn.

Debbie is one of my earliest figure paintings. It's simpler than the paintings I do now, with broader areas of color than I seem to be using at present. The painting is basically warm, and I selected it because it has large areas of dark values where color can be easily seen.

I always try to make my darks luminous. That means stressing color rather than value. In reality, the couch and worktable to the right seemed very dark and murky, but I brought the values up a bit, lightening them with a warm color (not white).

Notice how local color has been stressed in the lighter areas. I deliberately made the canvas chair lighter than the color I actually saw. If I were to paint the shadows on it today (I can't recall the mixtures I actually used then), I would darken the chair with yellow ochre or raw sienna and then I would choose a strong, warm yellow like cadmium yellow medium to give the shadows life. Again, you should choose colors that come from the tube as near as possible to the value you want. For example, you wouldn't start with a light yellow to match a middle-value color like the chair back. You would choose a raw sienna or yellow ochre instead.

MIXING FLESHTONES

Everyone always wants to know what colors to use for fleshtones. I wish it were just a matter of mixing the correct colors. Unfortunately, this is not the case. The colors you use really have very little to do with getting a good skin color. What does matter is the quantity and proportions of the colors in the mixture and where you place them on the figure, and how you mix and relate them to the rest of the picture.

The colors I mix for flesh are very simple. I use a red (cadmium red) and a yellow (cadmium yellow or cadmium yellow light or yellow ochre or raw sienna) for the warm areas. Then, to cool them, I use cerulean blue for the light areas and Hooker's green in watercolor and viridian green in oil for the darks.

I don't have any set proportions, though I tend to use more cadmium red in the mixture than cadmium yellow because the yellow is a stronger color. I use the same colors in both the light and shadow areas. The only difference might be substituting raw sienna for yellow ochre in the shadow.

There are no unique colors for painting the flesh of blacks, Hispanics, or any other racial groups. The colors I use are always the same. The difference is in the proportions of certain colors and how dark I make my "light" wash. For example, I use the same colors for the *shadow* of a white person that I would use in the *light* areas of a black person. It's true that on a dark-skinned person the colors would generally be darker and certain hues may seem more apparent—we might, for example, be more aware of the blues. But blue tones are on white skin, too. In fact, the mixture for a person with fair skin would have more blue and less red-yellow than, say, a person with olive skin. That's why there are no set formulas for painting fleshtones—because the proportions of the colors are as varied as the colors of each individual.

The proportion of warm to cool color also depends on the clothing the person is wearing, since the clothing reflects its colors onto the skin. It is also influenced by the colors of the

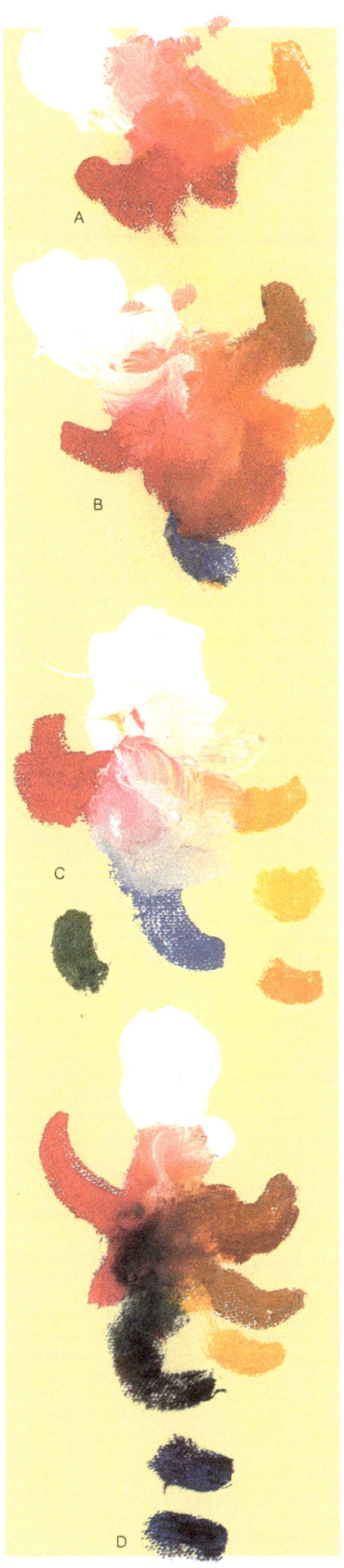

surroundings and the color idea of the painting. You can never separate the fleshtones from the rest of the picture. You must harmonize and relate all your colors. Thus a warm complexion surrounded by cool color might look "off" unless both areas are integrated.

OIL PAINT SWATCHES

Here are the basic fleshtone mixtures I use in oil:

a. Titanium white,
 cadmium red,
 cadmium yellow.
 Try this basic combination first before adding a complement like blue or green.

b. Titanium white,
 cadmium red light,
 cadmium yellow pale or
 cadmium lemon or
 cadmium yellow
 (or any other yellow you'd like to try),
 cerulean blue or
 permanent green light.
 This is the basic light fleshtone I use. I might mix all of the above as a single complexion color, or I might use only the red and one of the yellows with a complementary color. Don't look for a formula. You must experiment!

c. Titanium white,
 yellow ochre,
 cadmium red,
 any one of the cadmium yellows,
 cerulean blue or
 permanent green light.
 This makes a more subtle fleshtone. It's less vibrant than the others because the yellow ochre is so quiet, but I include it here because some students have trouble with yellow. They tend to add too much and their mixtures get too orange.

d. Titanium white,
 raw sienna or
 yellow ochre,
 cadmium yellow,
 viridian or
 cobalt blue or
 ultramarine blue.
 This is a darker mixture than the others, and I use it for shadows or darker complexions.

KIM AT STUDIO II (detail)

oil, 50" × 40" (127 × 102 cm).

This was painted several years ago, and I don't have a slide of the whole painting, but I want you to notice in this detail how gray the fleshtones are in the shadow. Kim had very fair skin and there weren't actually any warm tones on her face. But whenever you paint someone with fleshtones so cool and subdued, it's important to find a touch of warmth somewhere. I usually put my warmest tones where the shadow meets the light. I also exaggerate the warmth of certain areas by adding more cadmium red and yellow ochre or cadmium yellow light to my color. On the face, I choose spots such as the nose, cheeks, ears, and on the body, the elbows and kneecaps—places wherever red is usually seen. But this is not a rule. There are many fine paintings without red elbows and noses. It's just that when you need warm color, these are the places to find it.

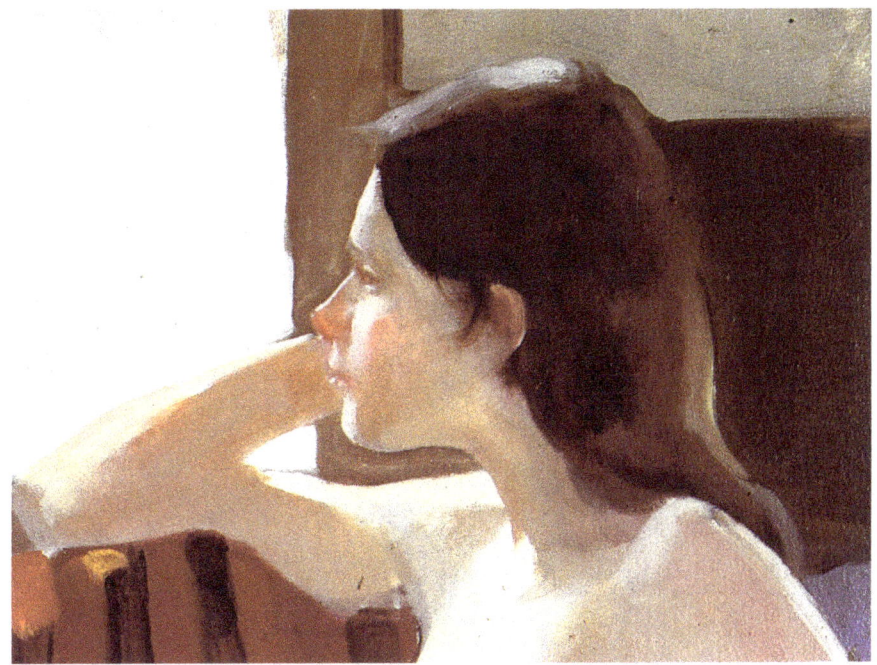

RED VEST

oil on canvas,
15" × 20" (38 × 51 cm),
collection the artist.

Charles Hawthorne always used to tell his students to paint spots of color, not detail. For example, he said that the mouth was not a separate dark shape pasted on a white face, but it was an integral part of the lower face. So when I did this demonstration for my class, I tried to show that although the mouth was darker than the face in places, it was a color change rather than a value difference.

Notice the edges of this model's mouth. I wanted to show that the mouth was part of her face, so I painted the mouth area with brushstrokes at right angles to the lips in several places and painted the skintones diagonally into the mouth to join the forms. Then I ran the lip color back into the skintones.

Manipulating color and brushstrokes like this does take some practice, so if you can't manage color changes like this, here is another approach. You can paint the face, then put down a color for the mouth. Try not to make it too dark, but make sure it has a good, warm color. Then put down your brush and blend the hard edges on the mouth with your thumb in two spots where the lips seem to blend into the face.

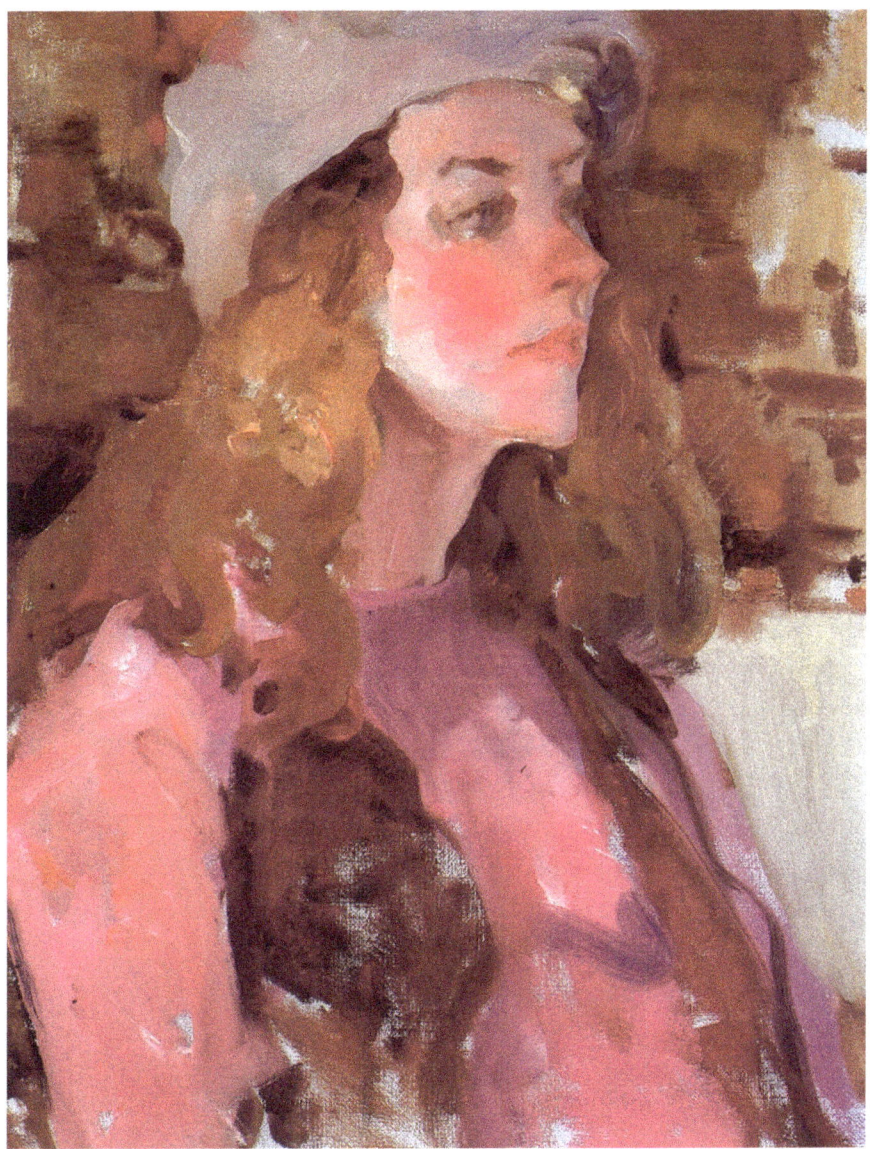

WATERCOLOR SWATCHES

Here are the basic color mixtures I use for flesh in watercolor:

a. Cadmium red,
 cerulean blue,
 cadmium yellow light.

b. Cadmium red,
 cadmium lemon,
 Hooker's green deep.
 (I always use the dark.)

c. Cadmium red,
 yellow ochre,
 cerulean or cobalt blue.

d. Cadmium red,
 yellow ochre,
 raw sienna,
 Hooker's green or
 ultramarine blue.
 (This is the mixture I would use in
 shadow or for a dark complexion.)

A

C

D

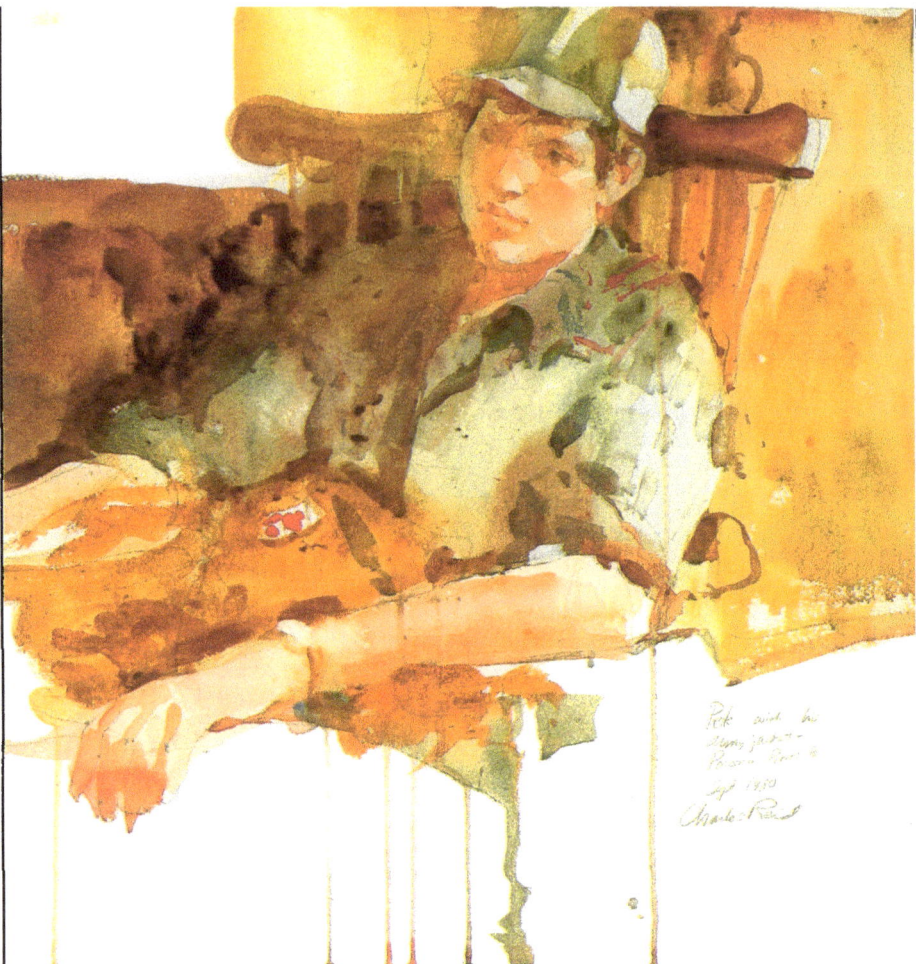

PETER

watercolor on paper,
24″ × 26″ (61 × 66 cm),
collection Judith Reid.

My family hates to pose and this always puts me off. It's no fun to paint if it's a trial for the model. In this case, the model scheduled for the class didn't show, and Peter agreed to substitute. He seemed happy to do it, and I did a painting that both Judy and I still think is just right for that period of his life.

I needn't go into the qualities I was trying to capture because I was in front of a class and my only hope and prayer was that the picture wouldn't be a disaster, especially since Peter was doing his best to help me along. I wanted to keep the face delicate, without strong light and shade, so I lightened the shadows. (You can see this if you compare the value of the chair on the light side with its value on the shadow side.) I wanted the strongest emphasis around Peter's ear, and so that's where I put the most contrast.

I kept all my colors very quiet. I mixed the blue-grays with cerulean, raw sienna, and yellow ochre, with some alizarin crimson added. I also placed some burnt sienna in the background and on a chair. Since I find burnt sienna a very raw color, I rarely use it alone, though I did here. I usually use it as a part of a mixture, either with raw sienna, a blue, or a green. Also, I don't usually use earth colors in mixing grays because the results are too muted, though in this painting it seems to have worked.

CHAPEL DOWNS

watercolor on paper,
22½″ × 26″ (57 × 66 cm),
collection Dorothy Barta.

The model didn't appear, so this young lady filled in. This happens often, and then someone in the class will make a command call to a son or daughter (no doubt with other plans) and ask the person to fill in for the model. In this case, Ms. Barta arrived and was cheerful about it—but I was taken completely by surprise. I just wasn't ready to paint such a pretty young woman with perfect features. Painting good-looking people is very difficult, especially in watercolor. There's always a need to model and correct the drawing. A man with a beard would have been much easier!

The main problem in painting people is the worry of getting a likeness. I've seen painters who do excellent landscapes and still lifes panic when they have to paint a model. They'll end up painting the background marvelously well, but the figure will look as though it was done by a much less experienced artist. Even though I've painted many figures myself, I certainly understood their problem as I painted this young lady. Whenever my students paint a person, I always tell them: "Think of the face as a flower and paint the color you see." But it's hard to follow your own advice sometimes!

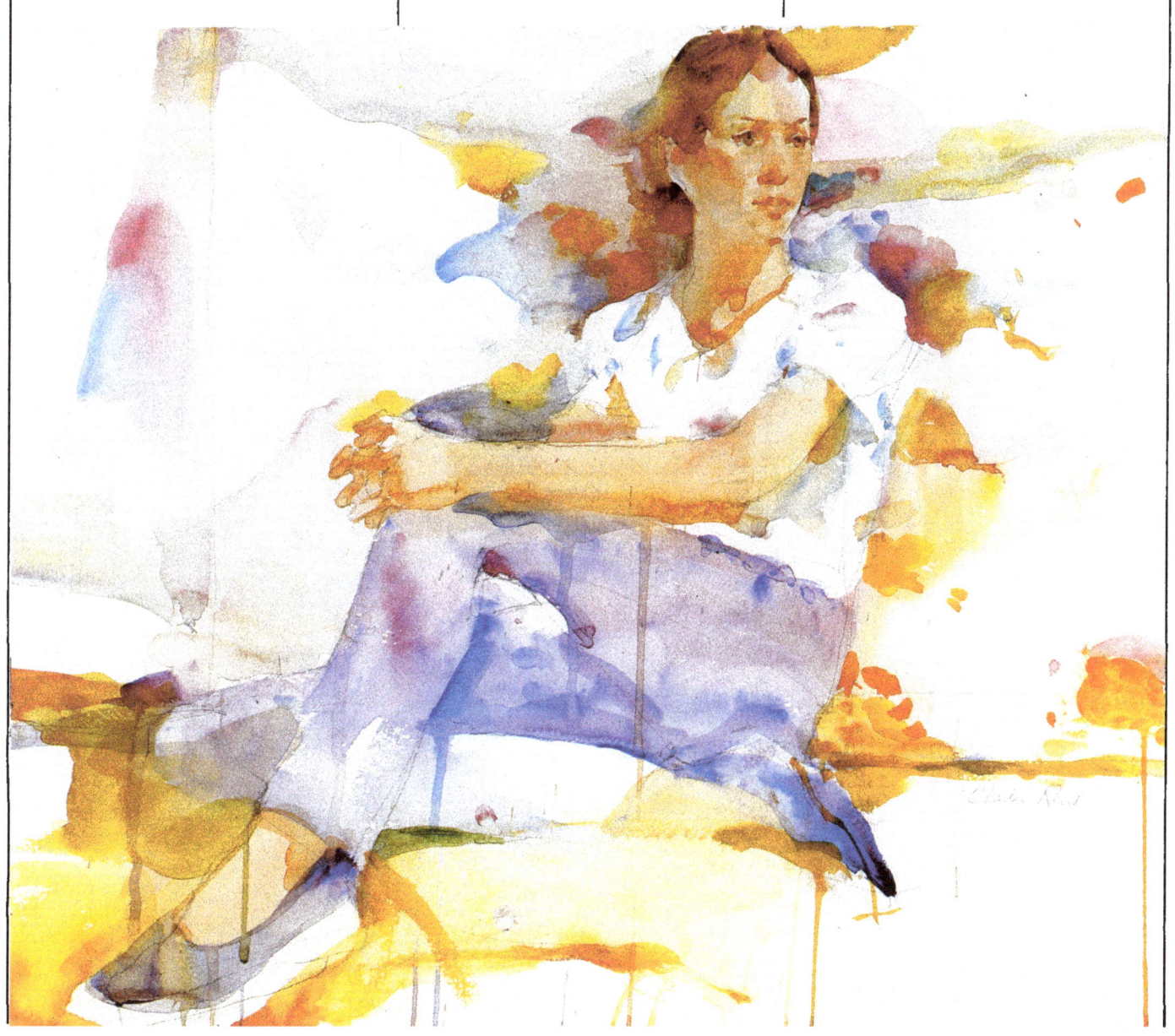

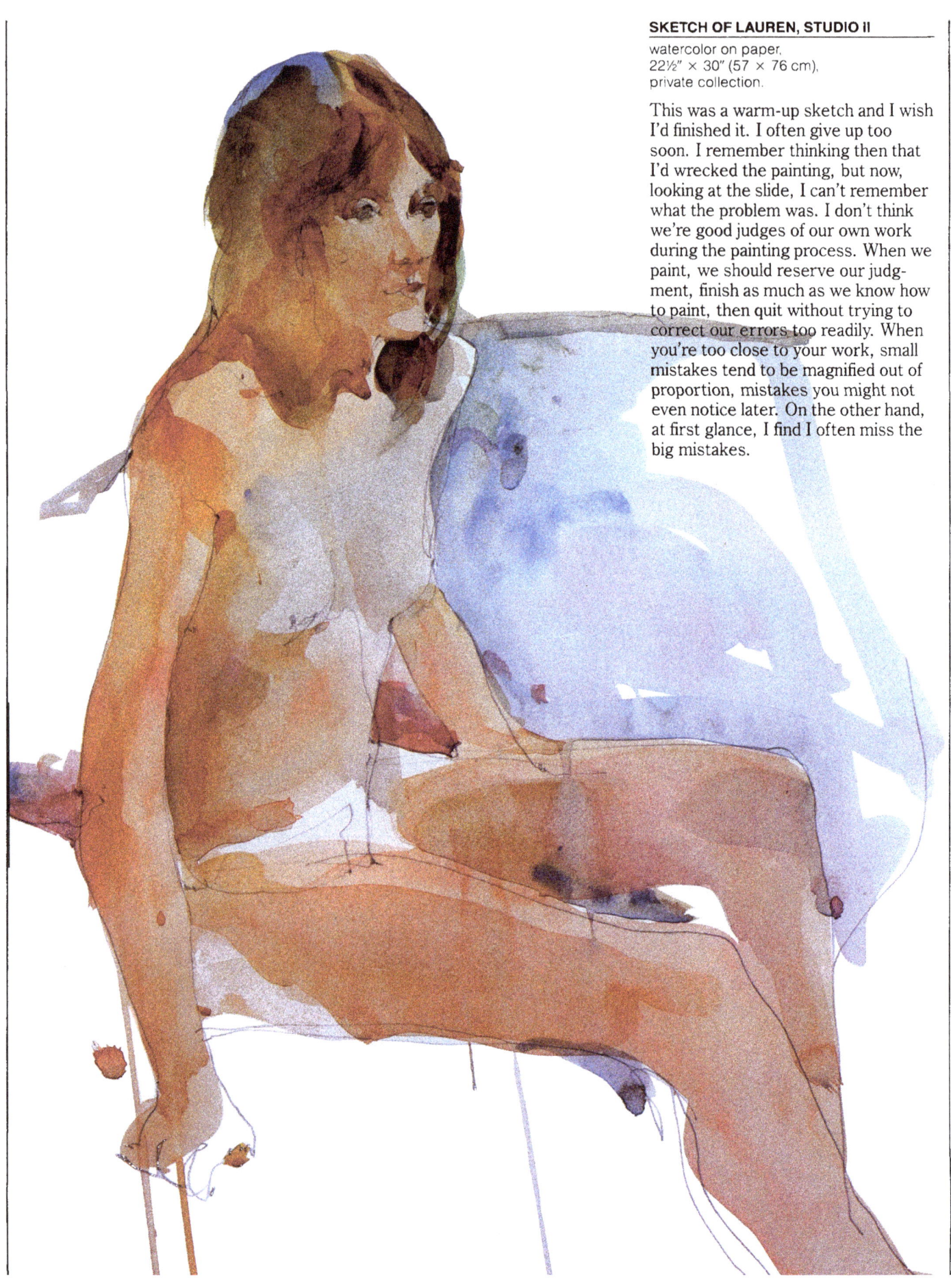

SKETCH OF LAUREN, STUDIO II
watercolor on paper,
22½" × 30" (57 × 76 cm),
private collection.

This was a warm-up sketch and I wish I'd finished it. I often give up too soon. I remember thinking then that I'd wrecked the painting, but now, looking at the slide, I can't remember what the problem was. I don't think we're good judges of our own work during the painting process. When we paint, we should reserve our judgment, finish as much as we know how to paint, then quit without trying to correct our errors too readily. When you're too close to your work, small mistakes tend to be magnified out of proportion, mistakes you might not even notice later. On the other hand, at first glance, I find I often miss the big mistakes.

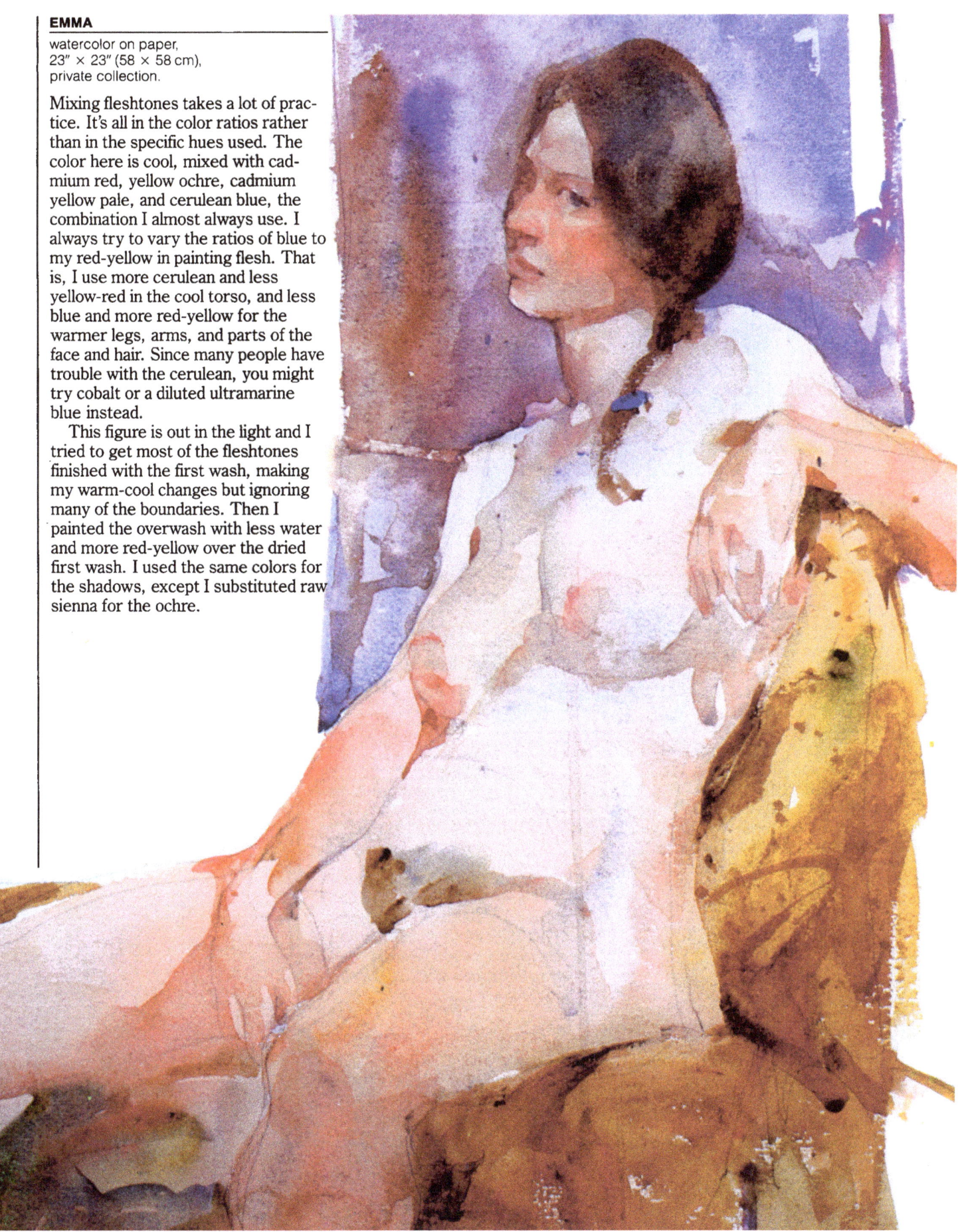

EMMA
watercolor on paper,
23" × 23" (58 × 58 cm),
private collection.

Mixing fleshtones takes a lot of practice. It's all in the color ratios rather than in the specific hues used. The color here is cool, mixed with cadmium red, yellow ochre, cadmium yellow pale, and cerulean blue, the combination I almost always use. I always try to vary the ratios of blue to my red-yellow in painting flesh. That is, I use more cerulean and less yellow-red in the cool torso, and less blue and more red-yellow for the warmer legs, arms, and parts of the face and hair. Since many people have trouble with the cerulean, you might try cobalt or a diluted ultramarine blue instead.

This figure is out in the light and I tried to get most of the fleshtones finished with the first wash, making my warm-cool changes but ignoring many of the boundaries. Then I painted the overwash with less water and more red-yellow over the dried first wash. I used the same colors for the shadows, except I substituted raw sienna for the ochre.

USING ANALOGOUS COLORS

Analogous colors are colors that are next to each other on the color wheel. They share a common base color—for example, yellow-orange, orange, and red-orange have the color "orange" in common; and blue, blue-green, and green has both "blue" and "green" as common elements.

One problem in using complementary colors—colors across from one another on the color wheel—for mixtures is that, in mixing these opposites, you can gray your colors too much and make them flat and muddy-looking. But if you mix your colors with analogous colors, you can't get into too much trouble. In an actual situation, of course, mixing complementary colors is also ncessary, so the assignment here should be thought of as an exercise only, not a method of painting.

ADJUSTING COLORS

When adjusting a color, it's important to work your way to it gradually, like climbing down a ladder instead of jumping from the roof. So when you want to lighten a dark color, you should start with another color from the same family—such as mixing alizarin crimson with cadmium red, cadmium red with cadmium orange, cadmium orange with a yellow, ultramarine blue with cobalt, or cobalt blue with cerulean.

To lighten a dark wooden table, for example, you might start with burnt umber (the local color) and mix it with raw sienna and burnt sienna to get the right hue. If the color seems too dull, you might then add some cadmium red light or even a touch of cadmium orange to it. If it gets too light, you could add more burnt sienna to the mixture.

The main idea is to keep the color idea alive. Thus, adding too much burnt umber to the mixture might make it too dark and dull. And adding black to darken it would make it dead-looking and colorless. I never darken a color with black except when mixing greens, where I use black as a blue in combination with cadmium yellow, yellow ochre, raw sienna, and raw umber to make some rich mixtures. I also use ivory black when I want a black or near-black. If I want to temper it, I might mix the black with a little ultramarine blue and alizarin crimson for a cool black, or mix it with burnt umber or burnt sienna for a warmer black. But you should never lighten black with white or you'll end up with a dull gray. Lighten it with a color instead.

Here are examples of analogous colors:

Red Family: cadmium reds, cadmium orange, alizarin crimson, burnt sienna, burnt umber.

Blue Family: cerulean, cobalt, ultramarine, phthalo blues.

Yellow-green Family: cadmium yellows, yellow ochre, raw sienna, raw umber, permanent green light, viridian, sap green.

Use ivory black only where the local color is black. Black may be lightened with cerulean blue where a cooler light falls on a black object, or lightened with yellow ochre where a warmer light exists. Like black, use titanium white only where the local color is white.

MY FAMILY

oil on canvas,
60″ × 50″ (152 × 127 cm),
collection Yellowstone Art Center,
Billings, Montana.

Here the yellow couch and Judy's blouse set the key for the entire painting—there is a touch of warmth in all other sections. The window dividers actually looked cool, but I decided to paint them a warm gray so they would tie in with the couch. I also wanted to convey the feeling of warm summer light and I felt that cool colors, though correct, would have detracted from that idea.

There are some cool areas here, too—my blue shirt and jeans, Peter's shirt and shoes, and Sarah's shirt, for example. But even when I wanted to suggest the actual colors involved, I tried to place a trace of warmth in each area.

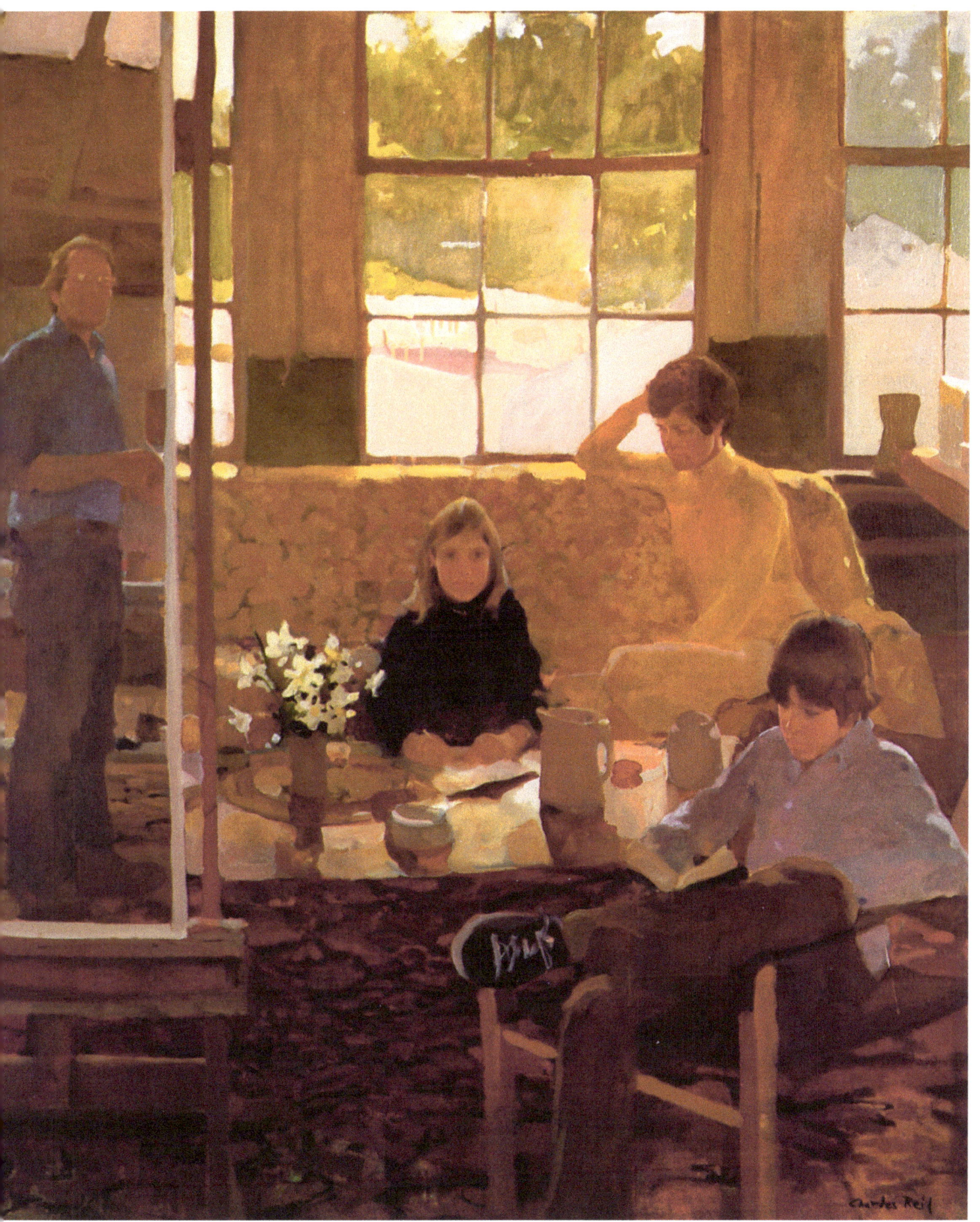

RIVER STREET

oil on canvas,
16″ × 20″ (41 × 51 cm),
private collection.

This oil painting was painted like a watercolor—I used only turpentine for my first "wash." The background, hair, and parts of the shawl and dress were washed in very thickly with some color changes. I also painted the head and hands at the same time, but added some white pigment to my washes there. (The other areas didn't contain white.) I also added a bit of medium to the fleshtones. (I used Winsor & Newton's Winton medium with a bit of turpentine to thin it slightly.) You shouldn't paint impasto with only turpentine as a medium because turpentine is a poor binder, though I think it's okay when used for oil washes early in the painting process.

RESTING

oil on canvas,
24″ × 24″ (61 × 61 cm),
private collection.

The model was taking a break, and I made a small color note and drawing of her in my sketchbook. During her regular pose I did another painting of her that wasn't particularly good, and I eventually junked it after using it as a reference for this one.

This painting was done in my studio at home. The red background was invented. I wanted to have two major shapes and get as close as possible to an abstraction as I could. I was very conscious of my reds, subduing most of them by mixing them with burnt sienna, raw sienna, and a little cadmium orange. I also mixed cadmium yellow medium with the raw sienna. The cadmiums are strong and the earth colors are so weak that you must add only a touch of the cadmiums in your mixtures or the cadmiums will overpower the earths. I rarely use burnt umber and raw umber, although I do notice a couple of dark earth tones here that I imagine are raw umber right from the tube. The only time I use the darker earth tones is in mixtures with very dark colors like ultramarine blue or viridian.

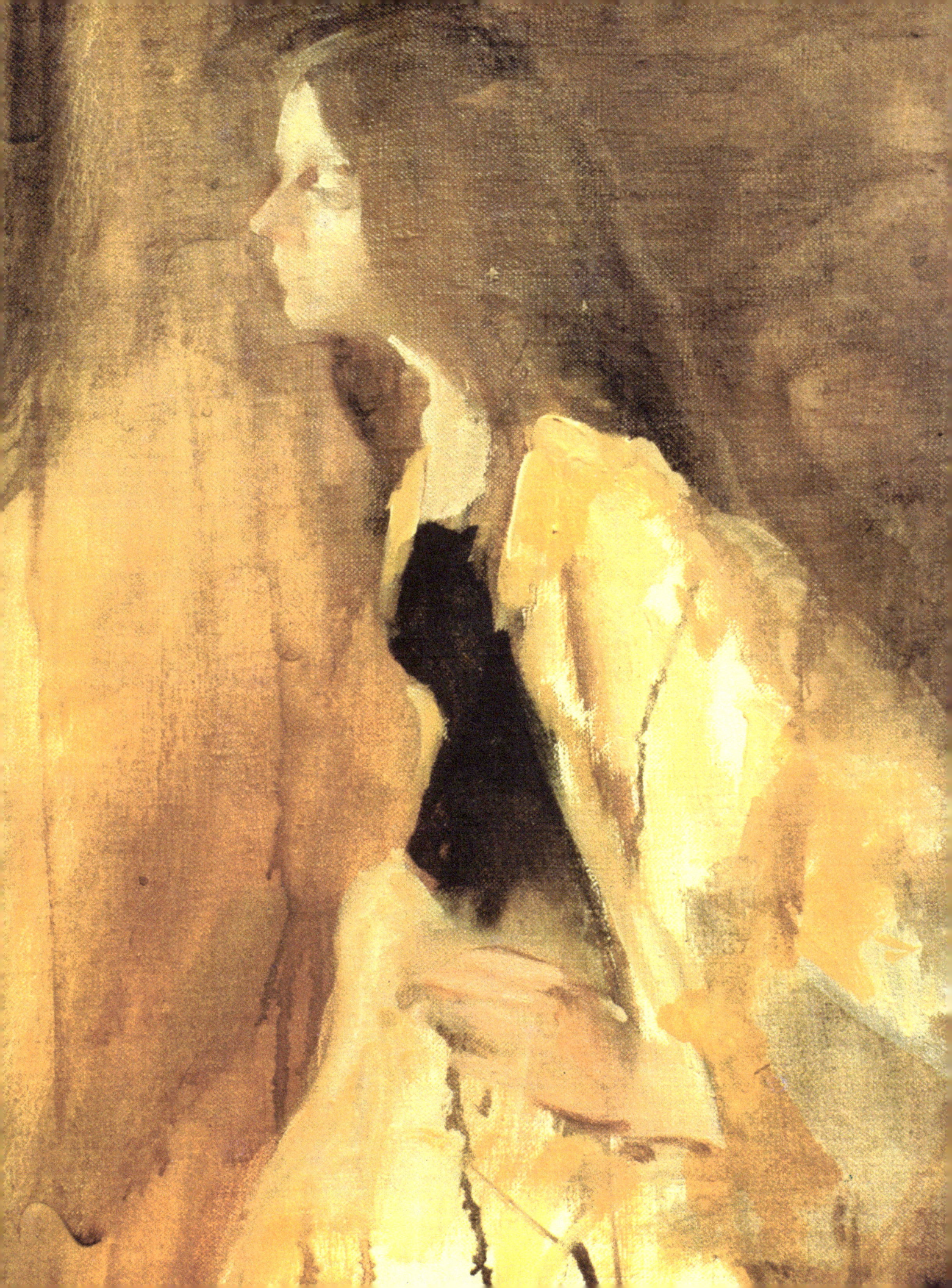

USING COMPLEMENTARY COLORS

Very few realistic paintings are painted entirely in pure complementary colors because the effect is strident and jarring. Of course there are always exceptions, and some very fine pictures have been painted with pure complements. The paintings of the Fauves come immediately to mind, also the work of Matisse, Marquet, Vlaminck, and Derain, who painted marvelous pictures in the beginning of this century. Still, most representational painters use complements for color accent and balance only.

To illustrate how complements can be used to balance and strengthen a painting, let's examine two of my paintings, an oil and a watercolor.

DAFFODILS AND AN ORANGE

watercolor,
24″ × 24″ (61 × 61 cm).

The main color idea here is the contrast between the blue jar, the yellow flowers, and the orange, although the conflict between the blue and orange is a bit strong for me! I rarely have two complements so close together and so strong. You'll have to decide for yourself if it works or not.

Notice that I tried to get some color balance in the painting by juxtaposing the yellows: the daffodils, the lemon, and the yellows in the distant grass. I also did the same by placing the greens in selected areas of the painting so that they would balance each other and interact with the other hues.

COUSINS

oil on canvas,
60″ × 50″ (152 × 127 cm),
collection the artist.

This is a painting of my two nephews, Mark Darlington and Tim Shields. Tim's blue jeans and Mark's red-brown shirt are complements, and they are the major colors in the painting. Notice that I've included some warmer notes of color in the jeans and have kept the red shirt "earthy" and restrained in intensity to prevent the complements from becoming too jarring. I believe I mixed the shirt color with cadmium red light, burnt sienna, and a little raw sienna. You can find other possible mixtures in the preceding section on analogous color.

Notice that I've only used pure, intense complementary colors in very small areas, such as the pure cobalt blue book on the far left, pure cadmium orange in a painting behind Mark's leg, and pure cadmium yellow medium on the cover and label of the gesso container at the lower right. There are other complementary colors here, too, but most of them have been modulated and grayed somewhat.

Notice also that there are no actual grays here. This is not to say that grays are necessarily wrong to use. It's just that I happen to prefer suggesting a specific color idea or color-value in each area.

part four
DIRECTING THE EYE

PAINTING WHAT YOU *WANT* TO SEE

Winslow Homer once commented in response to a tourist's query, "I paint exactly what I see." Without getting into a philosophical mire, I can only say, "Wait a minute. Homer was pulling our leg. Is it ever possible to paint exactly what one sees?" Homer always seemed to have been in a bad mood, especially when asked what he considered foolish questions. So I can imagine his glee as the tourist furiously jotted down the master's profound thought. If Homer had said it straight, he would have said, "I paint what I *want* to see."

Every artist makes adjustments in painting to fit a personal concept of the world. In my paintings, for example, I make value and color adjustments to try to capture a feeling of light and air.

To show you what I mean by painting what you want to see, let's compare some sketches of what I actually saw with the paintings that I ended up doing. (I based my sketches on memory and reference to the finished paintings.) My changes in the "reality" I see were triggered by my personal vision. Since we all see things differently, your response to the same subject might have been something other from mine. For example, you might have painted the strong value contrasts of my sketches rather than stress the colors of my paintings.

SKETCH OF DAFFODILS AND GRAPEFRUIT

This is a view I paint often, one of my favorites in the house. I have better light in the studio, but I like the "realness" of the kitchen—marmalade, grapefruit, and sugar jars seem more at home there. My kitchen is actually quite dark. The main light comes in through the window, leaving the objects on the table backlit. Putting on an overhead light helps, but the objects on the table still look like silhouettes—dark objects against a dark windowframe, with a lighter countertop and lighter values seen through the window. You can see all this in the sketch.

DAFFODILS AND GRAPEFRUIT
watercolor on paper,
16" × 21" (41 × 53 cm).

As you can see, I stayed with the local color of my objects in this painting, but I reversed the values. The windowframe is painted white, for example, but I lightened the value I saw there and darkened the view through the window. In other words, I didn't paint what I actually saw, but I painted what I *know* to be true. And I know that the windowframe is white and that the grass and woods are darker, with a warm rich green color. (One trick to painting the outside view is to ignore the value of the windowframe and concentrate on what you see beyond it.)

In painting this kitchen scene, I concentrated on getting the color likeness of each area instead of copying the actual value I saw as I painted these objects. I didn't paint the objects as though a light were shining on the objects—I still wanted to get a feeling of backlighting. I simply stressed the color likeness (local color) of each object over the value likeness I saw. But I kept the dark value I saw when I painted the cast shadows because I wanted to use the darker spot of color to anchor the objects and give some value strength to the countertop.

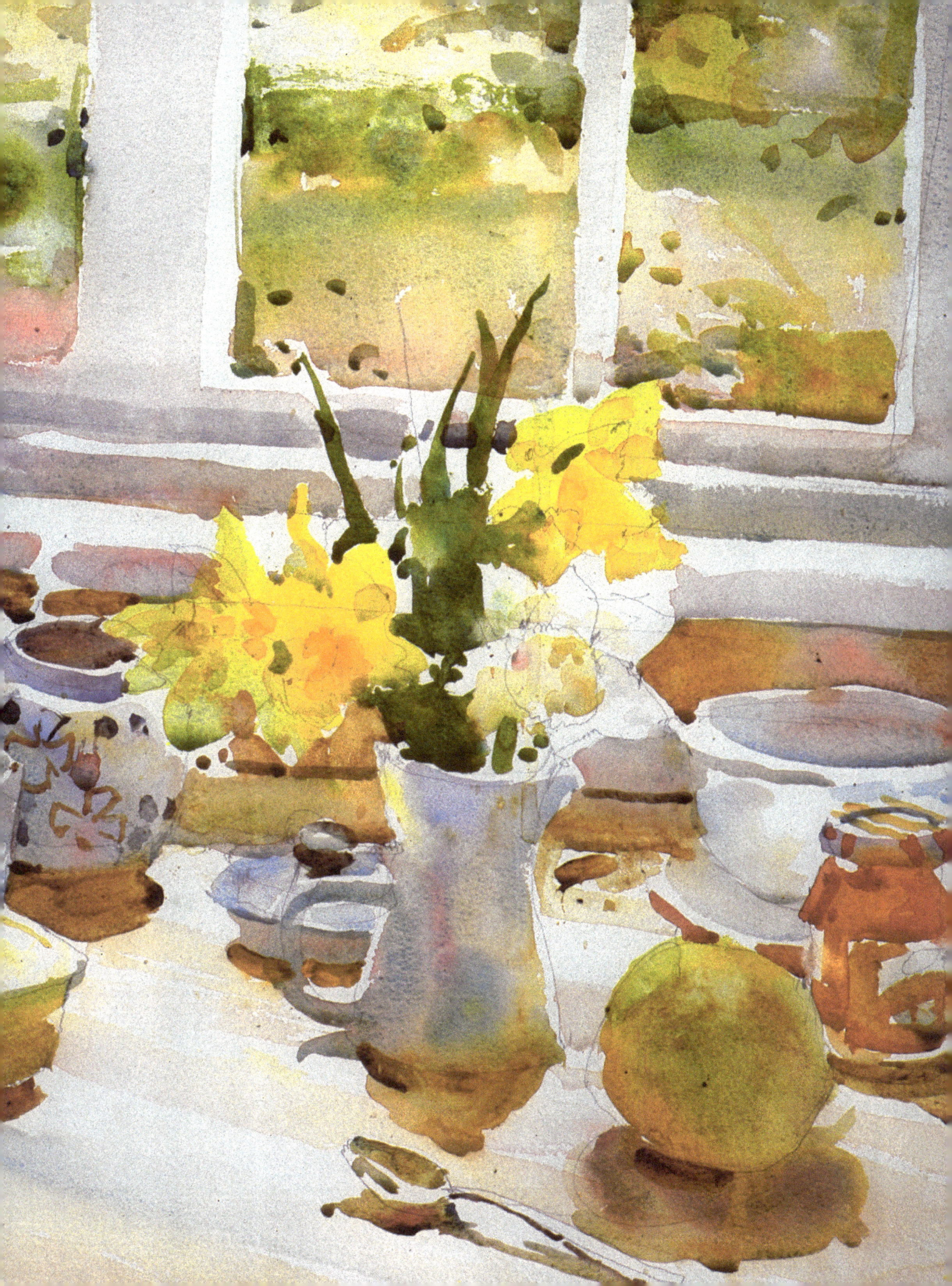

SKETCH OF FAYELLE

This is a sketch of what I actually saw.
The light and shade effect is so ob-
vious that this has become more of a
painting of value contrasts rather than
one of my subjects. This sketch could
make a good picture—indeed, it
would be a stronger statement than
my own painting. But whether it's
better is up to the viewer.

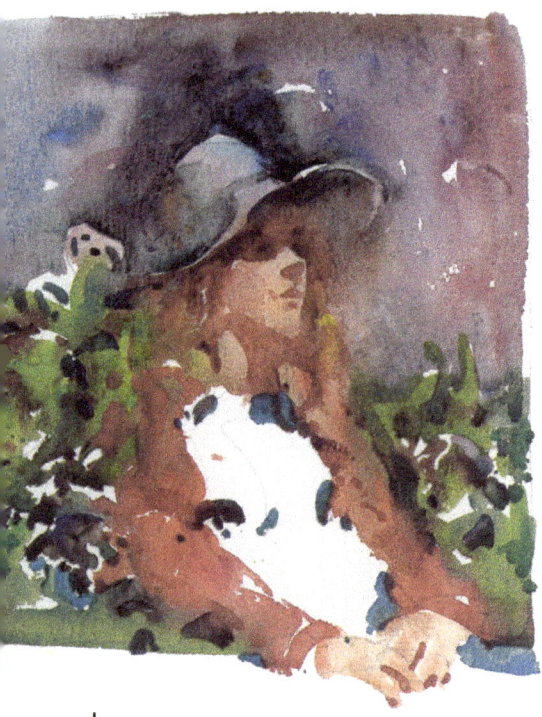

FAYELLE

watercolor on paper,
28″ × 21″ (71 × 53 cm),
private collection.

This painting reflects not what I saw,
but what I wanted to paint. I wanted
to do a painting with high-key, intense
color. Fayelle, the daughter of one of
my students, looked lovely sitting be-
tween two large bunches of dogwood.
I left lots of white paper showing to
enhance the feeling of light that I
wanted to convey.

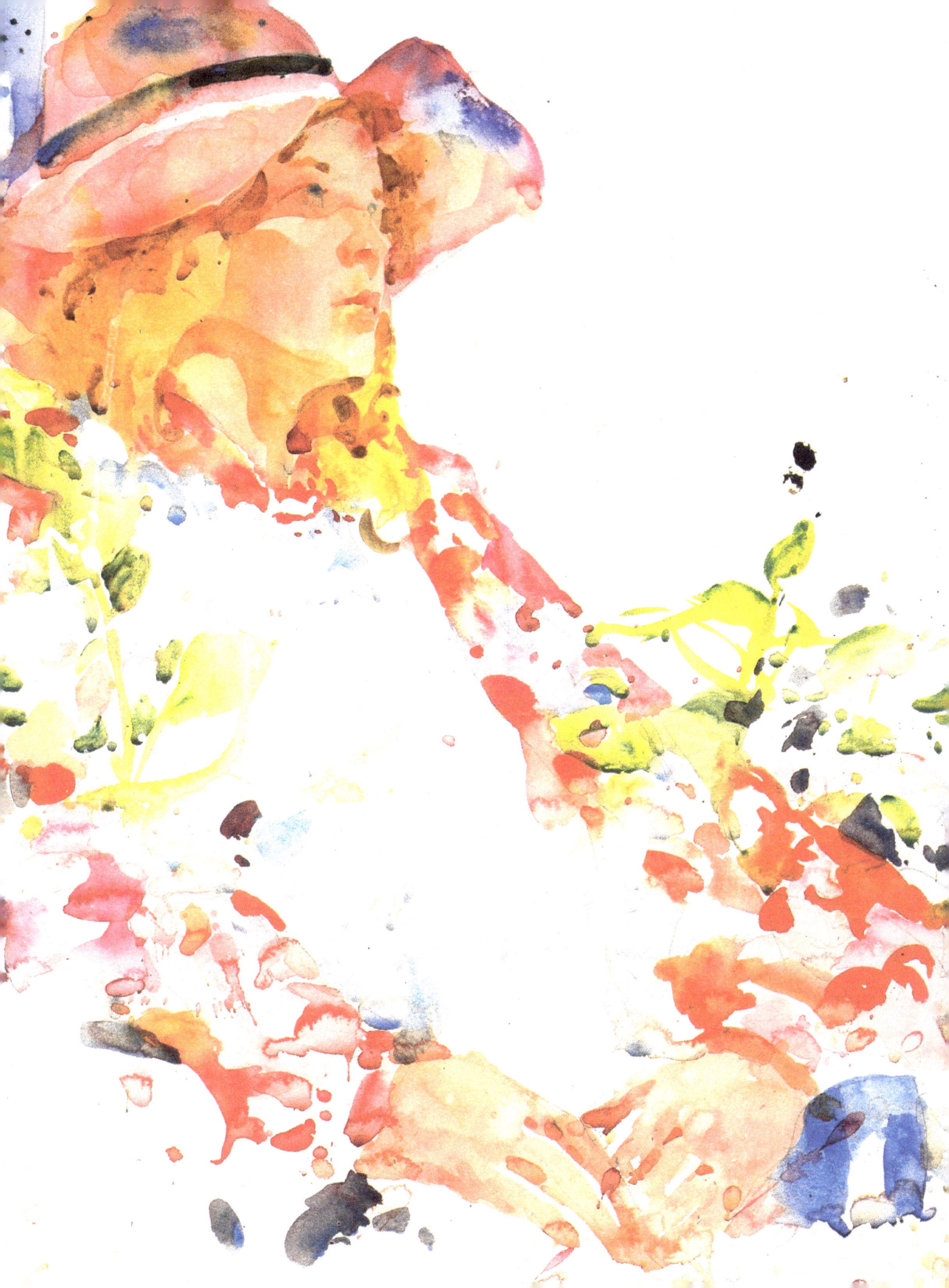

CREATING EMPHASIS AND A PERSONAL POINT OF VIEW

When an artist is attracted to a particular subject, it is usually because of some visual reason—an unusual shape, an interesting line, an exciting color combination, or any number of reasons of this type. The specific attractions can be as varied as the number of artists painting their subjects. But knowing the reason for the attraction is important, because it is that inspiration that must be carried into the painting if it is to have life.

To make my students aware of this process of subject selection and emphasis, I ask them to look at the model and decide what it was about the pose that was most exciting and that, in a sense, captured the essence of that particular model. They are then to convey this in their painting. I also ask the students to find a secondary area that also could be emphasized. I deliberately don't specify anything in particular to look for, since each artist should have a different reaction to the model and find something unique and exciting to emphasize that probably would be different from what would attract the other.

Trying to get my students to develop their own perceptions rather than copy my own style is a problem for me as a teacher. I react to certain qualities in a subject and can't help but show it in my demonstrations. Of course as an artist I have my own way of developing emphasis and can't help falling back on it in my teaching. But I wish students could get the *idea* of what I mean without imitating my *means* of doing it. Some students do understand this, but most think that my way is "The Way."

GIRL IN WHITE SWEATER AND BLUE JEANS

watercolor on paper,
21″ × 28″ (53 × 71 cm),
private collection.

This was done as a demonstration sketch for a watercolor class. The idea was to take the one area in the painting that made the most exciting shape and, in a sense, captured the essence of that particular model and emphasize it. I also looked for a secondary area of emphasis. I didn't specify "shape" as the particular quality I was looking for, though in this example I did emphasize shape and the effect of value contrasts.

For me, the "leggy" tapered jeans and boots were the first idea I saw. I also thought that the model's hair and face had exciting angles, and noted that this angular feeling was carried into the sweater. The model was wearing a white sweater, and this was important because there was a strong value contrast between the local value of the jeans and the sweater. On the other hand, she was sitting under a strong spotlight and, unless you squinted, the strong highlights made the jeans look almost as light as the sweater.

I made no attempt to make this vignette into a painting. It was really a diagram showing what areas I'd try to stress if I were to paint it. So I left the background behind the legs white paper, whereas elsewhere I used the background to emphasize the hair and sweater shape. Notice which specific areas I let melt into the background in order to make other areas stand out in greater contrast and become more important.

When some students still ask, "That's fine, but how do I do the background?" I get weary and wonder about their future. If artists can find emphasis and a personal point of view, they won't have to worry about the background. After all, Toulouse-Lautrec often left his backgrounds blank!

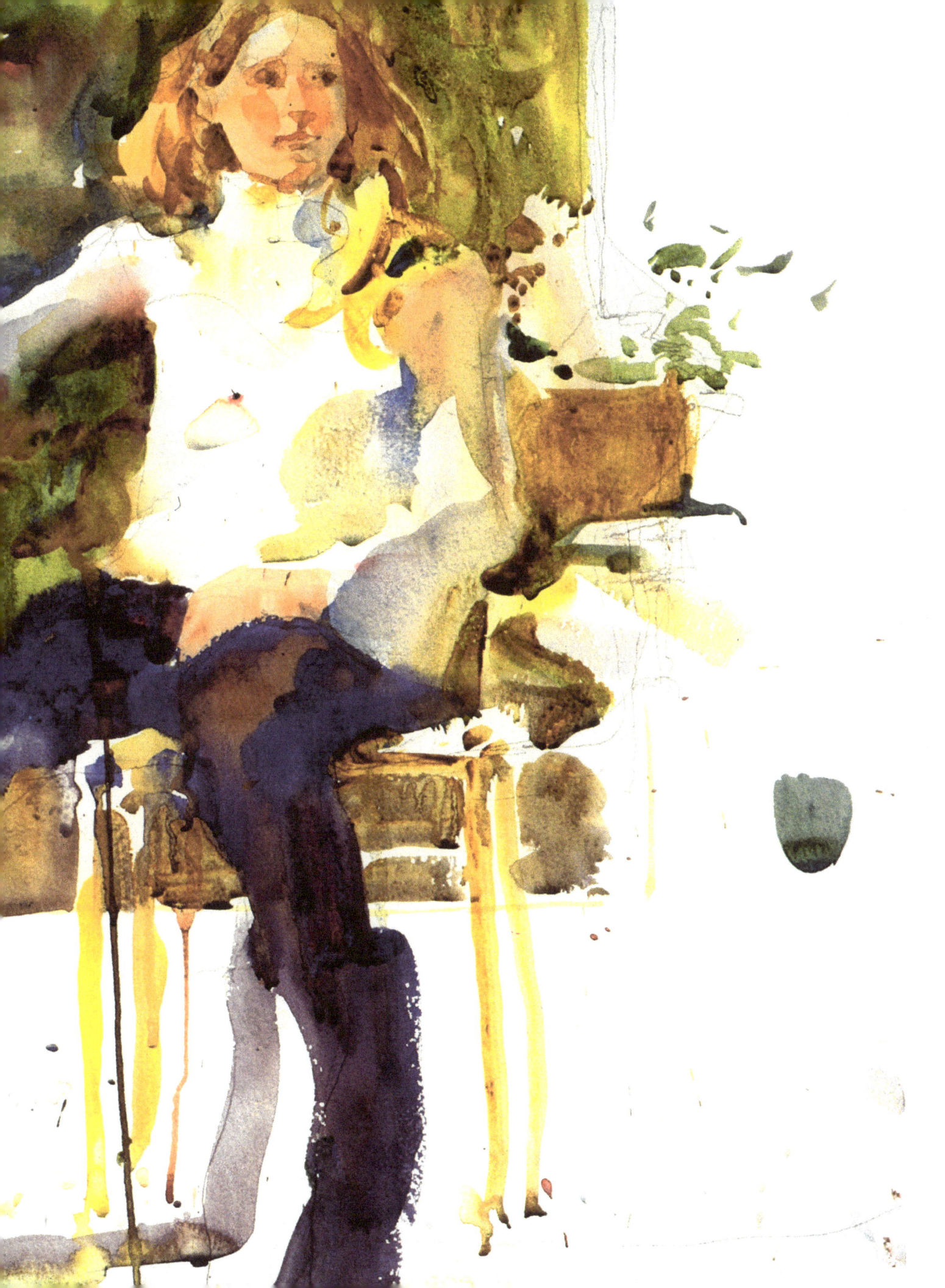

INTERPRETING THE LIGHT

As I have said earlier, you can interpret your subject any number of ways, depending on the aspect or quality of the scene you choose to emphasize. In *Sarah at High Hampton* (page 49), I stressed the local color on Sarah's face because there was a strong light and I didn't want her features to appear washed out. In *Daffodils and Grapefruit* (page 89), I wanted to paint the beautiful, bright local colors of my set-up. In *Fayelle* (page 91), I was also attracted to the brilliant light of the scene and the sparkling colors. When I painted *Girl in White Sweater and Blue Jeans* (page 93), I stressed the angles and shapes of the composition. Sometimes the attraction may not be the subject alone, but a combination of light, mood, and subject that triggers a painting. This was the case when I painted *Block Island, R.I.* (page 39) and it also holds true for the paintings shown here.

Even though I knew I was painting the light in the examples you are about to see, I still had to make choices. The accompanying sketches describe how the paintings could have looked had I emphasized the strong backlighting, stressing contrasts of light and shade (that is, values) rather than color. The effect of backlighting is dramatic, stark, and rather exciting. But other qualities can also be emphasized, and the finished paintings describe my final interpretations.

SKETCH 1

This is the view in terms of value, just about as I actually saw it. The strong backlight drowns out local color and makes us aware of dark silhouettes against a light-struck table, floor, and landscape. This would make a good painting, perhaps one even better than mine—the sketch is definitely a stronger idea than the one I painted—but it would be a different painting, and what you paint depends on the feelings you want to convey. The point I am trying to make here is that you can control a painting through value changes.

SKETCH 2

As I said before, I prefer to emphasize local color rather than light and shade, and so the second sketch of *Half Moons* portrays the scene in a gentler way, through an interplay of subtle colors and values. I was painting the light here, too. But I wasn't describing the strong backlight. I was painting another aspect of the scene, one more conducive to my painting style and perceptions. Again, both interpretations are equally valid. There is no one way to see or paint. But you must make a choice. And the approach you choose should be based on your own personality and what you want to say.

This time I sketched the scene in the afternoon, when I was able to see more color in the water and grass. I took the chair away and balanced the flowers by changing the color of the floor. The door frames were darkened slightly, but I kept the chair-back and table objects high in key. There's a lot to be said for sticking with a subject and trying serveral possibilities to make it work as a painting. I think we look too much for good subjects to paint and don't try hard enough to make what we have in front of us work through color and value changes.

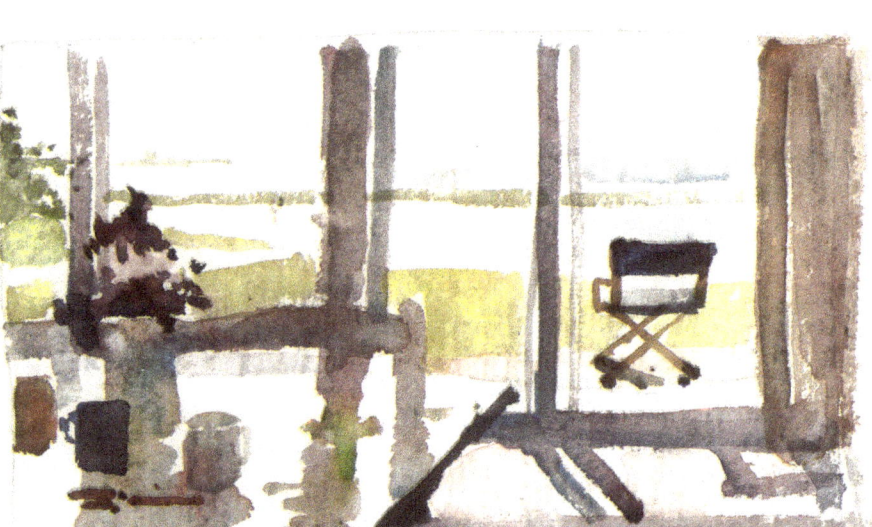

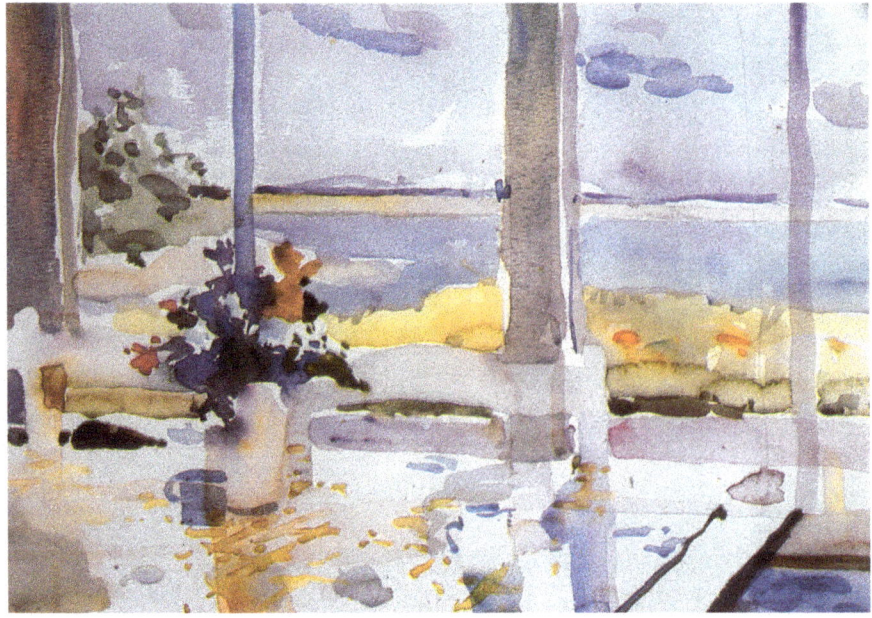

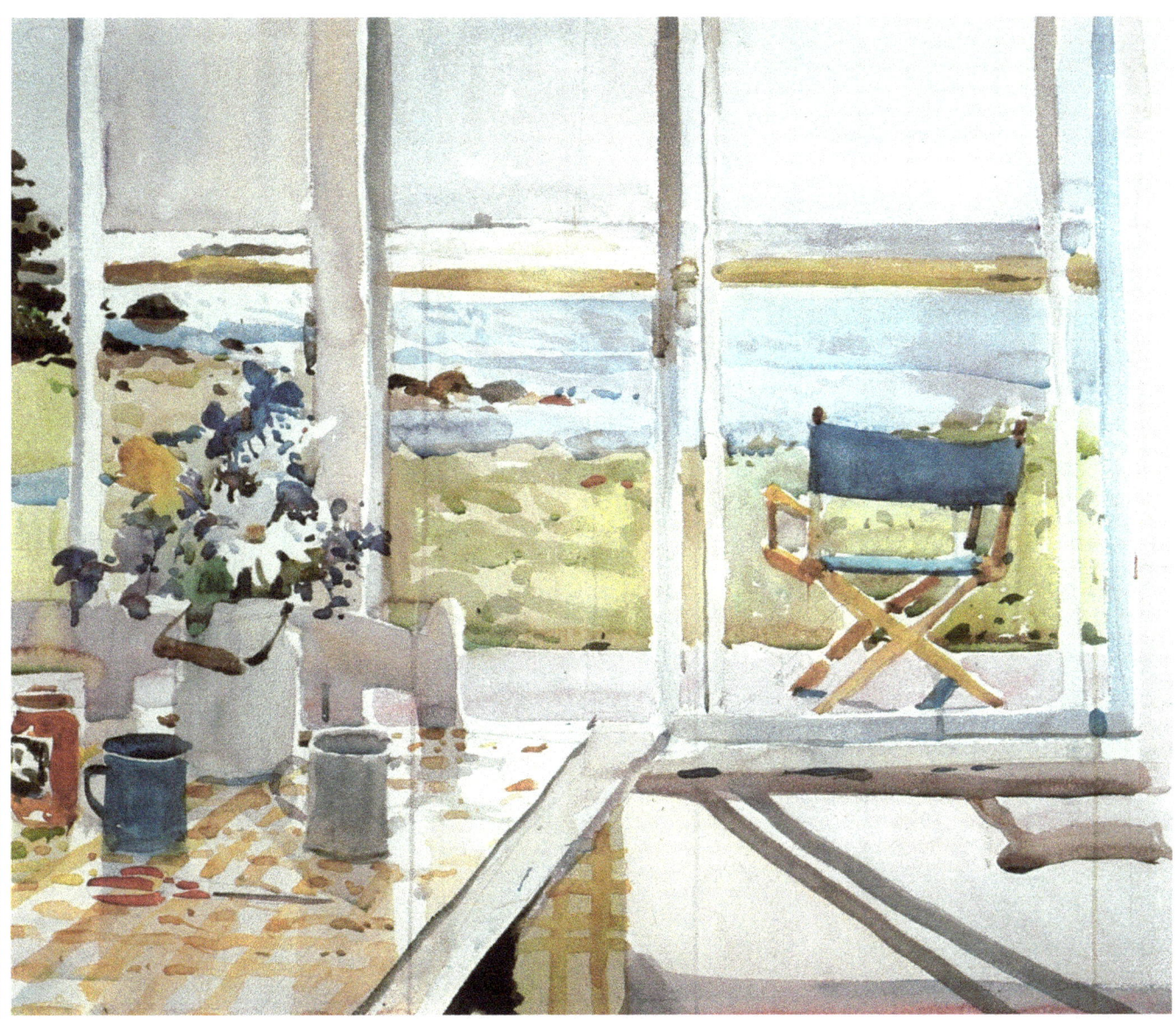

HALF MOONS

watercolor on paper,
22″ × 25″ (56 × 64 cm),
collection Marworth, Waverly, Pa.

I painted *Half Moons* as the sun rose over the ocean. Clear, crisp mornings like this are rare in Nova Scotia, and so I tried to paint the light outside as well as the light that filled the room.

Painting light is difficult. Ironically, a painting must also contain darks in order to express light, otherwise it will look washed-out. This painting is on the weak side and perhaps not as successful as I wished, but it did present an interesting challenge.

To express the feeling of light, I stressed the local color of each area in the room rather than the light-and-shade pattern that I actually saw. I also lightened the values in the shadows and in the rest of the room, to keep the painting high in key. I also painted the door frames, flower container, cup, and chair-back much lighter than they were, and I painted the flowers in terms of their local color rather than their value.

On the other hand, I recorded the values I saw in the landscape (and the chair leg) fairly accurately, keeping the color-values about the same as they would appear under a neutral light. To give the painting substance, I added a few dark accents—the table leg, the cracks and shadows under the doorway, and the dark spruce trees and rocks.

LUPINES IN FOG

watercolor on paper,
22″ × 30″ (56 × 76 cm).

I also tried to capture a feeling of light in *Lupines in Fog*. To "fix" what I saw and wanted to paint firmly in my mind, I sketched the idea for the painting first. It was a simple idea—a dark silhouette against a light background— and it seemed foolproof, but that was deceptive. If artists were able to carry off an idea this simple, they would have sure-fire winners all the time. The trouble is not in the basic idea, but in keeping the details that are added as you work from confusing the main idea. Details creep up on you while you're painting and, before you know it, you've lost the good, simple plan you started with and you have a different painting. I guess that's why I don't put too much stock in small preliminary sketches. A picture can look magnificent in a small sketch, but work done on a larger scale demands much more filler. What might look simple and good in a sketch might end up looking simply empty in a larger version.

Speaking of sketches, never make little scribbles with a 2B pencil and call it a "planning sketch." This kind of sketch is a *linear* solution to a problem. But painting demands *masses* of lights and darks. So make all your sketches with a brush and wash or oil pigment, and solve your problems in the medium you'll be using.

Notice the difference between my initial sketch, which stressed shapes and value contrasts, and the final painting, where the emphasis is on subtle color interactions. Both ideas work—but they really are two separate approaches, with two different moods.

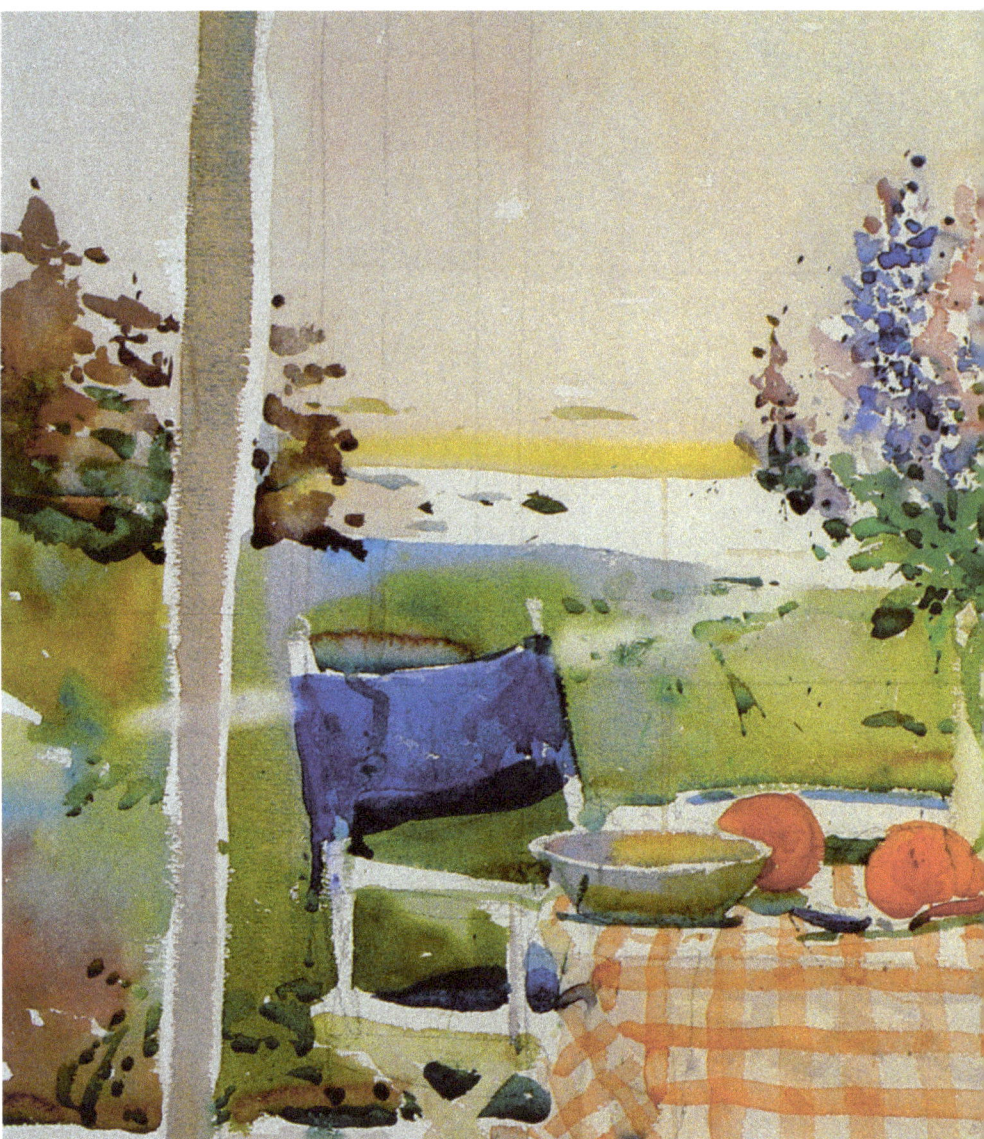

Sketch for Lupine — N.S. 6·28·82
Brown —

96

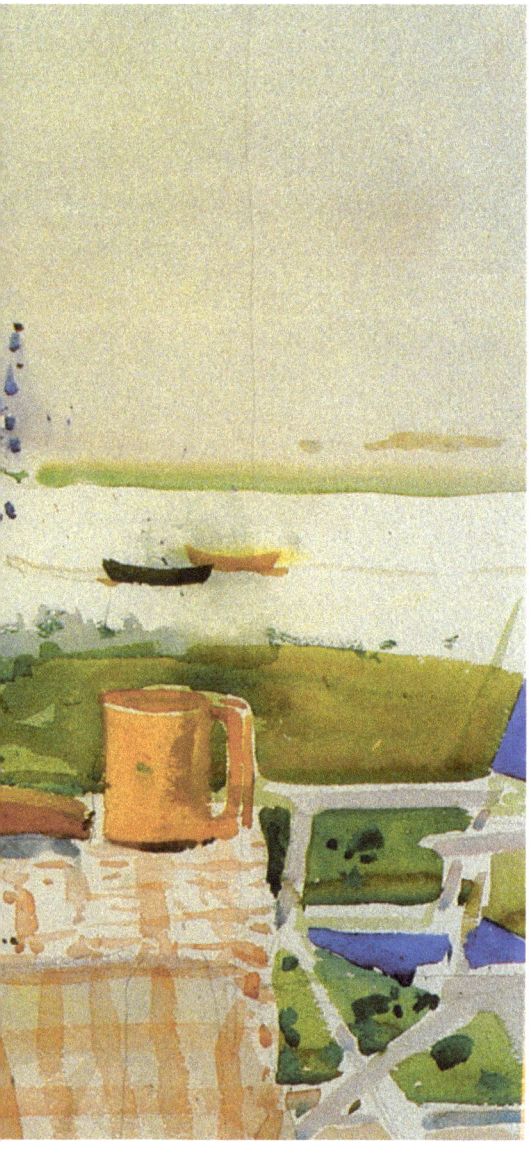

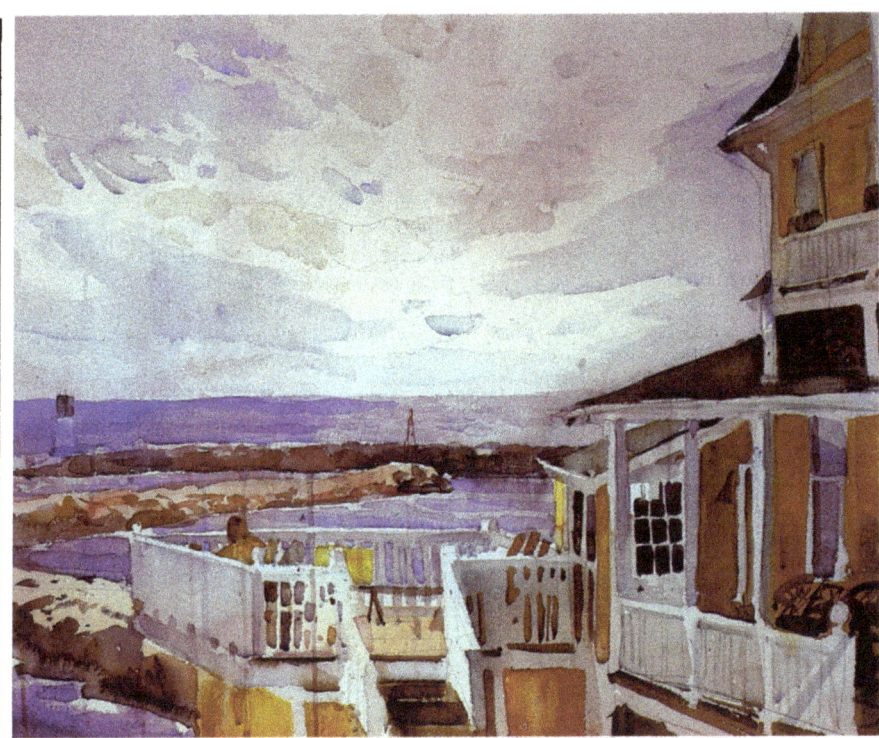

SURF HOTEL, BLOCK ISLAND

watercolor on paper,
22½" × 28" (57 × 71 cm),
private collection.

The lighting also inspired this painting. I always have trouble painting new places. It's particularly hard to take off for a week knowing I'll have to come home with something to show for the time off. On this particular trip, I trudged around Block Island painting one "dog" after another for two days. Then, coming back to my hotel feeling very low, I stared out my window and saw my view! I started *Surf Hotel, Block Island* the very next day. I wanted to get the feeling of the sun coming up, so I did the drawing the night before. That way I could immediately start painting at seven the next morning.

Every painting is different, and I rarely paint two paintings the same way. In this case I did the sky, water, and breakwater first, painting the negative shapes in the railing. Then at 9:30 A.M., I started work on the building and stopped painting for the day around 1 P.M. I finished the building the next day, without touching the water or sky again.

It's not supposed to be a good idea to do single sections of a painting, but it's sometimes necessary, especially if you're trying to capture a specific light like the one here. If you're painting a morning light, you should never work on the picture in the afternoon. It would be better to have a morning and afternoon painting going at the same time.

COMPOSING WITH COLOR

Since colors can emphasize or subdue areas in a painting, you must choose (and place) your colors with care. Here are some ways to shape a composition through color.

SARAH IN A RED JUMPER

oil on canvas,
14″ × 18″ (36 × 46 cm),
collection Judith Reid.

This painting of Sarah was done in one sitting. She wasn't pleased to be posing and decided to stare at me with as little expression as possible. She wasn't about to take a "pose." It was fun to go along with her and still manage a painting.

Since the pose was stiff and straight-on, I deliberately placed a red cloth behind her so the color-value tie-in between her red blouse and the cloth would insure that the pose was underplayed and not too obvious. To further reduce the formality of the pose, I made sure that the jumper wasn't symmetrical—notice that I continued it beyond her elbow on the left and let just a bit of it show on the right.

She was wearing a red bow, and I thought it would make a nice accent of color. So I lightened the wall and painted it a warm gray that tied in with the color and value of her hair. The result is that the top of her head gets lost against the background and the red bow stands out.

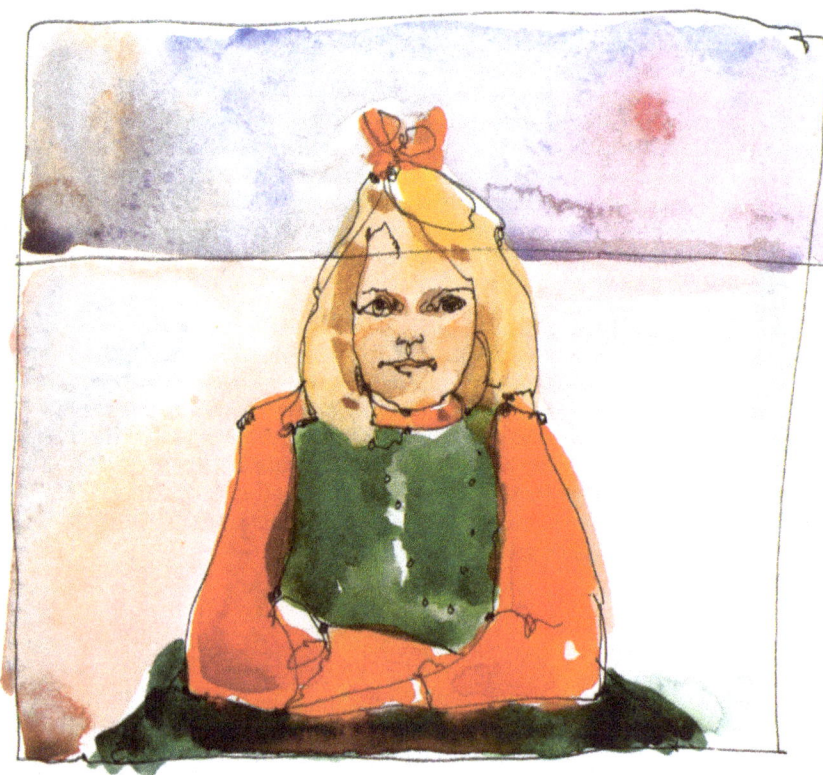

SKETCH

What a different painting my sketch would have made! Perhaps you may find it even better and more expressive than my painting. At any rate, it shows that you can competely change the idea and emphasis of a painting through the colors and values you choose.

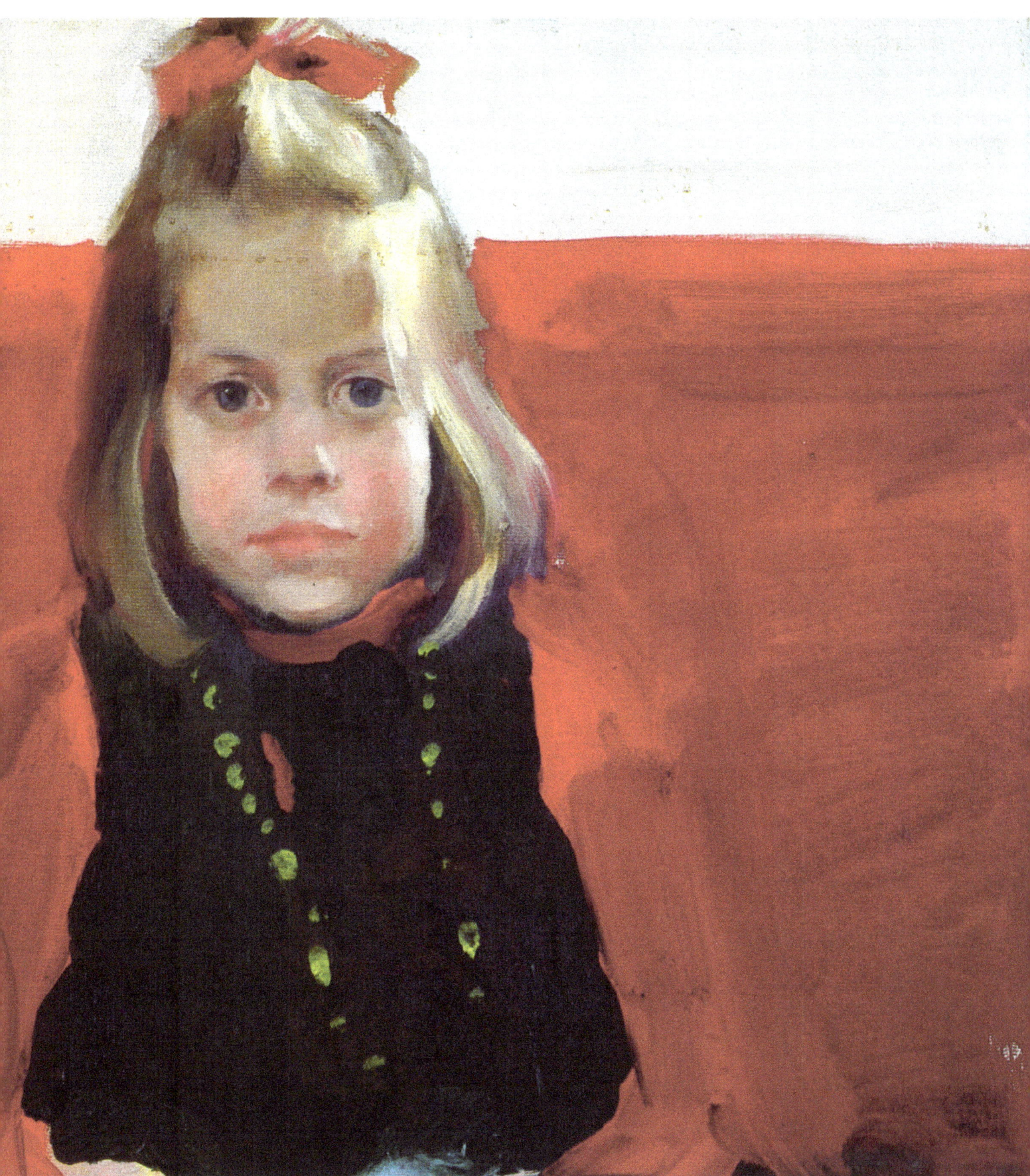

oil on canvas,
50" × 50" (127 × 127 cm),
collection Mr. and Mrs. Warren Pelton.

This painting was called *Thursday Morning* because every Thursday I used to meet with a group of fellow artists for a morning of painting. At the end of each session, each of us would take turns cooking lunch for the group. We started with cold cuts and, as time went on, worked up to Suprêmes de Volaille Véronique and beyond!

For this project, each of us posed for one session while the others painted. Of course, any idea of a proper composition was out of the question! We had only one model to work from each week and agreed to place the person where he or she would suit the group as a whole. Each model's pose required lots of adjustment in the painting, and the result probably looks a bit stilted. But I suppose most group portraits are painted this way, unless they're done from photographs.

The painting is essentially made up of warm grays, with cooler grays in Ann's blouse and Burt's face (the figure on the far right). The only apparent color here is the red that runs through the lower section of the painting.

Even though this was done ten years ago, I can still remember the agony of painting the windows. They went from warm to cool and then back to warm—with a bit of yellow or orange added to the white, then a bit of alizarin, then perhaps a touch of blue. I think you can see some examples of this "testing" in the windowframe on the left where some • parts are warm and other parts cool.

I chose my colors by comparing them to one another on the canvas, not by simply copying the colors I saw. That meant that the colors were not fixed, but grew organically with the painting. For example, I remember changing the color of the couch several times. Originally it was a warm ochre-green, and I was well into the painting before I decided to make it red. By then, the color of Burt's shirt had already been established, and I remember cutting out pieces of paper, painting them various colors and values, holding them against the painting, and asking my friends' advice about the color. We decided on

the red, and I painted a warm ochre pattern on it to tie it in with the warm browns above.

I think that the best lesson I learned from this project was to let the *painting* tell me what it wanted. I'm a purely visual artist, and it was good to have the painting become more important than what I saw before me.

ASSIGNMENT

This exercise will help you compose with color—and free you from copying the colors you see.

1. Make a careful line drawing, noting all the necessary proportions and relationships between positive and negative shapes. Your drawing should contain all the information you'll need to paint it. The actual subject doesn't matter. It should just be something you really want to paint.

2. Next make a careful color sketch of your subject, not careful in terms of realism, but again with as much color and value information as you can gather. Then take all your painting materials and go into another room or, if you're working on a landscape, return to your studio.

3. When you're no longer at the scene, transfer your drawing to your final working surface—watercolor paper or canvas. When you're satisfied with the composition, make a color sketch of your planned painting to give you a broad idea of the colors you'll want to use. If you're working in watercolor, you might make a complete painting from the sketch for your color note. If you're doing an oil painting, you might do a broad lay-in, perhaps working for about an hour on the sketch before putting it away. (It's hard to put a specific time limit on it, but with experience you'll start to know when you're getting the feeling of the painting taking over. It's sort of like a runner's "high.")

4. Then put away the original drawing and make several paintings using your color sketch as a reference. I don't mean to suggest this exercise as a way to paint a picture, but it might help you escape from the "tyranny" of the subject. In fact, I know this method worked in one case. I remember a student who had done very well in his art spending the last year in our class just making a drawing of the set-up, perhaps four hours of drawing, never using color. He ended up coming back with probably the best picture in class!

CREATING EMPHASIS WITH EDGES

There are several ways to create emphasis in a painting. You have already seen how it can be done through choice of colors *(Sarah, Thursday Morning)*, through the arrangement of values *(Half Moons)*, and by an emphasis on specific lines and shapes *(Girl in a White Sweater)*. But one of the most suble ways to direct the eye is through a careful selection of edges. For example, according to types of edges you use in various areas in a painting, you can create a soft, "lost" edge or blur where you don't want emphasis, and you can get a hard, crisp, precise edge (a "found" edge) where you do want people to look.

Most realistic paintings need this "now-you-see-it, now-you-don't" look. But lost-and-found edges have nothing to do with painting style. Nineteenth-century artists—such as Degas, Sargent, Whistler, and Renoir—depended on edge control to tie their subjects to the background. On the other hand, twentieth-century painters have tended to prefer making tie-ins through colors and values. (Gauguin seems to have started this trend.)

One common rule is that hard edges come forward or advance while soft edges go back or recede. Yet even though this is basically true, the rule is too simplistic to be taken at face value. For example, you may want an area that is coming forward to be unimportant, to fuse with its neighbor. Would you then make it hard, just because it's coming forward? Once again, such decisions should be based on the needs and demands of a particular painting and what you want to say there, and not on some rule.

DRAWING EXAMPLES

I made the first drawing of the model before any erasures had been made. Notice that it's hard to "read" the model's contour because all edges have received equal emphasis. The second example shows my drawing with the softer contours erased.

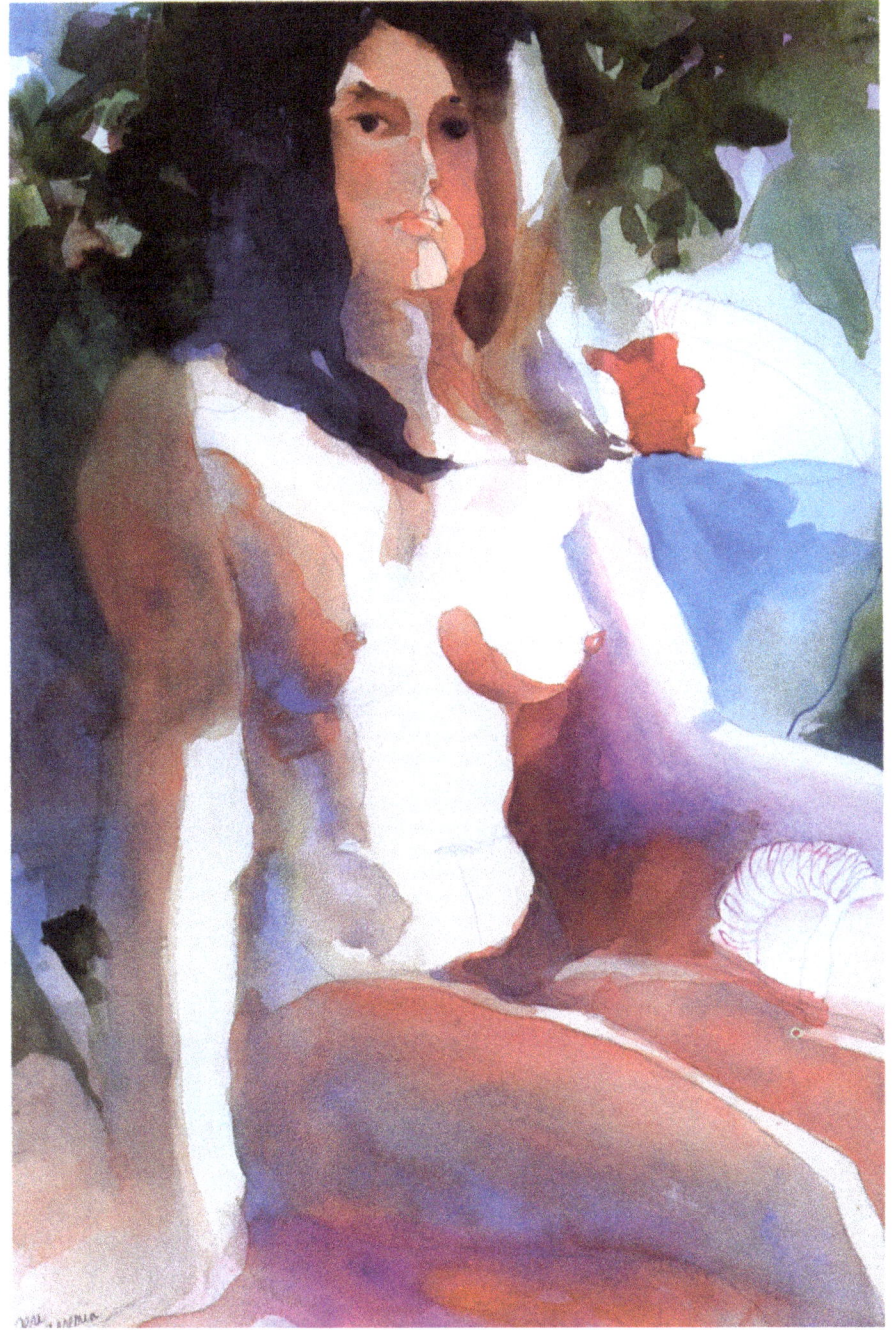

STUDENT PAINTING

This is a successful example of edge control, done by an experienced member of my class. Even though this is a complete painting rather than just a drawing, notice how well she handles the massing edge tie-ins. Do you see how she has developed emphasis? Can you see the "big blur" in the hair area and the hard-to-find contours in the arms and legs?

ASSIGNMENT

This exercise is based on a project I assigned my class. Even if you can't get a model, you can set up a similar situation, perhaps with a still life, and follow the basic idea of the project.
1. Make a contour drawing of the model, working in pencil so you can erase later. Try to have the figure or subject take up most of the picture space—let it overlap the borders in at least one, and possibly two, places. The rest of the painting should contain important background shapes, including shadow and cast shadow shapes.
2. Study the figure (or subject) for a few minutes, squinting the whole time.
3. Return to your contour drawing and erase any contour that was hard to see when you squinted. These erased edges will be the ones that you will later fuse with their neighboring areas when you begin painting.
4. Now that you've decided where to place the hard and soft edges, paint your drawing. Your painting should contain at least one large, completely soft-edged area—what Frank Reilly called the "big blur." Also, approximately a third of your edges should be soft, though the boundaries or contour lines should still be visible. The remaining edges should all be definite and crisp. I must remind you that this is not a formula for painting. It is only an exercise to help you understand how hard and soft (lost and found) edges work in creating emphasis. Your proportions of hard-to-soft edges will obviously vary according to the needs of each individual painting.

To minimize technical problems in handling the light areas, leave them as white paper. (If you're working in oils, just leave the canvas bare. This shouldn't present much of a problem, since oil painters usually paint their light areas last anyway.) Although you will doubtlessly see some hard edges within the figure itself (or your subject), I want you to ignore or underplay them for the purposes of this exercise. Just concentrate on the boundaries between the subject and the other areas in the painting.

MAKING EDGE TIE-INS

Most of us have no trouble making areas look isolated or separate. It's much harder to tie objects in with their surroundings.

Tie-ins can be achieved in several ways. You can create areas of similar value, for example, by putting a light object on a light surface, or a dark object on a dark surface. Or you can put objects of the same color in your set-up. You can also tie objects together through light and shade. A light object, for instance, will merge with a dark table on its shadow side. You can also create tie-ins by soften-ing edges to join two areas or through other color and value modifications. (When you soften an edge you are actually mixing the values and colors of two adjacent areas, giving them a common color-value border.)

Since the principle we're discussing is the same regardless of the medium, I have chosen both oil paintings and watercolors to illustrate my point. You should find at least one tie-in in each. Notice that separations of color or value are also found on edges within the object itself as well as at its outer edges.

BLUE CUP AND FIELD FLOWERS

oil on canvas,
26" × 26" (66 × 66 cm),
private collection.

Many of the objects in *Blue Cup and Field Flowers* are related by similarities in their local colors. For example, the flowers, vase, and doorframe —and the bowl, plates, and distant water, too—are various shades of white.

STUDIO YARD WITH ORANGES

oil on board (Masonite),
26″ × 26″ (66 × 66 cm),
private collection.

Foreground and background are linked
here through light and shade. For
example, the values of the white bowl
in shadow and the darker table out in
the light are almost the same.

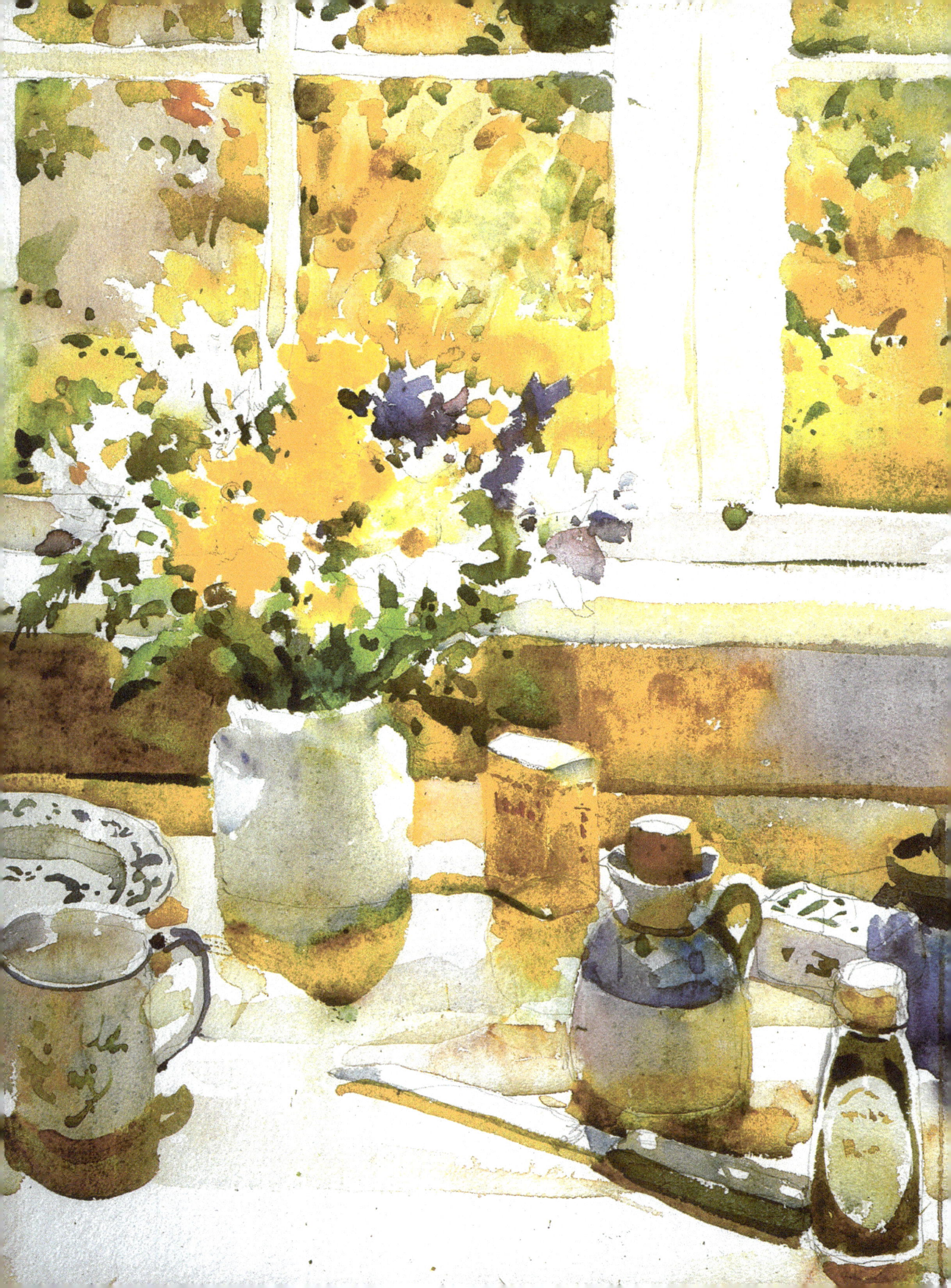

MAPLE SYRUP AND SPRING FLOWERS

watercolor on paper,
24″ × 12½″ (61 × 32 cm),
private collection.

Tie-ins here were accomplished through color modifications, though other methods were used, too. Notice how I cooled the right-hand side of the baseboard under the window to tie the color in with the blue-purple syrup container and other cool objects in the painting.

All three paintings were done against a strong backlighting, and so the objects and flowers had to be lightened several values higher than what I saw to bring them into tune with the backgrounds. Thus value modification also played a major role in relating these foregrounds to their backgrounds.

BONNARD AND CROWDED TABLE, NOVA SCOTIA

oil on canvas,
50″ × 50″ (127 × 127 cm),
collection Mr. and Mrs. John Barrett.

The greens in the grass and the small spot of distant spruces gave me the most trouble here, and I changed the color of the grass several times before I was satisfied with it. Actually the grass is more like a mowed field than a lawn, and I use a scythe in a very indifferent fashion to crop it. There are lots of small forms and dried clumps of yellow ochre mixed with the fresh shoots of new grass. One day I'll be able to paint it as beautiful as it really is.

This is the largest still life I've ever attempted. It was painted over a week's time in my house in Nova Scotia where, since I was alone, I could leave the set-up undisturbed. Looking at the painting, you'd think I had a constant north light, but the view was actually easterly, with dramatic light differences during the course of a full day of painting. The weather was constantly shifting, too. Some days were foggy, and there was one day of heavy rain. I was constantly tempted to alter various areas in response to a new color or value change that I saw during the course of painting it, but resisted the temptation. Nova Scotia is the kind of place that is never the same. The water may seem purple one day, a brilliant

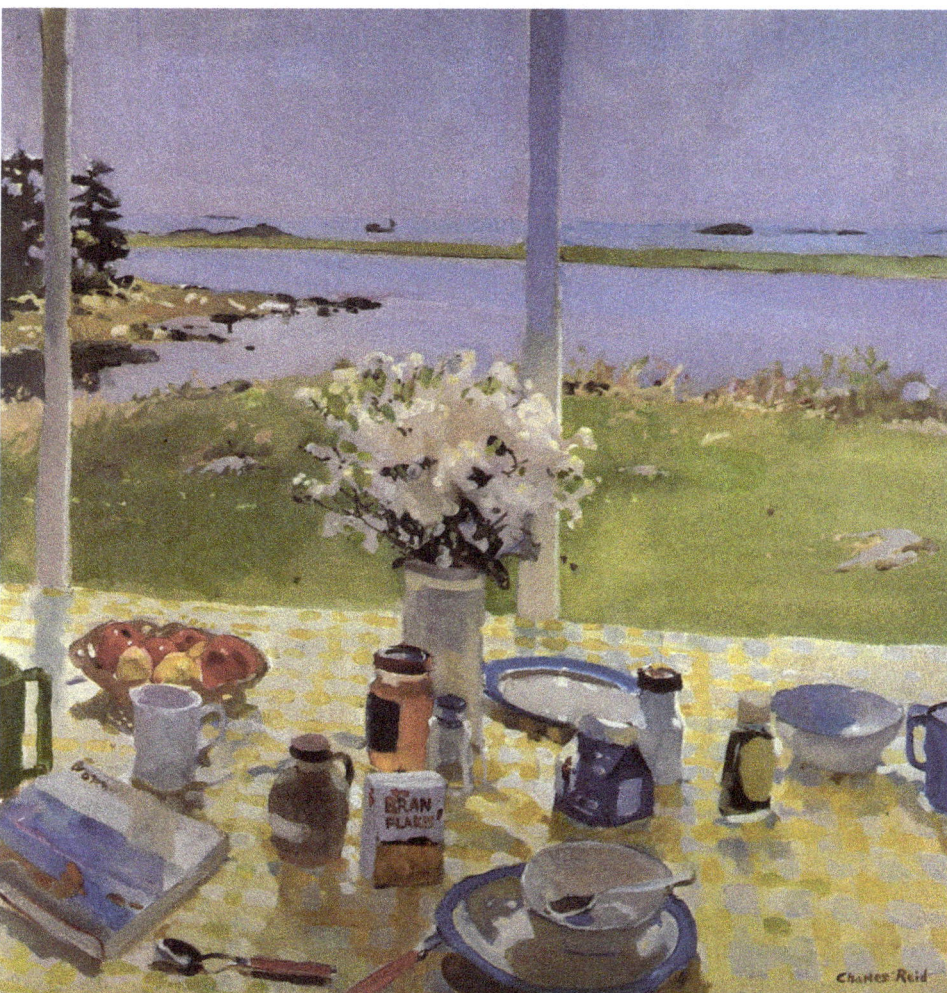

phthalo blue the next, or a dirty gray another time. Sometimes it can shimmer like diamonds. But you can't keep changing a painting or you'll end up with mud, so I pretty much stayed with the color idea I established the first day.

To start, I tried to cover the whole canvas with color notes, little swatches of separate colors. I made sure I worked around the edges, then worked back and forth between the still life and the outside scene—sky, water, grass, and trees. For example, I would work on the marmalade jar, with a lot of cadmium orange, then take the same orange and mix it with a little raw sienna and scrub the color into part of the shoreline on the upper left of the painting. Or I would put some purple from the water into the milk carton, too. The painting was like a patchwork quilt slowly being brought into focus.

ASSIGNMENT

Set up a still life that contains objects with a variety of local colors and values. Make sure one or two are similar in color and value to the table and to the background. Overlap some objects, and leave one or two of them separate. When you paint them, try to tie in almost all the objects either with an adjacent object or with an area of the table or background. It doesn't matter if one or two objects don't relate in value, but make certain their color is picked up somewhere else in the painting.

Try to tie in adjacent areas through at least one of the following:

1. Same local color.

2. Same local value.

3. Value connecting through light and shade.

4. Modifications in value (for example, through soft edges).

5. Modifications in color (for example, through color temperature).

RELATING MODEL AND BACKGROUND

Tie-ins between the figure and the background can be introduced in figure paintings pretty much the way they are done in still lifes, by modifying the values and colors in both areas so the entire painting is in harmony. As I said in the preceding section, this can be done by introducing color from one area into other areas in the painting, particularly adjacent areas. It can also be accomplished by softening the boundaries between two dissimilar colors. This will gray them slightly, so their colors are not as strong and individualistic. Here are some examples of what I mean.

JOHN PLAYING THE GUITAR

watercolor on paper,
14″ × 18″ (36 × 46 cm),
collection the artist.

This painting was done as a class demonstration. Although I worked in watercolor, the method used here (putting in the darks first and leaving the light areas white) is closer to a traditional oil painting technique. Notice that I ignored the value differences within the light and middle-value dark areas. Instead of making value changes within these darks, I suggested changes in form through color variations and have allowed adjacent colors to flow over boundaries.

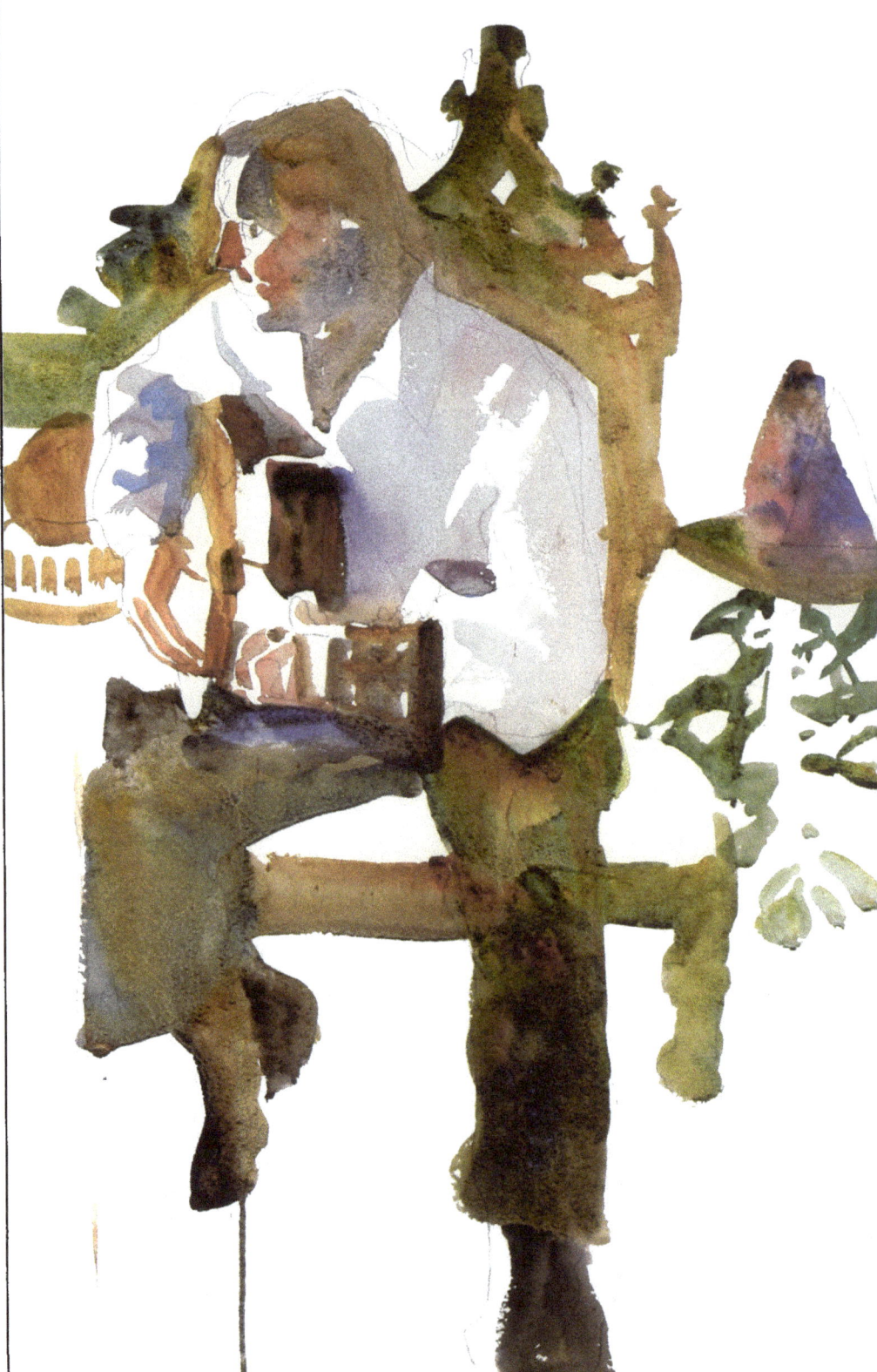

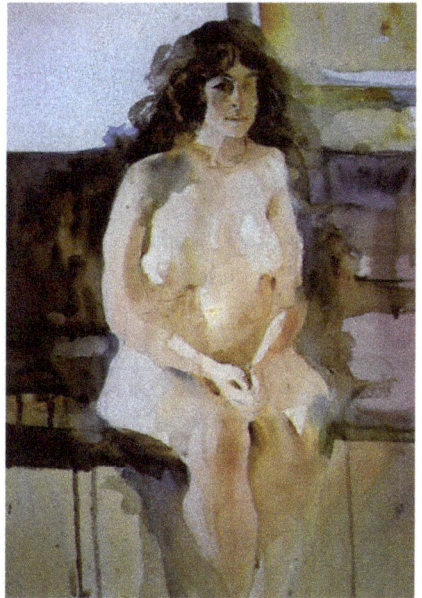

SKETCH CLASS

watercolor on paper,
22½" × 30" (57 × 76 cm),
courtesy Jack Meier Gallery, Houston.

I did this figure in a sketch class that had no backdrop. Since I liked it, I added a background around the model when I got home. But I think it shows. The model doesn't seem involved with her surroundings, and there are no good connections between the room and her figure. In retrospect, I think that I shouldn't have finished the figure so completely. I should have left some blurs that could have been worked into the surroundings I added later.

ROBIE'S STUDIO

watercolor on paper,
22½" × 30" (57 × 76 cm),
private collection.

The model was actually fairly skinny, but I made a poor drawing and before I knew it I had a Rubens! Please note all of the lost edges—I tried to let my shadow shapes flow through the figure and into the background. I could have lost the shadow side of the figure by blurring it into the background, but I liked the tentative pose and hated to lose an important gesture. I did lose the legs, though, except for a nice shape in the left leg. Whether you lose or find an edge doesn't depend on rules. It depends on what you want to stress in the painting.

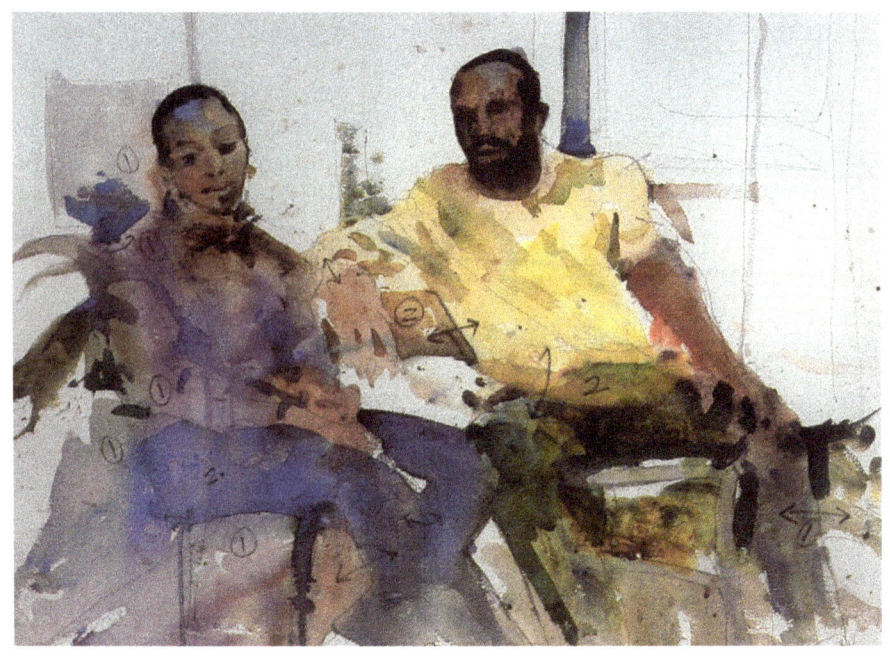

SNUG HARBOR
watercolor on paper,
22″ × 28″ (56 × 71 cm),
private collection.

Before I start painting, I always ask myself, "What's important here?" In this case, it is the heads and the man's gesture. (The woman's gesture is mostly seen in the position of her head.) Next I decide where I'll put the big connections joining the two people to each other and to the background. I also look for places where I can separate objects to define their shapes.

This painting was done as a demonstration to show how I would tie adjacent areas together in terms of value. The "1" on the painting indicates my first wash, and the "2" indicates a second overwash, done after the first wash was dry. (I don't always wait for a first wash to dry completely, but when working with light, rather watery washes, I think it's safer.) I used the first wash to connect areas—you'll notice that all colors marked "1" are the same value even though the hue is different. I used the second wash (marked "2") to create some definition of edges and separation of shapes. The point of the exercise was to show that a first wash can and should cross over boundaries, and that "lost" boundaries can be "found" again with a second wash.

The first wash was lighter in value than the second. I left the area above the woman's left leg white to separate her from the background. Then I massed the other areas, allowing her skintones to flow into the background and clothing. Since the man was wearing a light-colored sweater, I was careful to mass his dark skin only with the shadow areas. I carried some of the green of his slacks into her trousers (you can see it where the knees meet), and ran some of the alizarin in her slacks into his left leg. You can see other such "color bridges" wherever two different objects with different local colors meet—for example, where her left shoulder ends and his right cuff begins.

The darker notes of the second wash suggest separations—on the man's right sleeve, for example, and above the woman's right shoulder.

watercolor on paper,
21″ × 28″ (53 × 71 cm).

This was a painting I did as a class demonstration to illustrate how to use tie-ins between the figure and the background. It's a rather silly picture and catches nothing of the poised young woman who posed, but I hope you still can see all the places where I tried to connect the model with her surroundings. I've used soft edges, similar values between adjoining areas, and color tie-ins. Look at all the lost edges here. Also, notice where I made a boundary definite and where I fudged it.

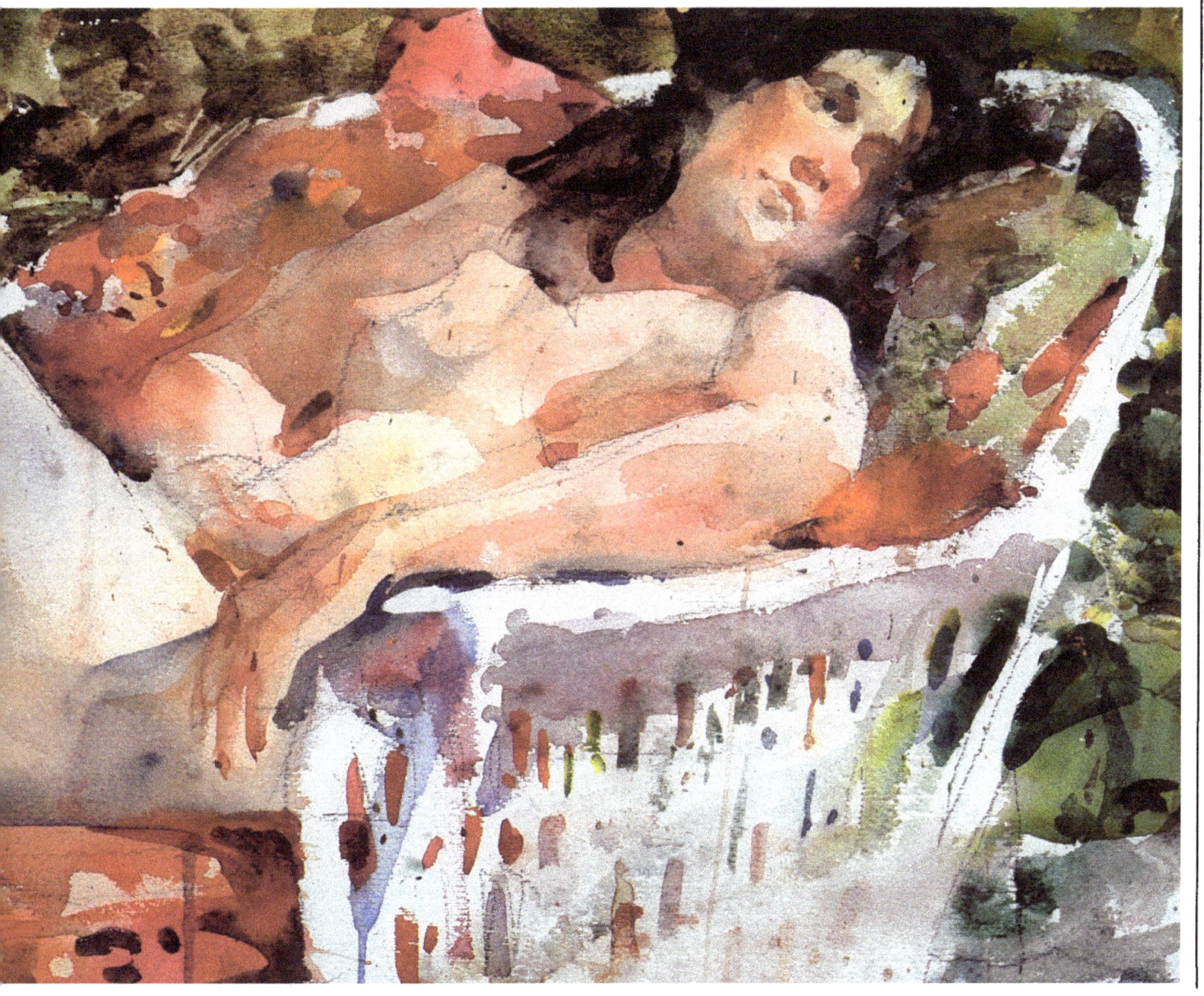

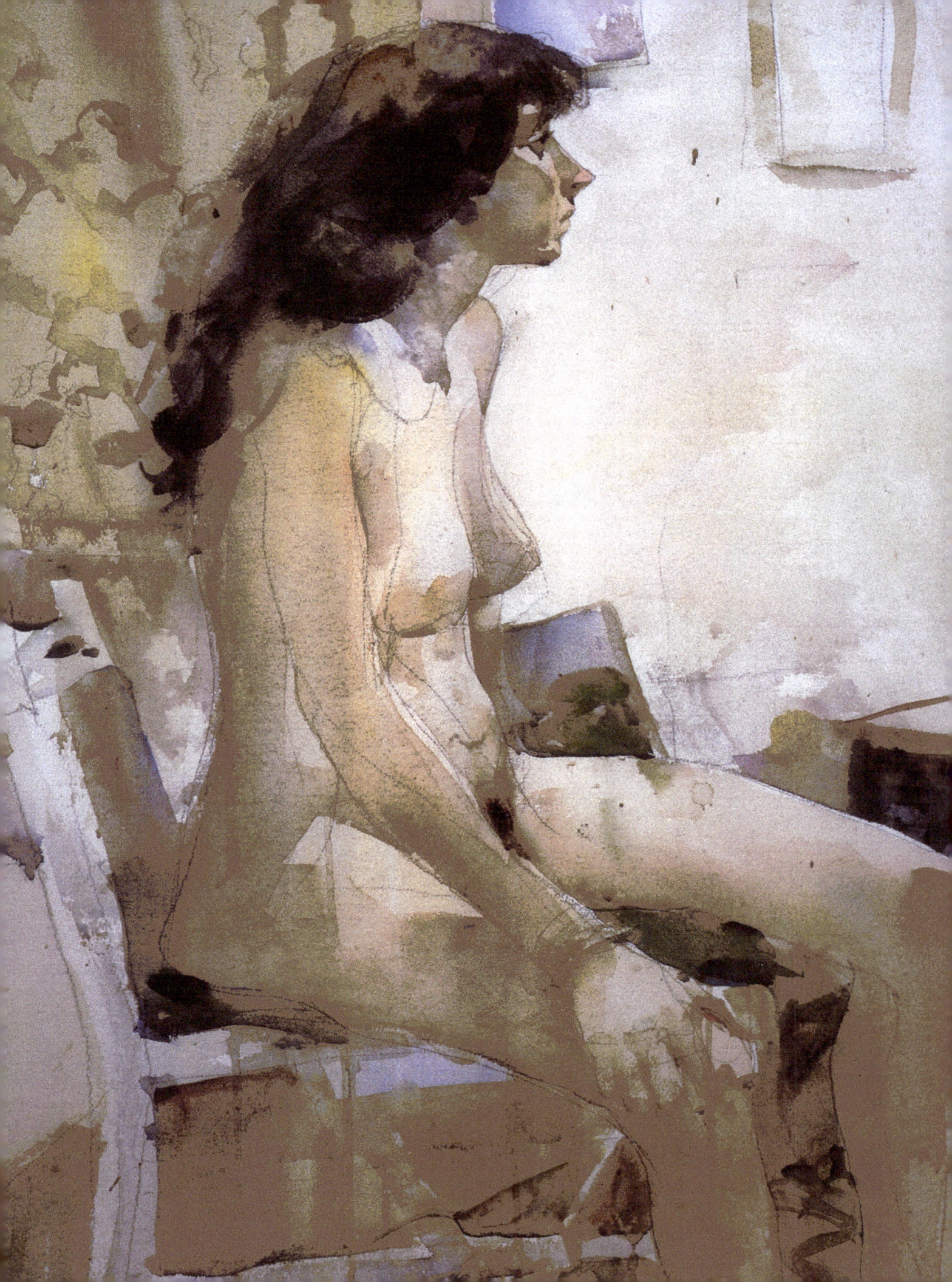

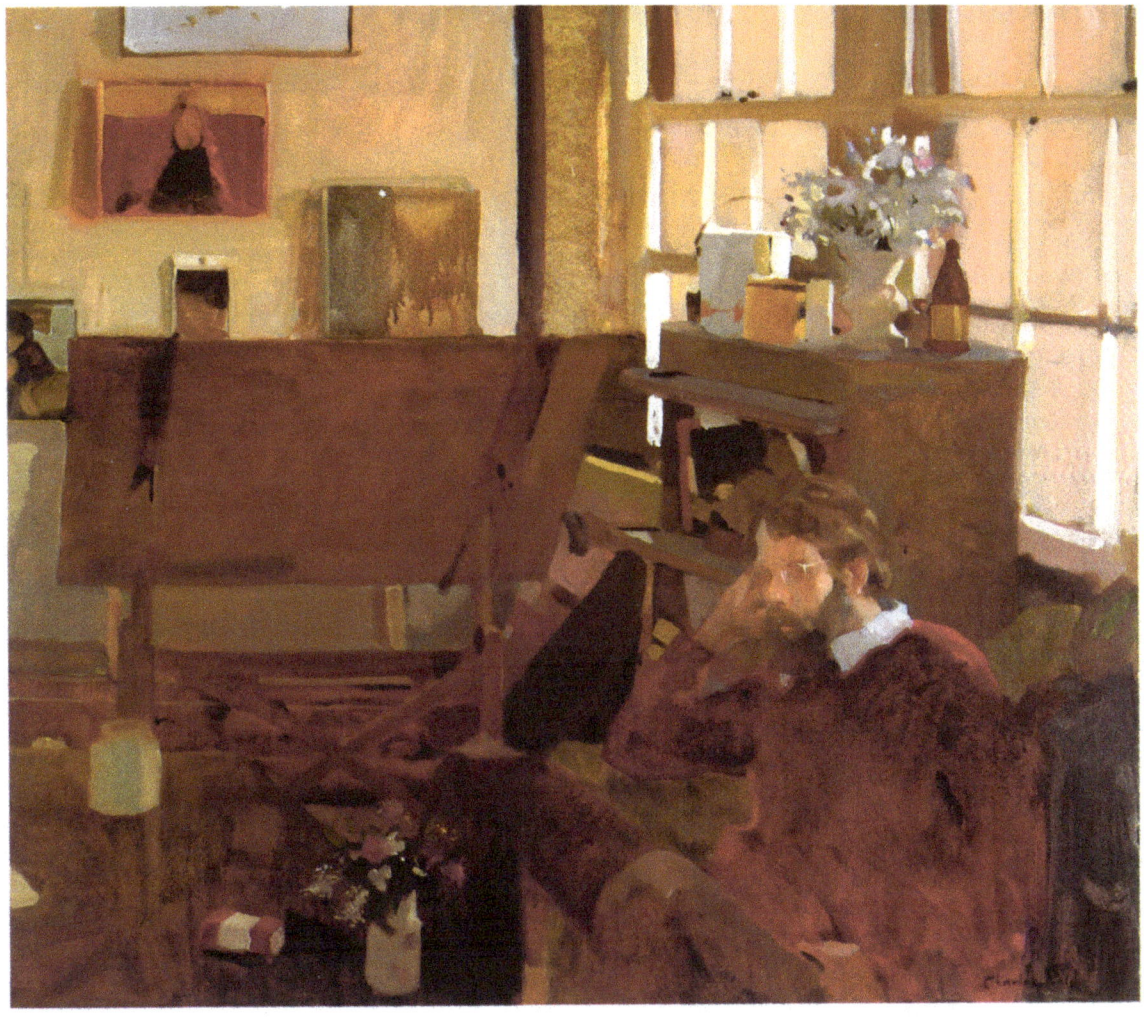

VARDA

watercolor on paper,
22½″ × 30″ (57 × 76 cm),
private collection.

I'm usually glad to see the last of my paintings, but this is one I wish I still had. Notice where I separated the figure from the background and where I connected it. The left leg is an obvious example. I used the darker background forms to set off her lower torso and leg, but I left an opening in those background forms to create an escape route. If I had made just one long, dark background shape, the leg would have been isolated. I wanted to set off her light-struck figure, but I didn't want to isolate her.

There's also another connection between the background and figure on the upper torso, where the light values on her body make a bridge with the light background. I stressed the shadow shapes on her face to make a fairly strong silhouette because I needed a strong contrast there against the background. Had the face been painted as light as the torso, the painting would have appeared weak and washed out. Also I wanted the viewer to be attracted to the face over other areas of the painting.

ALLEN AT STUDIO II

oil canvas,
40″ × 39″ (102 × 99 cm),
collection the artist.

This time I worked in oil. Although there are some soft edges here, I relied on color-value tie-ins to integrate Allen and his surroundings. Almost every area is tied in with a neighboring area. The obvious tie-ins are in value, but there are color modifications as well. For instance, observe how, behind Allen's sweater, the cabinet is warm, but as it nears the cooler objects by the window, its color gets progressively cooler.

I never feel locked into painting any object either all warm or all cool. If a warm object is next to a cooler area, I might add cool color to it to develop a connection between the areas. The painting of my daughter on the wall in *Allen at Studio II*, for example, is a bit isolated in terms of value, but I warmed the color of the adjacent wall to create a connection between both areas.

ASSIGNMENT

The purpose of this assignment is to force you to paint back and forth between the subject (the figure) and the background. When you do this, the background shapes will become just as important as the figure shapes. This will help to integrate the figures with the background so it does not look isolated from its surroundings. (Notice how I handle this on page 115 in *Wally*.)
1. Pose a model or set up a still life with one large, central object.
2. As you paint, try to connect all middle and dark values both within and outside of the figure. Leave any value lighter than a middle value white. The middle and dark values should include both local color values and the important shadow and cast shadow shapes. Ignore all subtle value changes and halftones.

HANDLING PATTERNS

Patterned areas can serve several functions in a painting. The most obvious one is to lend interest and detail to the work by providing many small forms to contrast with larger, more simple areas. Patterns can also provide "tie-ins" between adjoining sections of a painting. There can be tie-ins in value—where a light area can be tied to a darker one by introducing a light pattern into the darker area. They can also be tie-ins of color—where a warm area can be connected to a cool area by introducing a cool pattern into the warmer section or vice versa.

Here are two paintings, one in oil and the other in watercolor, to show you how patterns can add interest to a painting and integrate its elements.

JUDY'S TABLECLOTH

watercolor,
24" × 26" (61 × 66 cm),
collection the artist.

The checkered tablecloth plays a major role in this painting. Whereas the pattern of the oriental rug in *Wally* was fairly close in value, the checkered tablecloth here has a very definite value contrast. Also, its light and dark pattern creates essential value and color connections between the objects on the table and the tablecloth. In fact, the pattern of the cloth is actually more important than the objects (which accounts for the painting's title). Notice that I have deliberately "lost" some sections of the tablecloth pattern—the checks in the upper section of the table have been lightened considerably. By contrasting this area with the stronger pattern in the foreground, I have tried to create a feeling of space.

WALLY

oil on canvas,
40" × 50" (102 × 127 cm),
collection Brigham Young University.

Here I used the pattern in the oriental rug to lend interest to a very large area that might otherwise have been rather boring. In terms of color tie-ins, notice that the rug is primarily warm, but some cool notes there relate to cool touches of color in the table and on the figure. Also, the blue in the scarf ties in with the cool tones in the hair.

There are value tie-ins here, too. The white of the scarf relates to the white shirt, for example. And even though the rug is relatively dark, the variety of values in it makes the figure look less isolated because the darker parts of the pattern on the rug relate to the darker areas of the figure, and the lighter patterns suggest a connection with the lighter areas on the figure.

VIGNETTING

Vignetting—leaving a good deal of white paper around your subject—is yet another way to achieve emphasis. It may be an easy way out, yet if you have nothing interesting to place in your background, it's a possibility. A word of caution: if you plan to submit your painting for exhibition, I advise against painting vignettes. Judges often don't consider them finished paintings. However, vignetting creates a nice freshness that you can't get in any other way.

PETER—MAY 14TH

watercolor on paper,
22½″ × 28″ (57 × 71 cm),
collection Judith Reid.

This painting was done as a sketch—it really isn't a composition. But I'd like you to notice how I introduced white paper into the figure. When you plan a vignette, you can't finish a subject, person, landscape, or still life completely—painting everything within the subject—and then proceed to leave the outside white. In a vignette, you must allow white paper to appear within the subject too, to make a comfortable transition from the painted areas to the unpainted ones.

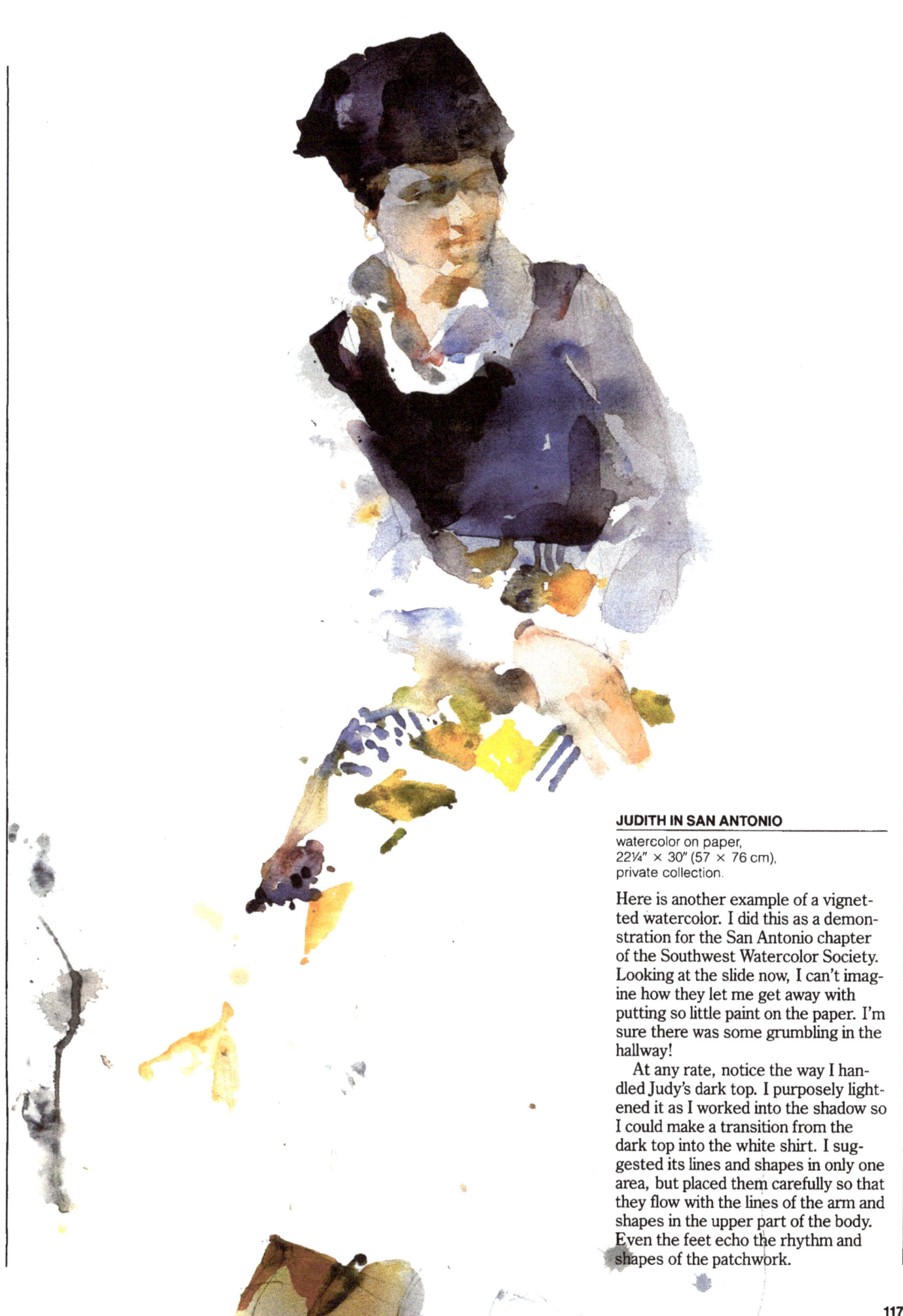

JUDITH IN SAN ANTONIO
watercolor on paper,
22¼″ × 30″ (57 × 76 cm),
private collection.

Here is another example of a vignetted watercolor. I did this as a demonstration for the San Antonio chapter of the Southwest Watercolor Society. Looking at the slide now, I can't imagine how they let me get away with putting so little paint on the paper. I'm sure there was some grumbling in the hallway!

At any rate, notice the way I handled Judy's dark top. I purposely lightened it as I worked into the shadow so I could make a transition from the dark top into the white shirt. I suggested its lines and shapes in only one area, but placed them carefully so that they flow with the lines of the arm and shapes in the upper part of the body. Even the feet echo the rhythm and shapes of the patchwork.

PAINTING AGAINST THE CONTOUR

Many students tend to repeat the contour of their subject in the background of their paintings by running their brushstrokes along the outline of the form. But "going with the flow" as I call it—repetitive brushstrokes that outline a form—isn't always a good idea. In fact, it can be boring and overly repetitive.

Instead of simply painting around a contour, you should decide whether you want to repeat a contour and strengthen it, or run across it and break it up. In other words, you always must keep the needs of your painting and your main idea in mind. You must know what you want to emphasize and what you want to subdue.

Look at some reproductions of paintings by van Gogh or Cézanne, particularly work done between 1885 and 1890. (I mention those two painters because their thinking is so visible in their brushwork, but Degas' pastels and Toulouse Lautrec's paintings are also good examples.) All these painters repeated the contour of the form in some places, and opposed it in others. For example, van Gogh echoed the contours in the background in order to set up a certain vibration and movement, something like a cartoon character who has been hit over the head. Cézanne's treatment of contour and background was much more complex. "The contour eludes me," he once said.

The point that I'm making is that you can't just paint the background around forms any old way. You must decide what you want to emphasize or subdue. Notice the way two of my students treated the contour.

ASSIGNMENT

Try to counter the action of a figure or object by painting opposing forms in the background of your painting or by stressing opposing forms within the figure using color, value, or line. Using color, for example, you could counter a standing figure with a strong horizontal line of color. Using value and line, you could subdue a light-colored vertical form with dark, horizontal contrasts in the background.

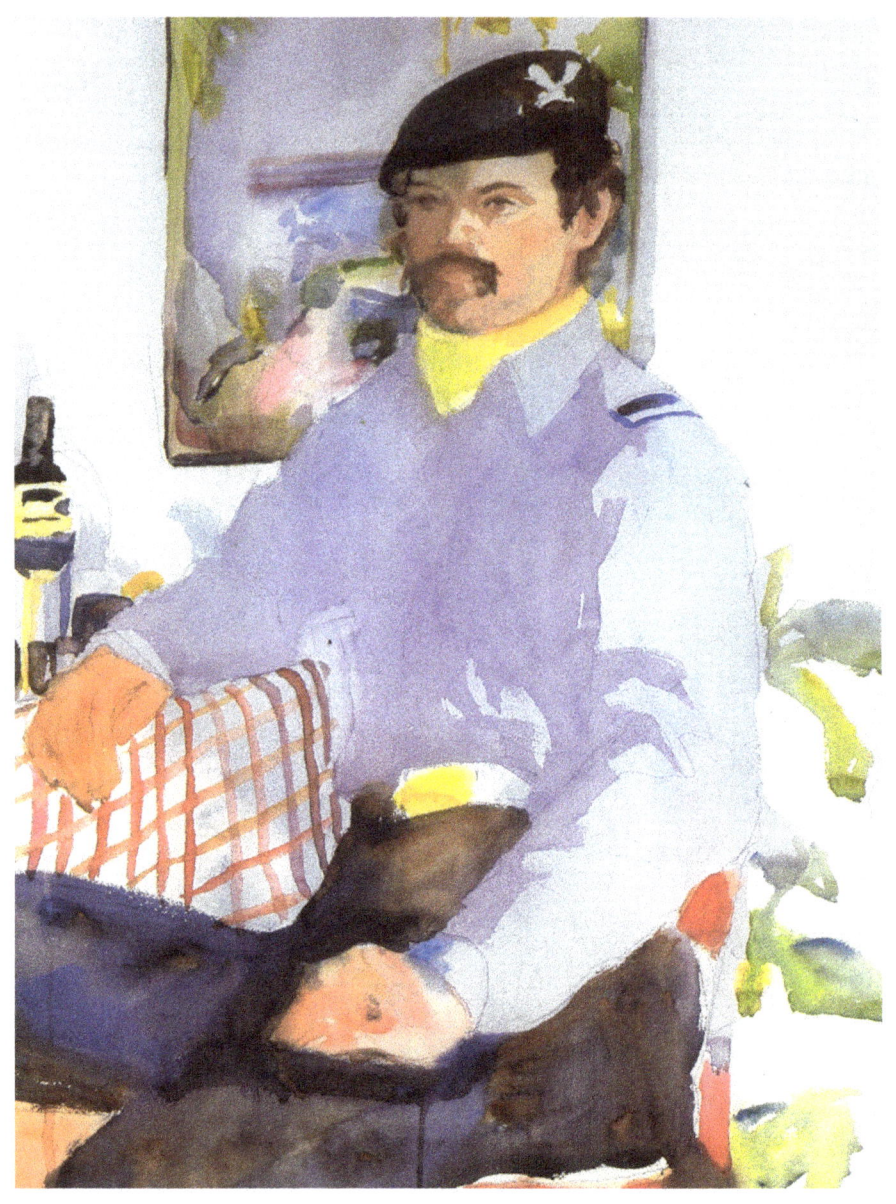

EXAMPLE 1

This student placed the greatest value contrast between the model and the background in the model's right leg. In terms of line, the leaves set up a repeating horizontal movement against the model's form. Notice how the artist used the strong reds in the tablecloth as diagonal lines, and how their right angle counteracts the contour of the figure.

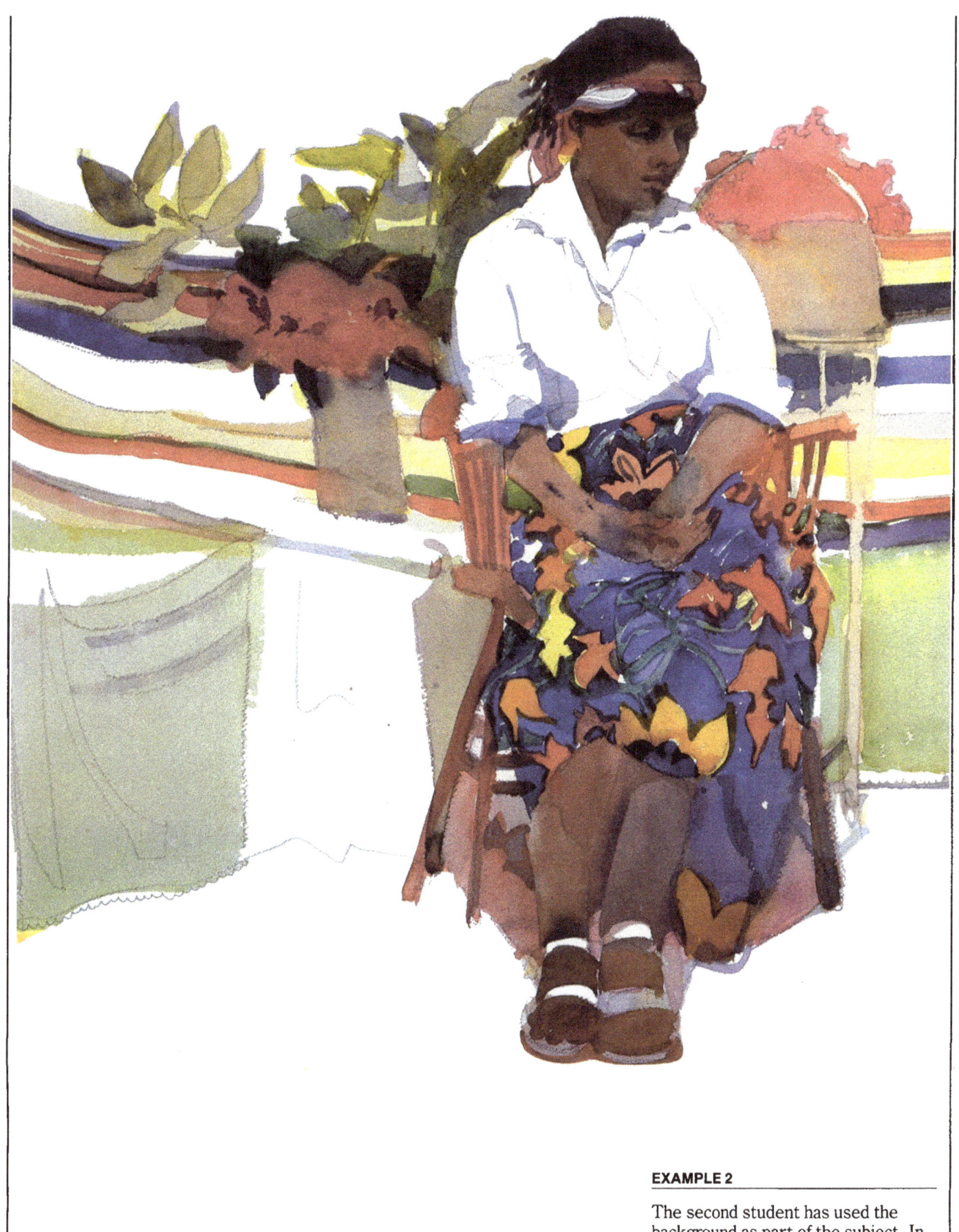

EXAMPLE 2

The second student has used the background as part of the subject. In fact, in importance, it's an equal partner with the figure.

LOOSENING UP

All of us get into ways of painting that work for the most part, yet just aren't satisfying, and so we want to break out of them and loosen up. Some of us think of loosening up in terms of splashing paint around or working faster—being "spontaneous" is a term I hear a lot. But "loosening up" or whatever you want to call it is a state of mind, not a state of the brush. Splashing paint on paper or canvas with the hand—without splashing it on with the "head" first—will just make a mess!

Before you rush to change your style, you must decide if you really want to change tracks after all. Are you really unhappy with your work? After all, some of us aren't meant to be loose painters. Painting reflects our inner selves and what we literally "are," and we are not all spontaneous by nature. As artists, we should be expressing our individual view of the world, not trying to conform to someone's idea of what a painter should be.

Some students have told me time after time that they want to be "free," yet they continue to paint in a careful, precise manner. I'm sure they like my work and really believe they'd like to paint like me, but inside they're painting just as they really want to—as their personality dictates that they paint.

It seems to me that a particular style of painting should not be based on technique, but rather on conveying an artist's thoughts and ideas. A good painting can be done with a controlled technique as well as a loose one. What really good painter have you faulted for being too tight? Vermeer? Van Eyck? Hopper? Wyeth? All of them had a fairly controlled technique, yet their paintings have life. Their looseness comes from their point of view, not their technique!

SKETCH OF THE ENTIRE PHOTOGRAPH

I've made a drawing to show you how the photograph actually looked. I made several paintings of this group of people, trying various arrangements of the figures (as you can see in the painting). I also tried using different color combinations—I remember one version had an ultramarine blue sky. There was also a breakwater behind the crew, but I became so intrigued with having a large empty space there that I left it out.

FRESHMAN CREW, YALE, 1885
oil on canvas,
24″ × 25″ (61 × 64 cm),
collection Mr. and Mrs. Allen Cramer.

At one point in my career, I set up problem situations to help me break away from the way I was painting. For instance, I forced myself to use colors I didn't like and to paint subjects I didn't normally paint. The experience taught me respect for good non-representational painting.

Since I needed a subject for these abstractions, I tried painting old photographs. In *Freshman Crew, Yale, 1885,* I cut off parts of three heads and used mostly grays and viridian green (a color I dislike for its coldness) to paint them. In a sense, this was a gimmick, but I do think you must impose some kind of challenge on yourself if you're ever going to change and improve your work.

VERMONT CART

oil on board,
20″ × 20″ (51 × 51 cm),
collection the artist.

I make paintings like this often. I try to find a particularly uninteresting subject and make a bad composition intentionally. It's one of the ways I have to keep from getting "tight." (I should have carried my bad idea further and cut off the garden cart at the margin, though.) Once I'm sure my composition is beyond repair, I'm free to concentrate on working out problem areas. In this case, I turned my attention to the color.

I have a lot of trouble with greens, so I spent my painting time here experimenting with mixing greens from earth colors. I tried raw sienna and yellow ochre with sap green and viridian. I also tried making greens with ivory black and cadmium yellow or cadmium lemon. I believe I used cerulean and cobalt blues with cadmium lemon in the foreground. Then, to get a milky look, I added titanium white to the foreground grass. I still didn't get what I wanted with my greens, but I thought I made some headway. (See the section on mixing greens for more advice.)

ASSIGNMENT

Thoreau once said, in answer to a complaint that he never went anywhere, "I have traveled a good deal in Concord." What he meant was that it was better to have a strong, intimate knowledge of a single nearby place—in this case, Walden and Concord—than a more superficial familiarity with bits and pieces of distant, glamorous areas like Venice or Paris.

This is a favorite quote of mine, but it applies particularly well to the point of this assignment. Instead of exploring your subject matter in a broad sense, painting a variety of subjects in only one medium, try exploring a single subject over a long period of time, say, several months. Thus, if you're an oil painter, put away your paints and draw for several weeks or work in watercolor instead, or if you're a watercolor painter switch to oils or draw. You may find drawing hard or boring, but it is the only way to truly understand a subject.

In terms of subject matter, choose something familiar and interesting to you—a person, a chair, a pear—anything. As you work, try to think in terms of different points of view, seeing the subject in unusual ways. For example, draw the subject from above and below. Do magnified versions of it. Do small studies on a large surface. Or do multiple versions of the same subject.

I once spent a month just making clay figures. At first they started out as academic studies. Then as I started to become more familiar with my subject and medium, I relaxed and an instinctive, personal point of view emerged, and I found myself elongating and exaggerating the forms. Let me give you another example: I can paint loose-looking figures now because I've drawn from the figure for years. On the other hand, because I don't understand landscape, my landscapes are tighter and often dry-looking. Constant contact with the subject will help. You can't paint something with life and joy unless you truly know it!

Baccaro Harbor. N.S. 8·2·77 CR

MODEL WITH LARGE PLANT

In this section, I've chosen some paintings that I think illustrate typical errors I frequently see in my classes. Unfortunately, since I teach mostly watercolor, oil painters won't find examples of their specific problems here. Nonetheless, since I won't be talking about poorly graded washes or faulty wet-in-wet errors, or other strictly technical subjects, oil painters should be able to apply these critiques to their paintings too. Throughout this book I've deliberately tried to avoid such "medium" problems, since many books on oil and watercolor painting techniques already deal with this information. As I've explained before, the aim of this book is not to teach painting in a specific medium, but to show you how to paint in general.

There is one trait both oil and watercolor painting students share. It's fudging. By "fudging" I mean over-mixing and overworking your colors until they turn lifeless and muddy, with smudged boundaries between areas. Oil painters *think* they can fudge all they want and get away with it, and watercolorists *know* they can't but still do it anyway!

As I write this, I'm looking at a reproduction of a Cézanne painting, *Fruit Dish and Apples*. How fresh it is! He set down the pieces of *oil* color on canvas as accurately and cleanly as a good *watercolor* should be painted.

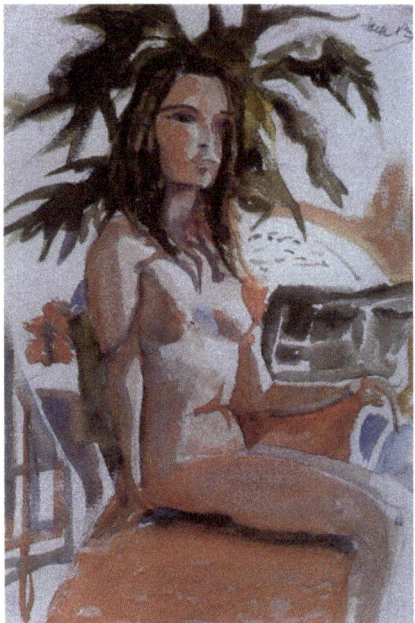

EXAMPLE 1

This is a typical figure painting by someone new to figure work. I think the main problem here is that the artist was trying too hard to paint a figure rather than simply trying to do a painting.

First of all, the proportions are off. The features are much too large for the head, which in turn is too large for the body. Also, the body forms get progressively smaller as our eye travels down the figure. This is a common problem. Many students make the head too big and body too small for fear of running out of space. If you do this too, try starting your contour drawing with a hand, knee, or foot. Don't worry if you cut off the head. This is just good practice in training you to keep your forms in proportion.

There is a second problem here, too. The student had tried to paint what he knew, not what he saw. The face was mostly in shadow and he tried to paint the features even though he couldn't see them. It would have been much better to ignore the features and paint the shadow pattern instead and aim for a good color-value there rather than an accurate likeness.

A similar problem occurred when he painted the body. The shadow shapes there are good, but the color has a washed-out look because he

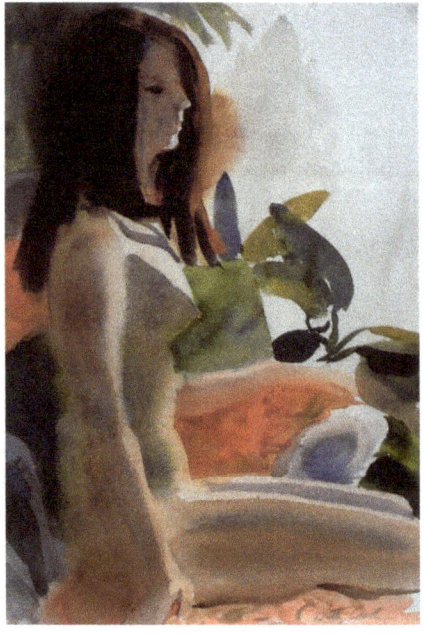

wasn't thinking in terms of rich color areas. Instead he got involved in trying to render a figure.

EXAMPLE 2

Here's another student's painting of the same model from practically the same position. This painting was done rather quickly, in about two hours, by a very experienced painter. As you compare the two works, try to focus on the painting differences rather than on their proportions, which is a drawing rather than a painting problem and is not of interest here.

First compare the feature grouping here in relation to the size of the head. The features take up roughly a third of the total head-hair mass, which is what they normally should do. There is also an excellent treatment of edges, with a good variety of both lost and found types, particularly in the hair.

Now look at the shapes. The hair has been treated as a single shape of rich color-value. The face is also a shape, with an accurate rendition of rim lighting. The figure, too, is made up of large shapes of color and basically two major values, a light and a shadow. Little attempt has been made to model and render the figure by adding halftones. Instead the shapes have been painted in strong, expressive colors.

KERI ON A CHAISE LOUNGE

These three paintings were done from the same viewpoint during a painting seminar. The three artists are not equal in terms of technical skill, but I try to stress ideas rather than skill in my classes since some rather clumsy artists have painted wonderful pictures because they had a point of view and something to say.

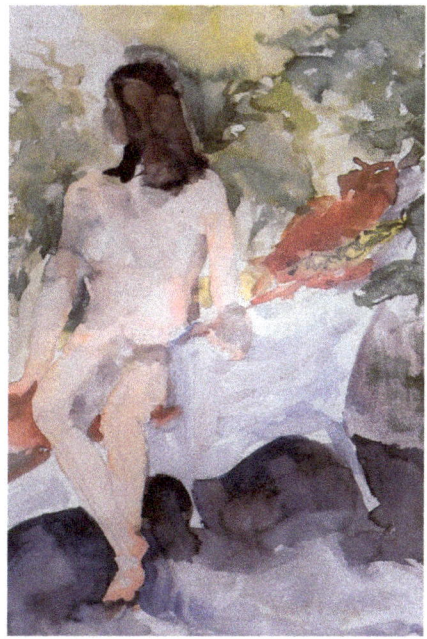

EXAMPLE 1

I like the delicate color-value relationships here. The painting is high in key, but because it has color-value, it doesn't seem weak. I think the color black works well. It forms a rather solid foundation for the high-key values above.

On the minus side, the painting lacks strong shapes in both the figure and background, with the exception of the definite shapes under the chaise lounge. There's a tentativeness here that might be caused by the trouble the artist had in painting the face. This person simply needs a lot of practice in drawing figures.

EXAMPLE 2

The chaise lounge and the model's head are fine here. The chaise wasn't painted perfectly, but still it's handsome in its imperfection. In fact, it's quite beautiful. Compare the handling of the chaise with that of the figure and plants. The chaise is painted simply and directly, while the plants and figure are weary and overworked. This student should be doing several paintings in the time it now takes her to do one. It would be better to have some clean, fresh color, as in the first example, even if the color is off and the contours unsure. One reason this is so overworked is because of the artist's obsession with getting every contour just right.

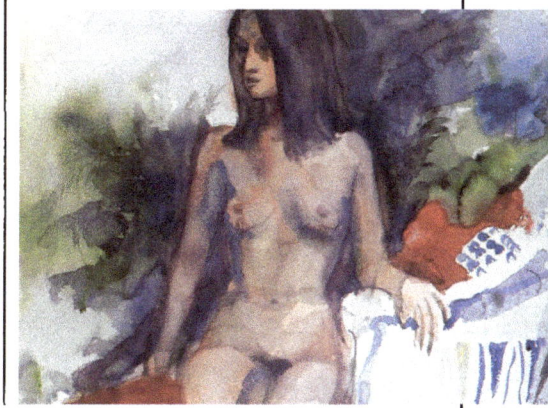

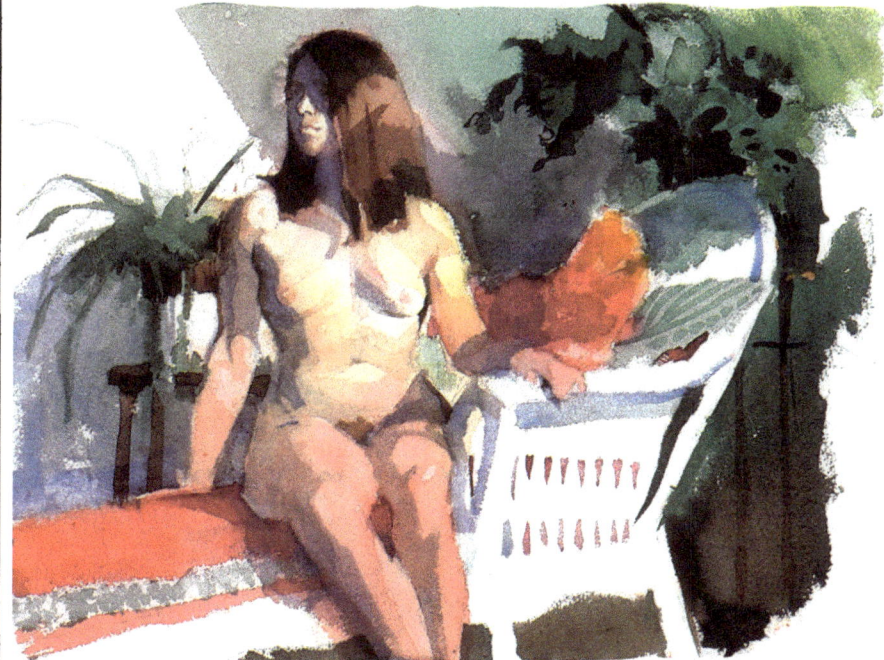

EXAMPLE 3

This student is experienced in both painting the figure and using watercolor. Altogether this is a very good job. One major advantage this artist has over the others is her evident drawing skills. It's a harsh thing to say, but if you can't draw the figure, you won't be able to paint it. My only objection is the lack of color relationship between the figure and the greens, which look acidic and harsh. They were made with viridian, but it would have been better to mix them with blue and either an earth yellow or one of the cadmium yellows. Notice that she didn't worry about softening the washes within the figure. This is good. I think a lot of overworking is due to oversoftening of edges.

TUFTSIE'S DAUGHTER

These three paintings were done at a recent workshop at Silvermine in Connecticut. All three students are already very accomplished artists in their own right, so any real faults in their work are due to the typically difficult conditions of a workshop environment. Artists don't usually do their best work in a situation like this, although they often do very fresh and spontaneous—if slightly unrealized—paintings, and this is the case here.

EXAMPLE 1

The head is excellent here, with fine paint handling, colors, and values. The expression is also terrific and the Clara Bow mouth quite effective. The only problem is in the thinking. The artist went for the "first stroke"— that is, for a finish—right away on the head, which was fine. But she painted the lower areas of the body more tentatively, using gray, washed-out tones. Perhaps she had wanted the head to stand out against the neutral washes below, or had hoped to brighten the lower area later through corrective overwashes. No matter what the reason, I question both lines of thinking. I don't feel that any section of a painting should be boring just for the sake of a focal point. Good painting elsewhere would never detract from a head painted as well as this one. As for the second possibility, you should never paint an area with the idea of going back to it. Think, instead, that you have only one shot at each area so you had better make it right the first time around!

EXAMPLE 2

I selected this painting because the artist made a breakthrough into color thinking here. Earlier in the week she painted *John Reading* (page 129). The two paintings, indeed, are of very different subjects. But I think there's also a different attitude in both toward the use of color.

If I could make one criticism, it would be that there is a certain sameness, a certain lack of substance between areas. For example, the light-struck hat and face are too similar in hue and value. More color-value difference is needed between these two important areas.

EXAMPLE 3

The person who painted this usually spends most of her time, both with and without the model, weaving rather intricate patterns of value and color. When she did this painting, I asked her to deal more directly with the problem—that is, in a sense, to be a bit more out of control. Normally, this painting would just be a start for her—she would work on it much longer than this. But I asked her to let me have it at this unfinished stage because it makes several good points.

First, notice even at this early stage that each area has a color identity and a color-value. There are no unspecific "tones" here. Notice, too, that the "big-composition" idea has been established. If she wants, she can always add more information on the left or right later, but she's clearly established the foundation of her picture right at the start.

I would fault this "start" on the lack of color interchange, though. She has grouped her warm and cool values into enclaves—and the areas are too separate. For example, since the figure is predominantly warm in color, she either should have placed warmer tones in the background or put more obvious, cooler colors in the figure. She could have cooled the figure by mixing alizarin crimson into the cadmium red light fleshtones. Since alizarin is a cool red, it would have tied in well with the cool background blues.

WASHED-OUT LIGHTS AND MUDDY DARKS

The following student paintings are not of the same subject, but each contains specific errors discussed earlier. Compare each painting with the sketch I've made showing how the error could be corrected.

WASHED-OUT LIGHTS

This painting was done in class. The assignment was to develop tie-ins between areas of similar value in and outside of the figure. This student is an excellent painter and was very successful in handling these tie-ins. The drawing and composition are fine, too, and the color in the middle and darker areas is generally nice and rich, with good warm-cool variations. But the problem is in the light areas. They are washed out and bland, appearing as "tones" rather than as color ideas.

J·14·82 Sketch of John Silvermine –
Tie-ins figure-background –

CORRECTION SKETCH

I strengthened the lights by exaggerating their color and by making some of the background areas a bit darker. Although this was an accident, it's better to get the color accurate even if the value does get a bit darker in the process. I used cadmium red light, cadmium yellow, and yellow ochre for the fleshtones in the light; and painted the shadows on the model near the picture frame with cerulean and cobalt blues. The background was painted alizarin crimson, cerulean blue, and yellow ochre for a light feeling, and I used alizarin crimson, ultramarine blue, and raw sienna in the drapery.

MUDDY DARKS

This was done by the same person who did *Tuftsie's Daughter* earlier. She is obviously a very capable painter. The handling of the watercolor is quite accomplished. But a bit of over-working is evident—the painting was worked on about a half hour too long. You can see the overwork in some of the "fuzzy" edges. More important, you can see it in the darks. They have no luminosity or life. This was be-cause, in her concern with value, she had ignored the color. She had also mixed her darks with too many col-ors. If you want a really dark dark, you're better off using plain ivory black rather than trying to mix a black. However, I try to get my stu-dents to allow light into their shadows by having them stress the color like-ness of the shadow even more than its value. That is, I think it's better to use dark hues rather than black for your shadows.

CORRECTION SKETCH

I tried to suggest the idea of dark darks without being too literal about expressing the values I saw. So, in-stead of copying the exact value of the dark. I tried to paint the shadows through warm-cool contrasts. You might say that I "pushed" the color.

Since I like to be able to identify the actual warm and cool colors that go into my shadows, I don't mix my watercolors on my palette as I would oil paint, but instead mix them directly on the paper. Of course, I'm speaking of my darks only. I tend to mix my lights more frequently on the palette rather than on the painting, just as I would oil paint.

SAVING A WEAK PAINTING WITH DARKS

If you're working on a painting and it seems to lack punch—if your colors appear weak and washed out—the problem may be that your values are too light and your colors too weak. You can correct the painting by throwing in some strong, intense color and definite darks to strengthen it. But it may be too late. Strong or dark color will probably look jarring and out of place on a weak painting, and unrelated to the rest of the painting. You must add your darks early in the painting stages, not as an afterthought. By then, it will probably be too late. You will probably end up having to adjust all your colors by repainting everything.

Dark values are extremely important in balancing a painting. All you need is one or two carefully placed darks. Don't put them in at random, and never add them just because they're there. You must decide if each dark will help your painting, then choose the best spots for them. If a dark doesn't help the composition, don't add it or it will just be distracting.

SKETCH

Here I sketched my painting of Daisy but left out the darkest values to show you how it would have looked without them. I actually tried to make all my colors about the same value, but I unconsciously did make two changes to compensate for the lost darks, without even intending to do so. Can you see what they are? I made the pinks behind Daisy more intense and a bit darker, and made the yellow in the dress more intense, too. So even though most of the values here are light and washed out, the intense tones give the painting some spunk.

DAISY AT SILVERMINE

oil on canvas,
30″ × 24″ (76 × 61 cm),
private collection.

I did this painting as a demonstration to see if a painting almost completely light in value could be helped with a couple of much darker values. You can decide for yourself if it works. I'm not sure.

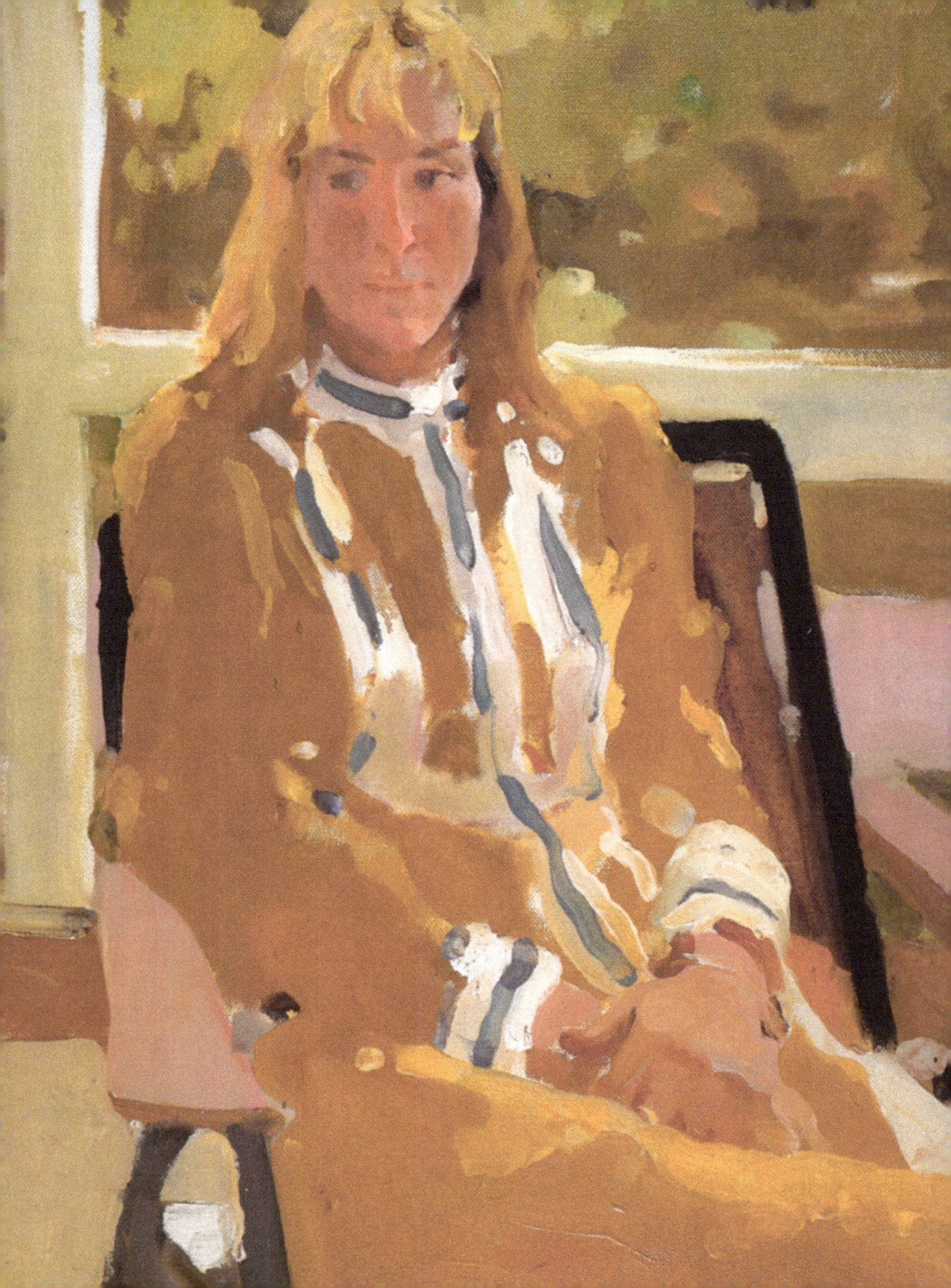

CORRECTING A DIVIDED CENTER OF INTEREST

Earlier I stressed the importance of making connections or tie-ins between the subject and its surroundings since I feel that a truly integrated painting depends on them. But tie-ins involve more than merely softening edges or repeating colors, shapes, or lines in various areas of a painting. They involve the essence of the composition itself. That is why you must plan your painting in a general sense in advance. If you don't, you will have problems similar to the ones I had on these two paintings. Let's take a look at what went wrong and how it could have been avoided.

LAUREN

oil on canvas,
40″ × 40″ (102 × 102 cm),
collection the artist.

Lauren was a young woman "in passage"—her life was in a period of change. She had a very good face, an active personality, and such a fascinating personal history that as she talked to me, I had trouble keeping track of what I was doing with the painting. I got so interested in my subject that I forgot to work out a good picture idea. The problem was compounded by the fact that she was about to take off for Florida and so I felt that I had

to finish her role in the painting quickly and leave the background for later.

There is really nothing wrong with doing this as long as I make major color and value notations of her complexion and costume on the painting. But she was wearing a black blazer, blue shirt, and jeans—and my studio (except for the oriental rug) contains very warm browns. By the time I had finished Lauren's portrait and began painting the background studio, she was gone and I found that I had no way to tie her colors into these surroundings.

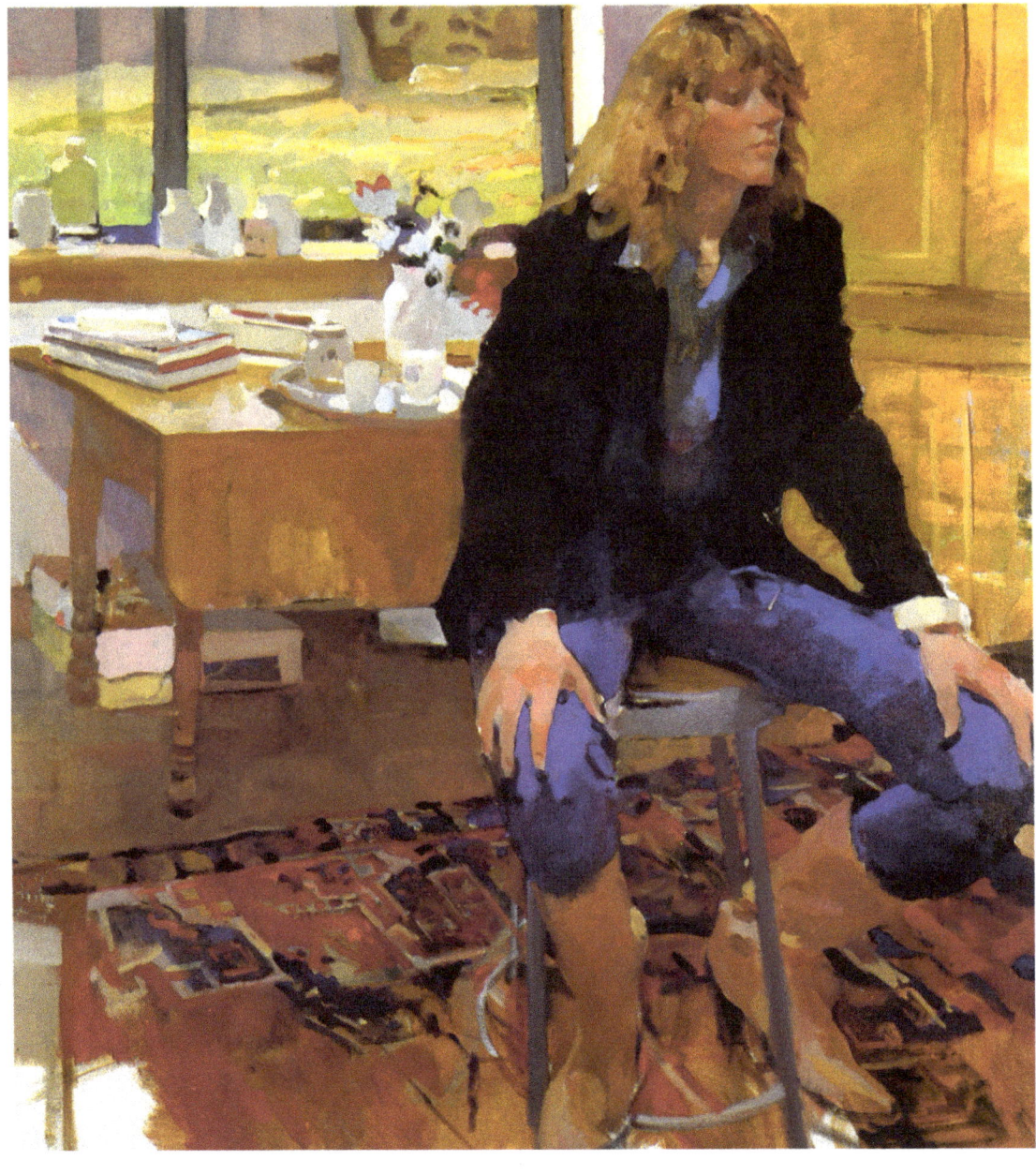

I also discovered an even bigger problem. Except for Lauren's blazer, there were no strong contrasts in the painting, no big light-dark pattern. I had hedged and made some half-hearted contrasts, but overall the values seemed "middling," neither here nor there.

A painting can be successful in a high or low key or it can have definite light-dark contrasts and be middle-range in both value and color. If you cover Lauren's figure with your hand, you'll see what I mean. Each half of this painting does work. But I couldn't have both within the same painting. I had to make a choice.

I thought of two possible solutions: I could cut off the left side of the painting and make it simply a portrait of Lauren without a strong background. Or I could look for and develop a major value and color tie-in between Lauren and her background. I decided on the latter course and sketched two ways I could develop these tie-ins.

SKETCH 1

Here I tried lightening the table and window area to create a major light area in the picture to balance the dark blazer. I also tried to put more color-values (stronger and darker colors) in the lower section of the painting to balance the too-dominant figure.

SKETCH 2

This time I tried to balance the figure by strengthening the upper part of the painting. I enriched the view through the window by adding some definite darks and by making the color of the grass more intense. Which solution would you have chosen? How else might this problem have been solved?

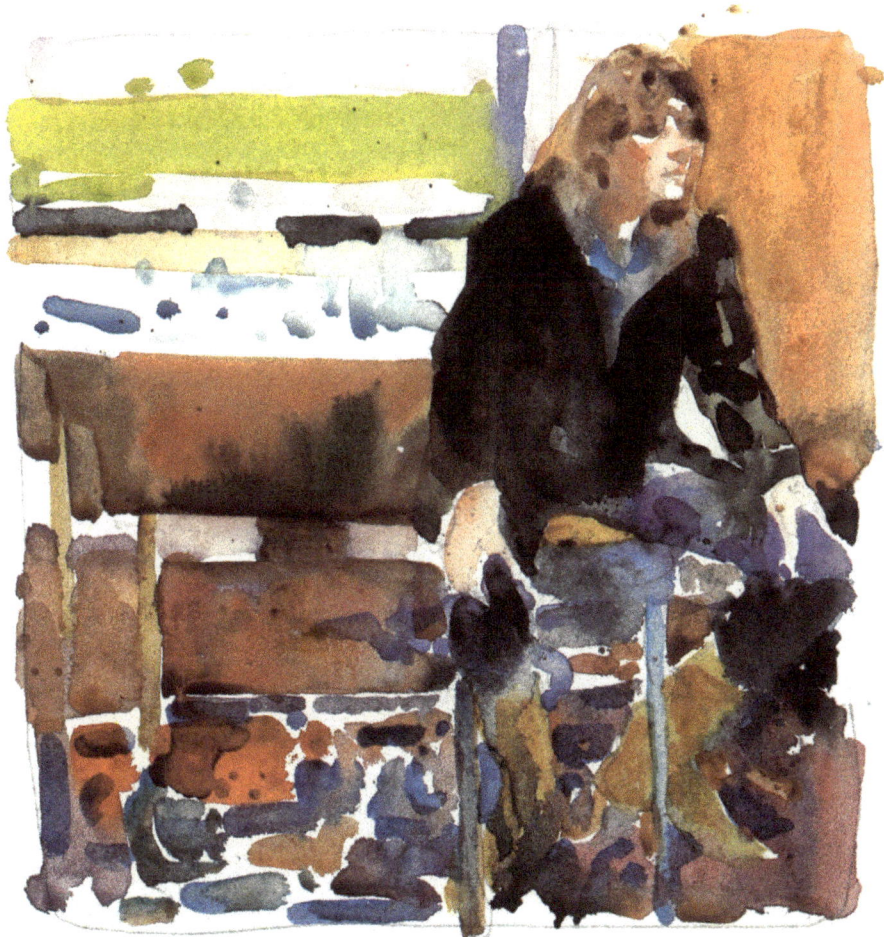

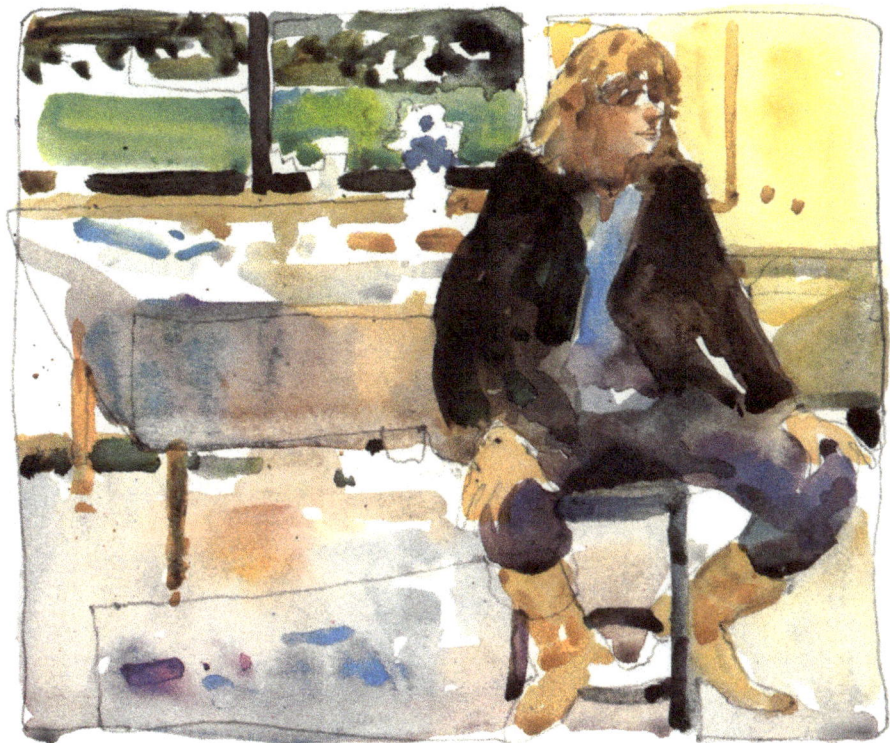

133

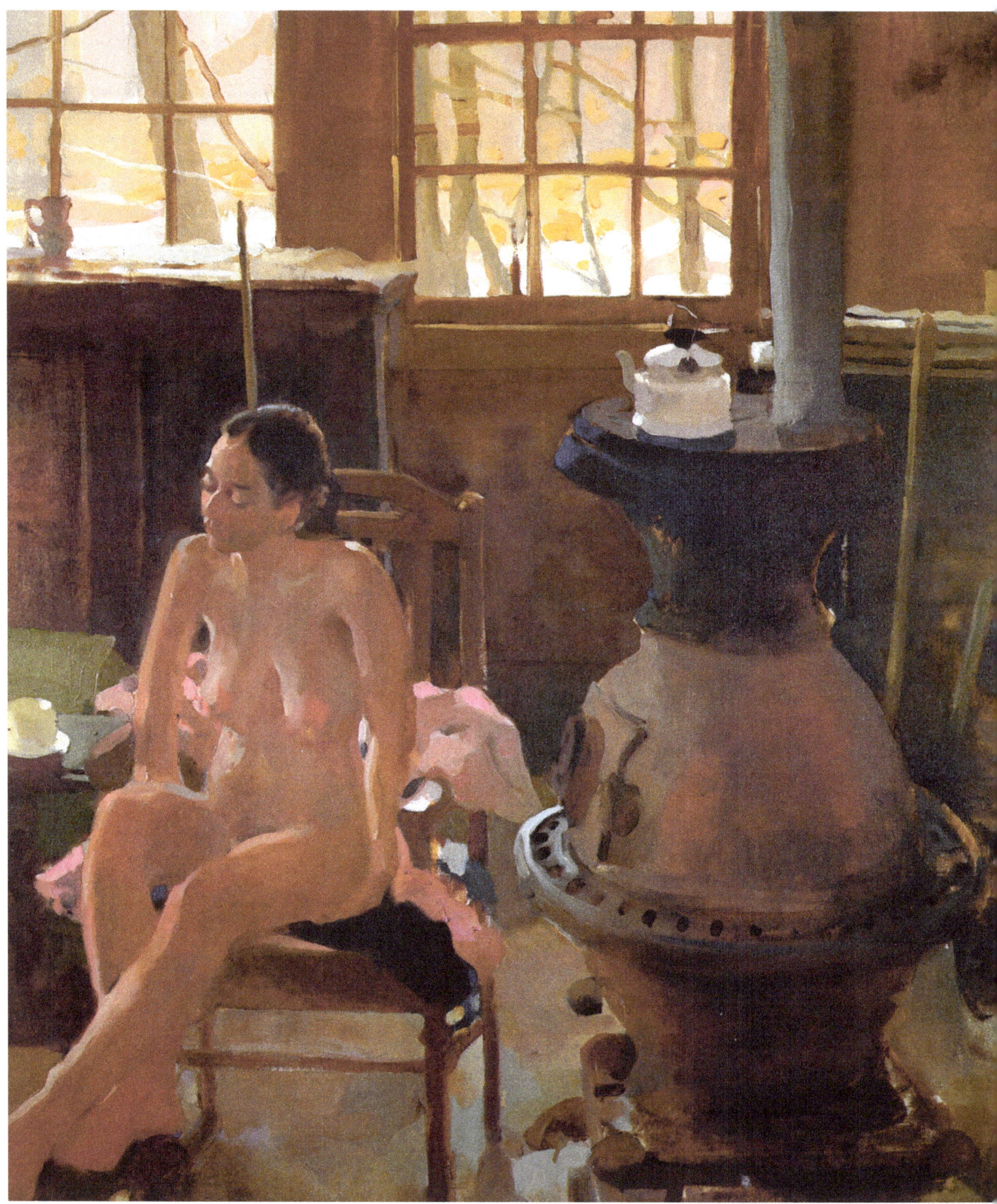

SPERRY'S STUDIO

oil on canvas,
50″ × 50″ (127 × 127 cm),
collection the artist.

This was painted in my friend Sperry Andrews' studio. The property had originally belonged to the American painter J. Alden Weir—Sperry's studio was actually built by Mr. Weir's son-in-law Mahonri Young (Brigham Young's grandson). Many great American painters of the late nineteenth and early twentieth centuries—Ryder, Hassam, Twachtman, Theodore Robinson—had stayed in Mr. Weir's house, which now belongs to Sperry. It's intimidating to paint with such important spirits lurking about!

Sperry and I have often shared a model, but since each of us has a different point of view, we're constantly deferring to the other's unspoken wishes. The result is that the question, "Well, what would you like to change?" goes back and forth until the model gets fed up and thinks of leaving. We then finally settle on a pose the model finds comfortable, no matter what it is. This is an exaggeration, but the fact is that it's hard to work with fellow artists you like and respect. Still, some of my happiest painting moments have been spent in Sperry's studio.

The main problem with this picture is the lack of connection between the model and the stove. They compete for attention because I was never able to decide which subject I was really painting. I think I should have let one or the other dominate. An obvious solution would have been to put the model in the foreground, yet I wouldn't have been happy with that, since I loved that wonderfully mottled, rich brown of the stove.

POTENTIAL SOLUTIONS (SKETCHES)

Here are two small pen-and-ink sketches showing what I'd do if I had another chance at painting the subject. One way to arrange the composition would be to put the model behind the stove and slightly overlapped by it. I'd try to make her a part of the stove, in a sense. But the second solution—the back view with a very natural and awkward pose—might be a good idea, too.

part six
LEARNING FROM THE MASTERS

CONNECTING DARKS

Looking at master paintings is an excellent way to improve your perceptions and advance your own painting. On the pages that follow, I have sketched samples of the work of four famous artists. Notice how the lessons of these paintings can be analyzed and applied—without copying the artists' painting styles.

HOUSE AT TWO LIGHTS, 1927 (AFTER HOPPER)

Hopper's painting intrigues me for several reasons. For one thing, I like the way the subject is crowded into the picture space. How many of us would have chopped off the top of the lighthouse and cut the Victorian house in half? Hopper wasn't interested in the picturesque, but in the pattern of

darks formed by the roofs, windows, shadows, and cast shadows.

There is also an interesting variety of warm and cool colors here. The main building on the right is mostly warm, while the light itself is cool, except for the yellow ochre reflection at the very top. Notice the warm-cool combinations included in some of the shadows and windows.

SKETCH

You can see from my sketch that the painting is basically a two-value picture. The middle values are just decorative, and without them the painting would still flow and hold together. Notice that most of the darks are connected—they're not scattered about. If they weren't connected like this, we wouldn't know what we were looking at when the painting was reduced to the essential light-dark pattern. We would just see a jumble of shapes and values without meaning.

SEEING SHADOWS AND DARKS AS COLOR

I've chosen two early Matisse paintings. Both were done in 1900 and both were painted in oil.

NOTRE DAME, 1900 (AFTER MATISSE)

I picked this example because of Matisse's treatment of the front of Notre Dame in shadow. I imagine if I had seen this scene I would have painted this backlit subject as a dark gray. Instead Matisse used a luminous pink. The even darker details are treated with a color change to green. Only the darkest darks are painted with black out of the tube. All the other darks are treated as color. In other words, you are more aware of color than value here.

PONT ST. MICHEL, 1900 (AFTER MATISSE)

Even though this was said to be painted in the same year, I would assume it's a later painting. It's much more analytical and more carefully orchestrated. Notice the shadows under the bridge and the cast shadow on the left. The only really dark areas are painted with black out of the tube.

Be aware of shadows as spots of color. Shadows can also be either warm or cool. Don't settle for cold grays. If you decide that you want a cool shadow, make it a *color*!

USING LOCAL COLOR

George Stubbs was a marvelous painter, combining exquisite technique with a primitive and humorous vision. In fact, I think Stubbs had much more in common with the Italian and Flemish "primitives" of the fifteenth century than he did with his romantic contemporaries in the late eighteenth century.

DETAILS OF SOLDIERS OF THE TENTH LIGHT DRAGOON, 1798 (AFTER STUBBS)

I chose two details from this painting because they illustrate the use of local color and because they're so amusing, though I haven't done the painting justice in my version of it. Notice that you're much more aware of the color-value of each area than you are of the effects of light and shade on it. There certainly is form here, but the painting seems to have more of a flat pattern of shapes and colors than it does roundness and depth.

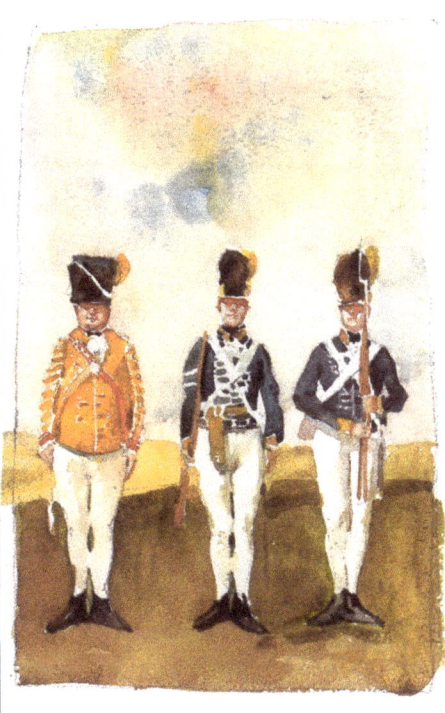

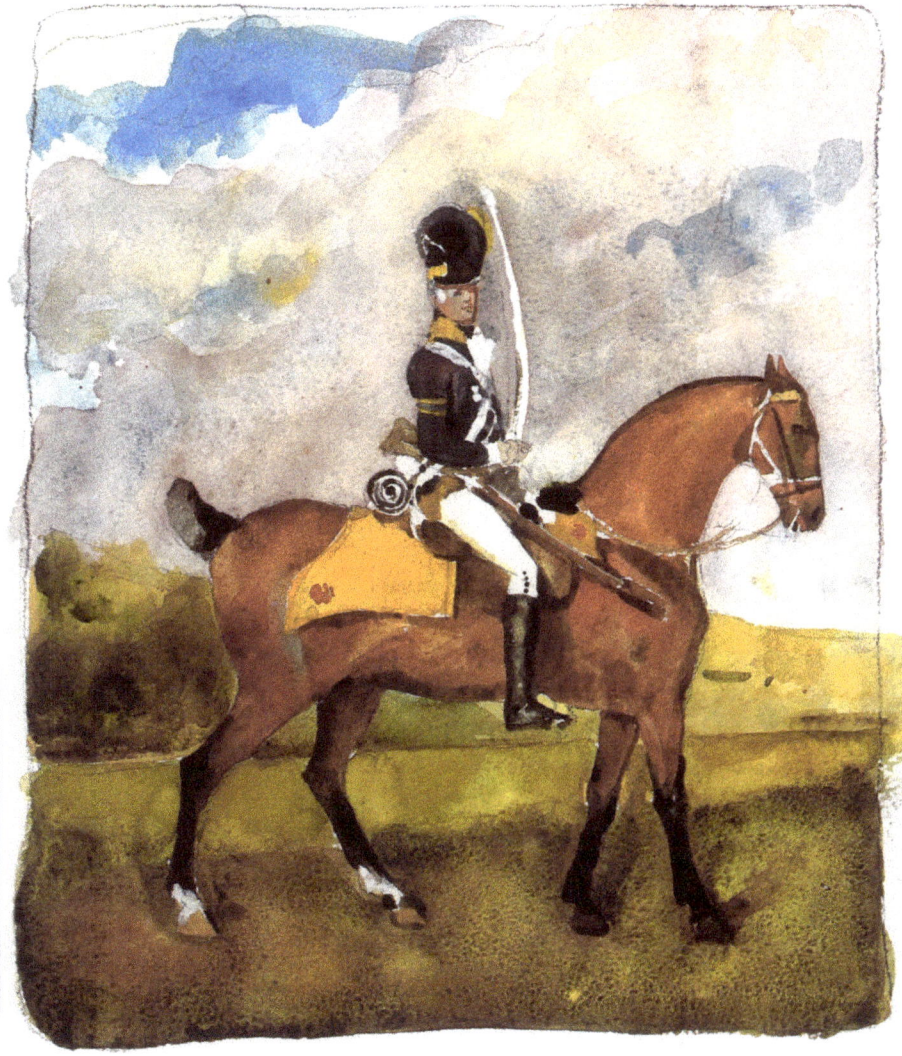

FLATTENING THE PICTURE SURFACE

In the preceding examples of old (and "young") master paintings, I have pointed out features of particular interest that have also been stressed in previous lessons. Now I will show you how I actually applied the lesson in a master painting to one of my own paintings. This is the way I think you should approach famous paintings—not to copy the work or its style, but to adapt the information there to your own personal approach. You should be doing this with my work, too.

The typical eye-level or near eye-level of a subject for example, isn't necessarily the best way to approach a subject. Looking down on a still life may make a much more interesting composition than the usual eye-level view. One advantage is that this perspective avoids background problems by eliminating them altogether.

BACCARO IRIS

watercolor on paper,
20½" × 25½" (52 × 65 cm),
private collection.

My painting, *Baccaro Iris*, doesn't really have a background. Because I am looking down on my set-up, the tablecloth is an integral part of the foreground. This viewpoint also helps me to flatten the space in my painting. I've had such an academic training that I find it difficult to get away from three-dimensional space (though you might wonder why I'd even want to flatten space, since most realistic painters break their necks trying to make some objects come forward and other things recede). I guess we all go through different stages where we're intrigued by different ideas. At the moment, my main interest is in color-value shapes on the picture surface. To me, these shapes are all-important for their own sake rather than because of what they represent. By no means do I intend to suggest that this is "the way" to see and paint. But I do think it's one worth thinking about.

If I had gone the full route, I would have painted the pattern as vertical and horizontal stripes. This would have really flattened the picture, but I also think it would have given it a more static feeling. (I'm still not liberated enough to forget such things as movement!)

SHORE AT BERMUDA, C. 1900 (AFTER HOMER)

I want you to notice a few things in this sketch I made of a Homer watercolor. Homer rarely softened an edge. He also ignored traditional ways of indicating distance. In this painting, the picture plane is flattened because he has used a most intense color in the water and has painted a very definite edge on the horizon. But despite that, the flat planes and hard edges actually seem to create a marvelous feeling of distance.

SUGGESTED READING

My favorite art books are those that contain good reproductions along with some intelligent text. Since most of the books in my library were bought on sale or purchased some time ago, I hesitate to list titles that would be difficult to find or out of print, though I admit there are a few of them in the list below. Therefore, I've deliberately limited the number of titles and publishers of specific books although, even if a book is out of print, perhaps you can still find it in a library.

Where the book I've listed contains reproductions of an artist's work, the specific book is less important than getting a copy of any book that contains the art since, with modern printing methods, even "sale" books are usually excellent in terms of reproduction quality. Phaidon, for example, publishes good books with adequate reproductions at a very reasonable cost. I recommend their books on Stubbs (by Gaunt) and Manet (by Richardson), though both are out of print. I also think that books by Bernard Dunstan, in addition to those listed, are excellent, although many are also out of print by now.

BOOKS ON PAINTING

Chadbourne, Alfred C. *A Direct Approach to Painting.* Westport, Conn.: North Light.

Cogniat. *Bonnard.* New York: Crown (out of print).

Corsellis, Jane. *Painting Figures in Light.* New York: Watson-Guptill, 1982.

Downes, Rackstraw, ed. *Fairfield Porter: Art in Its Own Terms, Selected Criticism 1935–1975.* New York: Taplinger, 1979.

Dunstan, Bernard. *Learning to Paint.* New York: Watson-Guptill and London: Pitman Publishing, 1970.

———. *Painting Methods of the Impressionists.* New York: Watson-Guptill and London: Pitman Publishing, 1976. Revised edition, 1983.

Eiseman, Alvord L. *Charles Demuth.* New York, Watson-Guptill, 1982.

Hawthorne, Charles W. *Hawthorne on Painting,* introduction by Edwin Dickinson. New York: Dover, 1938, 1960.

Henri, Robert. *The Art Spirit,* edited by Margery A. Ryerson. Philadelphia: Lippincott, 1923, 1960.

Hockney, David. *Paper Pools,* edited by Nikos Strangos. New York: Abrams, 1980.

Hoopes, Donelson F. *Eakin Watercolors.* New York: Watson-Guptill, 1971 (out of print).

———. *Sargent Watercolors.* New York: Watson-Guptill, 1976.

———. *Winslow Homer Watercolors.* New York: Watson-Guptill, 1976.

Impressionism, edited by the staff of *Realities* magazine. New Jersey: Chartwell Books, 1980.

Kramer, Hilton. *The Age of the Avant-Garde: An Art Chronicle of 1956–1972.* New York: Farrar, Straus, and Giroux, 1973.

Levin, Gail. *Edward Hopper: The Art and the Artist.* New York: Norton, 1980.

Rewald, John. *The History of Impressionism.* New York: Museum of Modern Art and New York Graphic Society, 1980.

Russell, John. *The Emancipation of Color. The Meanings of Modern Art,* vol. 2. New York: Museum of Modern Art, 1974.

———. *Vuillard.* New York: N.Y. Graphic Society (out of print).

Vaillant. *Bonnard.* New York: N.Y. Graphic Society (out of print).

Viola, Jerome. *The Painting and Teaching of Philip Pearlstein.* New York: Watson-Guptill, 1982.

BOOKS ON DRAWING

Edwards, Betty. *Drawing on the Right Side of the Brain.* Los Angeles: J.P. Tarcher and New York: St. Martin's Press, 1979.

Hogarth, Paul. *Creative Ink Drawing.* New York: Watson-Guptill, 1968.

———. *Creative Pencil Drawing.* New York: Watson-Guptill, 1964, 1981.

Kaupelis, Robert. *Experimental Drawing.* New York: Watson-Guptill, 1980.

———. *Learning to Draw.* New York: Watson-Guptill, 1966.

ARTISTS OF INTEREST

Since so many of the books I recommend are not readily available, I've also listed names of various artists under categories that I've mentioned in this book. Naturally these are personal favorites of mine and in no way are intended to suggest the final word, and many superior artists have been left out. However, these are artists whose work I refer to often when I need help, inspiration, or joy—artists of many styles and persuasions. I think that having such a broad list is important, and that every artist should have one, regardless of what art is currently considered "important." Don't box yourself into an influence that reflects your style alone.

FOR DRAWING

Edgar Degas, Henri Toulouse-Lautrec, Rembrandt Harmensz van Rijn, 15th and 16th century Italian masters (I didn't list names since they're all so good), Paul Cézanne, Hans Holbein the Younger, Henri Matisse, Pablo Picasso, Edwin Dickinson, Richard Diebenkorn, Philip Pearlstein.

FOR COMPOSITION

15th and 16th century masters (such as Piero della Francesca, Jan van Eyck, Bernat Martorel, Hans Memling, Pieter Breughel the Elder), Jean-Baptiste Chardin, Edgar Degas, Edouard Manet, Pierre-Auguste Renoir, Paul Gauguin, Edouard Vuillard, Pierre Bonnard, Henri Matisse, Giorgio Morandi, Andrew Wyeth, Philip Pearlstein, Richard Diebenkorn, Johannes Vermeer, Fairfield Porter, Winslow Homer.

FOR COLOR

Pierre Bonnard, Edouard Vuillard, Henri Matisse, Paul Cézanne, Paul Gauguin, Winslow Homer, Rufino Tamayo, Robert Motherwell, Richard Diebenkorn, Fairfield Porter, Giorgio Morandi, Joseph Albers, Milton Avery, Willem de Kooning, Camille Pissarro, Georges Seurat.

FOR BEAUTIFUL GRAYS

James McNeill Whistler, Edouard Vuillard, Kensa Okada, Edwin Dickinson, Berthe Morisot.

FOR FLATTENING THE PICTURE PLANE

Almost all the modern artists I've listed above flatten the picture plane to some extent. (If you're not sure what I mean by flattening the picture plane, look at my example of Winslow Homer in the "Learning from the Masters" section.)

FOR LOCAL COLOR

15th and 16th century Italian and Flemish painters, Diego Velàsquez, Johannes Vermeer, George Stubbs, Paul Gauguin, Edouard Vuillard.

FOR PAINT HANDLING

John Singer Sargent, Willem de Kooning.

FOR SIMPLIFICATION

Paul Gauguin, Winslow Homer, Andrew Wyeth, Milton Avery, Fairfield Porter.

INDEX

 We hope you enjoyed this title
from Echo Point Books & Media

Before Closing this Book, Two Good Things to Know

Buy Direct & Save

Go to www.echopointbooks.com (click "Our Titles" at top or click "For Echo Point Publishing" in the middle) to see our complete list of titles. We publish books on a wide variety of topics—from spirituality to auto repair.

Buy direct and save 10% at www.echopointbooks.com

DISCOUNT CODE: EPBUYER

Make Literary History and Earn $100 Plus Other Goodies Simply for Your Book Recommendation!

At Echo Point Books & Media we specialize in republishing out-of-print books that are united by one essential ingredient: high quality. Do you know of any great books that are no longer actively published? If so, please let us know. If we end up publishing your recommendation, you'll be adding a wee bit to literary culture and a bunch to our publishing efforts.

Here is how we will thank you:

- A free copy of the new version of your beloved book that includes acknowledgement of your skill as a sharp book scout.

- A free copy of another Echo Point title you like from echopointbooks.com.

- And, oh yes, we'll also send you a check for $100.

Since we publish an eclectic list of titles, we're interested in a wide range of books. So please don't be shy if you have obscure tastes or like books with a practical focus. To get a sense of what kind of books we publish, visit us at www.echopointbooks.com.

If you have a book that you think will work for us,
send us an email at editorial@echopointbooks.com

www.ingramcontent.com/pod-product-compliance
Lightning Source LLC
Chambersburg PA
CBHW052136170526
45162CB00003B/31